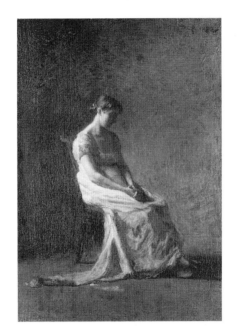

Cornell Studies in the History of Psychiatry
edited by Sander L. Gilman and George J. Makari

Madness in America

Cultural and Medical Perceptions
of Mental Illness before 1914

Lynn Gamwell and Nancy Tomes

❧

Cornell University Press

Binghamton University Art Museum
State University of New York

Copyright © 1995 by the State University of New York at Binghamton

First published 1995 by Cornell University Press

Edited by Suzanne Kotz
Designed by Ed Marquand and John Hubbard
Produced by Marquand Books, Inc., Seattle
Printed in Hong Kong

Library of Congress Cataloging-in-Publication Data
Gamwell, Lynn, 1943–
 Madness in America : cultural and medical perceptions of mental illness before 1914 / Lynn Gamwell, Nancy Tomes.
 p. cm. — (Cornell studies in the history of psychiatry)
 Includes bibliographical references and index.
 ISBN 0-8014-3161-1
 1. Psychiatry—United States—History. 2. Mental illness—United States—Public opinion. 3. Social psychiatry—United States—History.
I. Tomes, Nancy, 1952– . II. Title. III. Series.
 RC443.G35 1995
 362.2'0973—dc20 94-46520

Page 1: Thomas Eakins, *Retrospection*, 1880 (fig. 3.24); page 3: detail, title page of *Charles Julius Guiteau, The Assassin: Phrenological Delineation of His Character*, 1881 (fig. 3.20); page 10: "Madness," in *Essays on the Anatomy of Expression in Painting*, 1806 (fig. 1.11); page 43: detail, "Ball of Lunatics at the Asylum, Blackwell's Island," 1865 (fig. 2.6); page 118: detail, "The Electropoise," 1895 (fig. 3.41).

Contents

Foreword

Madness in America explores the changing views of mental illness held by the medical profession and by the surrounding culture from the colonial period to the First World War. Tracing the evolution of the diagnosis and treatment of mental illness in the United States, along with the early development of psychiatric thought and practice, the authors also examine the cultural anxieties and expectations inextricably entwined with medical opinion. Evocative illustrations drawn from the medical community, popular culture, and the fine arts constitute a vivid history of how the mentally ill were represented in the world of the asylum and beyond. As they describe the successive ways in which Americans have defined madness and attempted to treat it, Lynn Gamwell and Nancy Tomes illuminate some of the most important cultural forces, assumptions, and fantasies in our past and, by extension, raise questions about how we perceive the mentally ill today.

This interdisciplinary volume is a most appropriate choice to inaugurate the series Cornell Studies in the History of Psychiatry. Once considered a province of little interest to anyone outside the profession, the history of psychiatry has grown as a field since the 1970s, attracting scholars from social and cultural history, fine arts, and literature. At Cornell University Medical College, the History of Psychiatry Section has provided an interdisciplinary forum that has fostered and attempted to bridge these many perspectives on psychiatry's past. *Madness in America* similarly attempts to build such a bridge. Furthermore the Section's Oskar Diethelm Library, which has developed into a unique archive of books, manuscripts, prints, and photographs, provided a good deal of primary source material for this volume. It is the aim of this series to publish works that build on the Section's scholarly tradition and to reach both those readers who find psychiatry's past absorbing in itself and those who view the field as a window into broader social, intellectual, and scientific arenas.

Sander L. Gilman, Ph.D.
George J. Makari, M.D.
Coeditors, Cornell Studies in the History of Psychiatry

Preface

In 1992 we decided to use the historic occasion of the 150th anniversary of the founding of the American Psychiatric Association (1844–1994) to collaborate on a study of the evolution of American attitudes toward mental illness. We set our time frame from the colonial era, when America's diverse medical traditions originated, to the eve of World War I, by which time American psychiatry had begun to split between psychological and biochemical approaches to treating madness.

Initially we aimed to trace the treatment practices of three parallel traditions: Native American, Anglo-American, and African American. But the research involved for each area forced us to narrow our focus to mainstream Anglo-American medicine, and to provide only brief sketches of Indian and African beliefs and treatments where they most directly touched on Western practice. We also encountered, but had to set aside for future study, other American healing traditions that include colonial French Catholicism, Spanish customs in the South and West, and eastern European practices brought to America by late nineteenth-century Jewish immigrants.

While limiting our scope to Anglo-American asylum medicine, we sought to broaden the medical narrative to include politics and culture, particularly the interrelated matters of race, ethnicity, gender, popular culture, and the arts. To render these complex issues accurately, we relied on the advice of experts in diverse fields, whose names are listed in the acknowledgments at the end of this volume.

As coauthors we brought different approaches to our subject: as an art historian and museum curator, Gamwell comes from a tradition that focuses on images and objects; as a historian of medicine, Tomes works in a discipline grounded in the explication of written texts. Together we sought to integrate images and words as primary sources, and not to treat images as ancillary illustrations of the text.

In pursuing this goal, we were inspired by the work of scholars of English and Continental psychiatry who have brought new attention to visual data. But since most histories of American psychiatry focus on texts alone, the search for appropriate images presented a special challenge. We cast a wide net, sifting through the archives of American mental hospitals, libraries, historical societies, and museums. Sometimes we came upon a powerful object or image that told a story, such as the keys fabricated from nails, wire, and tin by patients hoping to escape a Wisconsin asylum (fig. 2.26). In other cases we looked for a picture or object that would bring to life a specific practice we chronicled—such as a ticket stub to a mesmerist's lecture (which we found, fig. 3.37) or a log book of visitors who came to view asylum lunatics (which we did not find, although we did locate a sketch by a former patient of a fashionable couple viewing him in his barred hospital compound, fig. 1.26). We also took a fresh look at some famous images in the fine arts that related to our topic, such as Benjamin West's monumental *Christ Healing the Sick* (fig. 1.23), which led us to West's little-known preliminary drawings, haunting studies of a demoniac boy being held by his parents (figs. 1.20–1.22).

Because our visual and written source materials are often emotionally volatile—ranging from depressing to inspiring, infuriating to hilarious—we have taken special care with our use of them. At every stage of writing, editing, and designing this volume, we have attempted to maintain a respectful attitude toward the mentally ill and to avoid sensationalism, without lapsing into a monotone. Believing that the impact of images is more visceral

than that of words, we were particularly mindful of the selection and placement of pictures, especially those that were racist, sexist, homophobic, or demeaning to the mentally ill.

Finally, throughout the research and development of this book, we have maintained a dialogue with our colleagues in the mental health professions. In treating often controversial subjects, we have tried to take all sides into account. At the same time, we have been aware that those outside a field who critique its practices may all too easily fall into naive, even arrogant, pronouncements. Thus we have attempted to remain conscious of our own prejudices while listening carefully to our learned advisers.

Note on Terminology

The terms used to describe mental illness and its treatment changed markedly over the decades chronicled in this book. Rather than use modern terms that did not exist or held different meanings in the past, we have employed the language of the times we portray, even at the risk of offending modern sensibilities. The evolution of psychiatric terminology reflects not only scientific shifts in explaining and treating insanity, but also the continuing effort to rid mental illness of its stigma and sense of hopelessness. We ask that our readers hear these words in their historical context.

"Distraction" was used in the seventeenth and eighteenth centuries to signify a state of mental agitation and excitement short of complete madness. In the eighteenth and nineteenth centuries, Americans used the words "demoniac possession," "madness," "lunacy," and "insanity" to describe what we today call mental illness. Each word had a different connotation. The use of "demoniac" to describe a person possessed by a devil reflected the continued influence of biblical explanations of madness. "Lunacy" derives from the traditional belief that intermittent derangement was related to phases of the moon. Both terms were used throughout the nineteenth century, even after religious and astrological explanations had been abandoned as unscientific. "Lunatic" developed a special legal meaning, signifying that a person's mental alienation was so profound that he or she could not enter into binding civil transactions. "Madness" was a more vernacular term, suggesting wildness, lack of restraint by reason, and loss of emotional control. This last meaning survives today when we describe an angry person as "mad." Because madness was an emotionally charged term tinged with contempt, early American physicians preferred the more clinical "insanity," which literally means not "sane" (clean, healthy). Of this early vocabulary, only "insanity" persists today in medical circles, where terms more commonly stress the medical nature of insanity—"mental illness," "mental disease," and "mental disorder."

The language used to describe physicians who specialized in the treatment of the insane also has changed. In eighteenth-century England, physicians who ran asylums for the insane were called "mad-doctors." In the wake of the asylum reform movement, which began in the late 1700s, doctors who headed up the new reform-minded institutions referred to themselves as "asylum doctors" or "asylum superintendents," and to their field of specialty as "asylum medicine." English specialists called themselves "alienists" because they treated abnormal or "alien" states of mind. The term "psychiatrist" first appeared in the mid-1800s in Germany and gradually came into use throughout Europe and the United States. "Psychiatry," the name for the branch of medicine that treats mental illness, derives from the Greek *psyche*, which means "breath," "spirit," and "animating principle," and is personified by the goddess Psyche, the ethereal, winged beloved of Eros. In the ancient myth, Psyche is liberated from confinement in a dark palace of erotic pleasure the moment she lights a candle and discovers a painful truth.

To diminish the threatening aspect of the institutions they supervised, successive generations of asylum doctors and psychiatrists sought suitable designations for them. "Hospital" emphasized insanity's status as a disease. "Asylum," used in the first half of the nineteenth century, suggested a refuge from the maddening world. As institutional care deteriorated in the late nineteenth century, "insane asylum" took on strong negative connotations and was replaced by more neutral terms such as "center for nervous diseases" or "psychiatric hospital."

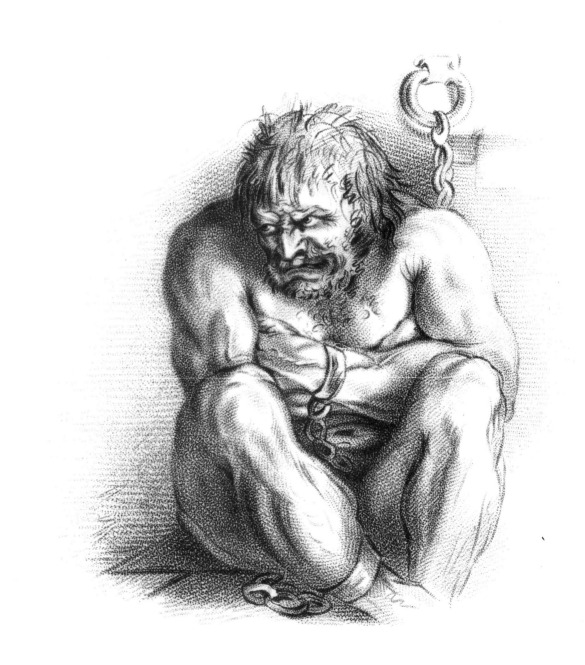

Madness and the Asylum in Early America
The Seventeenth Century to the 1810s

The original thirteen American colonies were cultural as well as political extensions of England. From their tenuous beginnings in New England and Virginia, British enclaves in North America prospered and expanded through the exchange of raw materials for English manufactured goods. By the 1750s, the New World colonies had helped spur the beginnings of the Industrial Revolution in England. Colonial society was dominated by wealthy merchant and planter elites, sustained by independent farmers working rich soils, and dependent, particularly in the South, on white indentured laborers and a growing number of enslaved African workers.

The culture of these prosperous colonies was strongly shaped by the eighteenth-century Enlightenment faith in reason, humanism, democracy, liberal institutions to cure society's ills, and progress in manufacturing and production to fill its needs. Fed by both secular and religious sources, the American Enlightenment produced a commitment to broadly representative political institutions and a skepticism about concentrated power and governmental authority. American colonists saw themselves as full-fledged English citizens worthy of representation in the British Parliament, not as mere subjects with no direct political voice, a perception that set the stage for conflict with British imperial rule and eventually led to the American Revolution.

Although dominated by an English majority, the American colonies were far more ethnically diverse than the mother country, given the presence of Native Americans, African Americans, and other Europeans. England provided the dominant models for social and political institutions, but they coexisted with and, to some degree, accommodated non-English and nonwhite customs.

This pattern of parallel traditions extended to the evolution of attitudes and practices concerning mental illness. Colonial hospitals and medical practices strongly resembled their English counterparts, yet the Anglo-American model constituted only one of several within the larger population. The native traditions of North America and Africa each offered perceptions of madness that distinguished American attitudes from those of the English.

NATIVE AMERICAN TRADITIONS

Perpetuating Columbus's misapprehension that he had reached the East Indies in 1492, the term "Indian" is applied to vastly different aboriginal peoples who lived in the Americas prior to the European migrations. Before 1600, an estimated one million Indians, speaking two thousand languages, lived north of the Rio Grande. In economic and social organization, they varied from small bands of hunter-gatherers to densely populated agricultural societies. Over the ensuing centuries of contact with Europeans, Indians both resisted and adapted to the white presence in ways that profoundly influenced Native American notions of madness and healing.

Early accounts left by European missionaries and traders suggest that conditions such as hysteria, hallucinations, severe depression, and demoniac possession were familiar, if not common, among many native tribes. Indian terms for what we would call

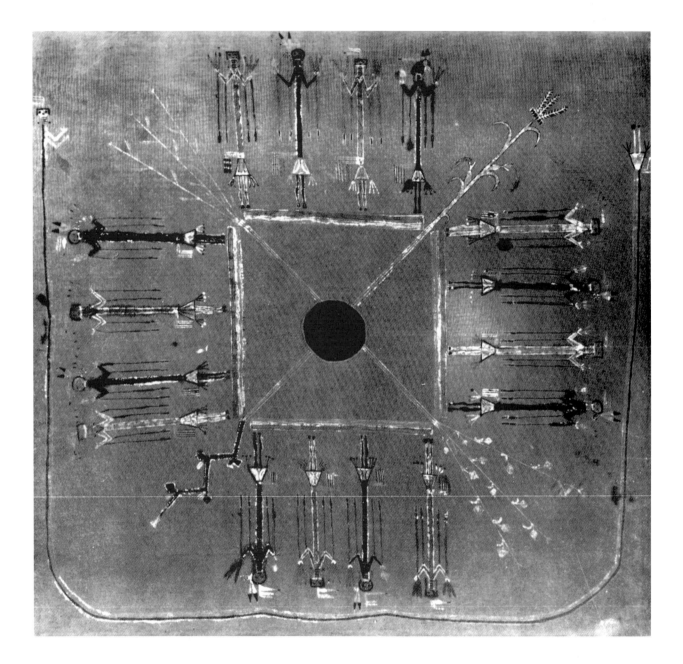

madness included "soul loss" and "being lost to oneself," and suggest the sense of self-alienation at the core of the experience.

Although Indians had a sophisticated knowledge of herbal remedies for physical ailments, they conceived of disease primarily in supernatural terms. They held a complex worldview in which invisible spirits, both good and bad, continually interacted with human beings, who could be bewitched by the living or possessed by the spirits of the dead. Indians believed that supernatural agents caused most mental afflictions, and that those who broke fundamental moral laws, such as taboos against incest, were at particular risk for madness.

This fundamentally spiritual conception of disease was reflected in Indian healing practices. Throughout the year, the community participated in religious ceremonies designed to keep the world in balance and to ward off disease. Ceremonial dances and rituals might offer opportunities for individuals to express accumulated anger or anxieties, or to drop customary patterns of self-control. Special mourning rites helped guide family and community members through the death of loved ones, thus staving off excessive grief or melancholy.

In addition to these prophylactic rituals, individuals who became physically or mentally ill underwent healing ceremonies tailored to specific ailments. Among the Iroquois, for example, certain medicine societies specialized in rituals for particular conditions: the Corn Husk Mask Society had a rite for stopping bad dreams or hallucinations, the Otter Society a rite for nervous tremors. For severe mental illness, the Navajo used the Night Way ceremony, during which a night chant, or *yeibichai* (Navajo for "talking gods"), was performed (fig. 1.1).

The central figure in Indian curing rites was the shaman or medicine doctor. To become healers, individuals first and foremost had to give evidence of supernatural powers, which were often associated with signs of physical or mental abnormality; someone born with a congenital defect, subject to convulsions, or prone to extended hallucinations was regarded as potentially having supernatural skills. Either men or women could serve as shamans, and individuals who combined the appearance, personality characteristics, and powers ascribed to both sexes were marked as possessing magical power, particularly to mediate between the two gender worlds.

Fig. 1.1. "First Dancers," Navajo night chant rug, woven in the early 20th century after a traditional sand painting, 26⅝ × 24½ in. National Anthropological Archives, Smithsonian Institution, Washington, D.C.

The Navajo believed insanity could result from breaking major taboos, such as incest. The fluttering flight of moths suggested to them the erratic behavior of a mentally ill person, and they used the term "acting like a moth" to describe insanity.

The night chant, so named because it took place at night, was a curing ritual for mental illness in which the gods of the sacred mountains were invoked on the sufferer's behalf. The ritual lasted more than a week and required many sand paintings of healing symbols, whose powdered pigments were brushed away after use. While a medicine man or "singer" performed the chant, the afflicted person sat in the middle of each successive painting and absorbed the power of the healing symbols and figures pictured there. The design for this rug, known as First Dancers, features a black lake in the center, surrounded by four alternating quartets of black male gods, wearing round masks with black-tipped white eagle feathers, and blue female gods, wearing rectangular masks. Stalks of white corn, blue beans, black squash, and blue tobacco divide the quadrants. A rainbow forms the body of the guardian figure that borders the rug on three sides.

Sand-painting designs were traditionally done in secret with impermanent materials. In 1896, however, a white man on the exploratory Wetherill expedition convinced a Navajo to weave him a single rug with a sand-painting pattern. In 1917 Hosteen Klah, a Navajo shaman who had demonstrated rug weaving at the Chicago World's Fair of 1893, dared to pass on the secret designs to Anglo-Americans in a large-scale commercial venture. Klah feared retaliation from the gods, but when nothing happened to him, he set about regular rug production, despite bitter protests from other medicine doctors.

Fig. 1.2. George Catlin, "Dance to the Berdashe," engraving in *Illustrations of the Manners, Customs, and Condition of the North American Indians* (London, 1832–39).

Catlin described the "berdashe" as "a man dressed in woman's clothes, as he is known to be all his life, and for extraordinary privileges he is known to possess. . . . A feast is given to him annually; and initiatory to it, a dance by those few young men of the tribe who can, as in the sketch, dance forward and publicly make their boast. . . . Such, and only such, are allowed to enter the dance and partake of the feast" (vol. 2, pp. 214–15).

Fig. 1.3. George Catlin, *Old Bear: A Medicine Man,* 1832, oil on canvas, 29 × 24 in. National Museum of American Art, Smithsonian Institution, Washington, D.C., gift of Mrs. Joseph Harrison, Jr.

Catlin described the role of the medicine doctor:

> All tribes have their physicians, who are also medicine (or mystery) men. These professional gentlemen are worthies of the highest order in all tribes. They are regularly called and paid as physicians, to prescribe for the sick; and many of them acquire great skill in the medicinal world, and gain much celebrity in their nation. Their first prescriptions are roots and herbs, of which they have a great variety of species; and when these have all failed, their last resort is to medicine or mystery. (*Illustrations,* vol. 1, p. 39)

Because colonial-era accounts of Indian culture were written by whites, it is impossible to get a native perspective on shamans who crossed gender lines. Within Anglo-American society, homosexuality was considered a crime in the seventeenth and eighteenth centuries, and in the nineteenth century gradually came to be viewed as a mental illness. In colonial times executions for sodomy (copulation with a member of the same sex or with an animal) are recorded in the English colonies, in Virginia (1624) and New Haven (1646), and in the Dutch New Netherlands colony on Manhattan Island (1646). After the American Revolution, punishment shifted from death to mutilation; for example, a revision of Virginia law, undertaken by Thomas Jefferson and others in late 1776, declared that "whosoever shall be guilty of . . . sodomy with man or woman shall be punished, if a man, by castration, if a woman, by cutting thro' the cartilage of her nose a hole of one half inch diameter at the least" ("Plan Agreed Upon by the Committee of Revisors at Fredericksburg," Jan. 13, 1777). (For the movement of homosexual behavior from legal to medical jurisdiction, see p. 162.)

Early accounts of Indian shamans manifest the biases of white authors. French colonists called shamans "berdashes," the French word for male prostitute. George Catlin, an American artist-traveler, described Indian crossdressing and same-sex dancing in his *Illustrations of the Manners, Customs, and Condition of the North American Indians:* "This is one of the most unaccountable and disgusting customs that I have ever met in the Indian country" (London, 1832–39, vol. 2, p. 215; fig. 1.2). White accounts confirm, however, that the practice was widespread in many tribes and that shamans held respected positions in Indian society (fig. 1.3).

Indian shamans regularly invoked supernatural aid in treating the mentally afflicted. They first would try to determine the cause of illness through divination or dream analysis. If the illness stemmed from breaking a taboo, the curing ceremony included some form of confession, followed by rituals of atonement and purification. If witchcraft was suspected, the shaman used special rituals to counteract the witch's malevolent powers.

ANGLO-AMERICAN TRADITIONS

Prior to the 1700s, Anglo-American colonists accepted both natural and supernatural explanations for madness with little sense of contradiction. The prevailing physical explanation for mental disease, which originated in antiquity and was refined in medieval physiology, was based on the theory of the four bodily humors: blood, phlegm, choler (yellow bile), and black bile. A person's character and general health reflected a preponderance in his or her body of one of these fluids; accordingly, one's disposition might be sanguine, phlegmatic, choleric (bilious), or melancholic. An imbalance in the humors could cause mental derangement, which was treated by restoring the balance by bleeding or purging (evacuating the bowels of) the patient. Assuming a close connection between bodily and mental afflictions, the colonists also believed that physical conditions such as a high fever or an upset stomach could produce mental derangement.

Following biblical tradition, colonists traced the religious cause of all disease, including madness, to the Old Testament story of the original sin of Adam and Eve—eating from the tree of knowledge of good and evil. Those who committed especially grave sins, such as murder or adultery, might go insane as punishment. Influenced by several dramatic New Testament accounts of Christ and his disciples casting out demons, colonists also believed that Satan sent devils to enter people's bodies and literally possess their minds.

The notion of madness as demoniac possession is found in the early writings of Cotton Mather (1663–1728), a prominent Puritan minister in colonial Massachusetts who wrote some of the earliest and most original American works on the subject of medicine (fig. 1.4). The evolution of his views on mental disorder exemplifies the changing direction of Anglo-American thinking in the late 1600s and early 1700s. In his early writings, Mather emphasized the supernatural origins of madness. In a sermon, "Warning from the Dead: A Blessed Medicine for Simple Madness" (1693), he wrote, "There is an unaccountable and inexpressible interest of Satan often times in the distemper of madness." He blamed Satan for causing the melancholy of a fellow clergyman, claiming that because Satan was "irritated by the evangelic labors of this holy man," he had tormented him with devils of depression (*Magnalia Christi Americana,* London, 1702, p. 441). Pamphlets expressing similar views were widely circulated in the American colonies (fig. 1.5).

Like Mather, most seventeenth-century colonists believed that humans possessed by the devil—female witches or male

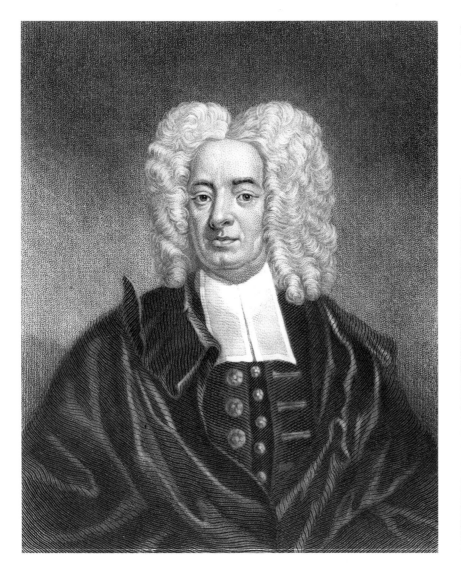

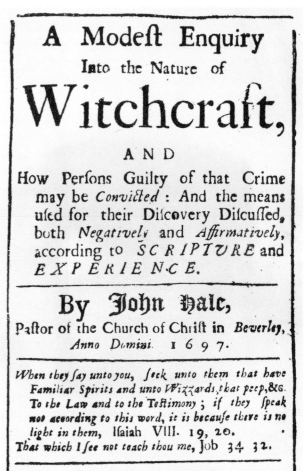

Fig. 1.4. Cotton Mather, 19th century, engraving by C. E. Wagstaff and J. Andrews from a painting by E. Pelham. Peabody Essex Museum, Salem, Massachusetts.

Fig. 1.5. Title page of John Hale, *A Modest Enquiry into the Nature of Witchcraft* (Boston, 1702). Peabody Essex Museum, Salem, Massachusetts.

warlocks—acquired the power to bewitch others. Colonists who suddenly became despondent or distracted might suspect that their mental torment resulted from black magic and seek the identity of the devil's human agents.

The last and most celebrated outbreak of witchcraft accusations in the American colonies began in Salem Village, Massachusetts, in 1691. A group of young women in this farming community began to exhibit bizarre behavior, including outbursts of uncontrolled anger, hallucinations, and contorted limbs. After examination by a physician ruled out physical disease as a possible cause, authorities moved ahead with witchcraft investigations. Under questioning, the afflicted girls named three women as their tormentors, one of whom, a West Indian slave named Tituba, confessed to being in league with the devil and claimed that Satan had many other followers in the area. Over the next few months the girls identified scores of additional witches and warlocks. Colonial authorities set up a special court in Salem to prosecute the cases. By 1692 more than one hundred individuals had been accused, and ultimately nineteen were executed for the crime of witchcraft.

Eventually the Salem witchcraft investigation was discredited. As the girls accused individuals of higher social rank, among them Cotton Mather himself and the wife of the colony's royal governor, colonial authorities began to question the motives of the accusers and finally halted the trials. Once an ardent supporter of the witch-hunting enterprise, Mather repudiated the Salem proceedings and suggested that it was the girls themselves who had formed a pact with the devil.

Still, Mather took a harsh view of his third wife, Lydia, who a few years after their marriage in 1715 began to have furious rages, which Mather described as "little short of a proper satanic possession." He came to fear the social stigma associated with mental derangement: "I have lived for near a year in a continual anguish of expectation, that my poor wife by exposing her madness, would bring a ruin on my ministry" (1719 entry, *The Diary of Cotton Mather,* Boston, 1912, pp. 583, 586).

By 1724, when Mather wrote *Angel of Bethesda,* considered by many to be the first distinctively American contribution to medical literature, he gave more natural, physical explanations for madness. Although he still believed that demoniac possession caused some cases of madness, he dwelt at greater length on the somatic origins of the disorder and the various physical means to cure it, including venesection, purges, and herbal remedies.

After the Salem debacle, formal accusations of witchcraft virtually ceased in New England. Yet, as Mather's characterization of his wife suggests, religious conceptions of madness as originating in sin or Satanic possession persisted in the eighteenth century, especially among the spiritual descendants of the Puritan New Englanders. Under the influence of the Enlightenment, however, the eighteenth-century medical community looked more toward physical explanations along the lines of the humoral theory.

AFRICAN-AMERICAN TRADITIONS

The first Africans to arrive in North America were brought as slaves by white settlers to Jamestown, Virginia, in the early 1600s. The practice of slavery remained occasional and incidental until later in the century, when a prosperous English economy created expanded markets for New World products. Southern planters, unable to find sufficient white indentured labor to supply their rapidly expanding tobacco and rice plantations, turned to slave traders. Most slaves came from the western coast of Africa and represented a variety of linguistic and ethnic groups, including the Bantu, Yoruba, Ibo, and Hausa. Some went to the northern colonies as house servants and craftsmen, but the majority went south to work on farms and plantations. Although forced to submit to the authority of white planters, they retained many African beliefs and customs, particularly those concerned with healing and magic. Even when, in time, African Americans adopted aspects of their masters' Christianity, many never completely abandoned African healing beliefs or their faith in magical practices.

African-American healers had a broad knowledge of herbal medicines useful against common ailments, but if a disease lingered, healers and their patients suspected a supernatural cause. The African worldview described negative events, including illness, as possible evidence of magic and sorcery. Suffering was seen in highly personal terms, and thus the healing process required identifying, through divination or dreams, the evil source of illness. Specialists in magic, known as conjurers, hoodoos, voodoo priests, and rootmen, were among the most feared and respected members of the slave community. Like Indian

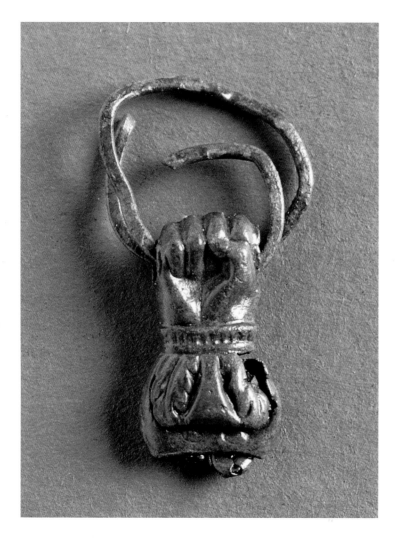

Fig. 1.6. Slave charm, early 19th century, stamped brass, ¹⁵/₁₆ in. high.
The Hermitage: Home of President Andrew Jackson, Nashville.

This small brass ornament with a clenched fist was recovered from the slave quarters at the home of Andrew Jackson, near Nashville, Tennessee. According to slave narratives, such amulets were used to protect the bearer from witches.

shamans, conjurers could be either men or women. They were often distinguished by some physical deformity or a reclusive, eccentric personality; their healing powers seemed to depend upon their outsider status.

By offering magical remedies for misfortune, conjurers provided some sense of control within the arbitrary world of enslavement. Cruel treatment by a master, the afflictions of illness, or the sale of a beloved relative could be assuaged, at least partially, by magical rituals. Conjurers offered particularly potent remedies for rage, an emotion slaves rarely expressed openly; slaves could use magic to strike back covertly at those who hurt them. To some extent, then, conjuring served as an antidote to demoralizing aspects of slave life.

This side of conjuring is suggested by a legend known to former slaves and their families, and recorded in the 1930s by novelist and folklorist Zora Neale Hurston. The story concerns a conjurer named "Old Dave," who used magic against a planter who had murdered another slave. Old Dave slowly conjured the planter's wife and children into insanity. In their madness, the family members became the agents of punishment, abusing, attacking, and otherwise making the planter miserable, until he died a broken, lonely man (*Mules and Men,* Philadelphia, 1935, pp. 240–42).

Witchcraft and conjuring also were used to settle scores among slaves themselves. Even a rumor that someone had consulted a conjurer caused tremendous agitation and anxiety in the potential victim. According to slave accounts, a slave who thought himself to be the object of a spell might literally go mad from fear. Some victims reportedly stopped eating and wasted away; others were said to behave like animals, crawling on all fours and making bestial noises. Many slaves wore charms or amulets designed to ward off magical assaults (fig. 1.6). If they had reason to fear bewitchment, they might immediately enlist a conjurer to work a counterspell, turning the magic back on the sender.

NEW VIEWS OF MADNESS IN EIGHTEENTH-CENTURY AMERICA

The driving principles of the Enlightenment—that reason is the essence of human nature, that science can explain the universe, and that society can be continually improved through human

effort—reshaped the conception and treatment of madness over the course of the eighteenth century in England and the American colonies. Loss of reason came to be seen as equal to loss of humanity; madmen were seen as little better than animals. The first hospitals were established to protect citizens from the threat to social order posed by violent lunatics.

Foreshadowed by the natural laws of light and motion proclaimed by English physicist and philosopher Sir Isaac Newton (1642–1727), the Enlightenment climate of materialism came to full maturity in America with medical figures such as Benjamin Rush (1745–1813), who believed that the entire universe, including man's mind and morality, could be explained in terms of physical laws and fitted within a scientific, rational structure. To explain the physical workings of the body, Rush updated the old theory of four humors with principles drawn from Newtonian physics and organic chemistry. He believed that all disease processes, including madness, stemmed from disorders of the vascular system. Like most of his medical contemporaries, he recommended restoring the body's internal balance by opening the patient's veins to allow copious bleeding and by administering purging enemas (fig. 1.7). Physicians called Rush's therapeutic approach "heroic treatment" because of its great risk to the body—leading, they hoped, to a heroic cure. Rush summed up his diagnoses and treatments for insanity in *Medical Inquiries and Observations upon the Diseases of the Mind* (Philadelphia, 1812), the first major American medical treatise on mental illness.

Artistic and literary styles associated with the Enlightenment shared the assumption that the human mind is capable of comprehending the inner workings of the world, which can be revealed and communicated through rational methods. Although a finished artwork was understood as the product of judgment and skill, artists and physicians alike believed that initial creative impulses were irrational. Continuing the age-old association of creativity and madness, Benjamin Rush noted:

> The records of the wit and cunning of madmen are numerous in every country. Talents for eloquence, poetry, music and painting, and uncommon ingenuity in several of the mechanical arts, are often evolved in this state of madness. . . . The disease which thus evolves these new and wonderful talents and operations of the mind may be compared to an earthquake, which, by convulsing the upper strata of our globe, throws upon its surface precious and splendid fossils, the existence of which was unknown to the proprietors of the soil in which they were buried. (*Medical Inquiries,* pp. 153–54)

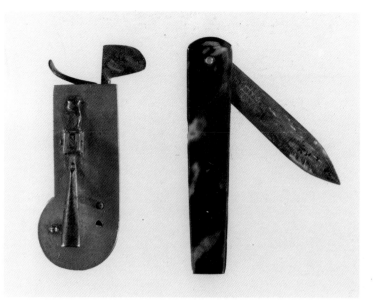

Fig. 1.7. Bleeding lancets, late 18th century. Mütter Museum, College of Physicians of Philadelphia.

These lancets were used to open a patient's vein for therapeutic bleeding. The blade of the lancet on the left, which is the type used by Benjamin Rush, was spring-loaded to speed the incision and thereby reduce its pain.

Whereas creative intuition remained raw in the deranged mind of the madman, the skilled artist refined passionate impulses into a complex work which manifested human and artistic maturity.

Nowhere is Enlightenment taste clearer than in eighteenth-century attitudes toward the academic sketch. Neoclassical painters, such as Philadelphia-born Benjamin West (1738–1820), were trained to begin any major work by making many spontaneous, rapid sketches to capture first impressions (see figs. 1.20–1.22). To complete a painting, the artist refined these raw impulses through increasingly tighter drawings and oil versions, until the overall composition was resolved and every detail painstakingly executed. Creative art began in the intuitive sketch, but finished art was adult, rational, and sane.

The rise of science in the eighteenth century slowly eroded the foundations of religion and ultimately led to the secular science of the modern world. But many physicians of the Enlightenment, such as Rush, sought to keep science consistent with

Christianity by claiming that the Newtonian universe was designed by God. Old beliefs that God or Satan intervened directly in human affairs were replaced by a conception of disease as a violation of natural law. God created humans with a certain physical and mental makeup; as long as they followed the principles of right living, they would stay healthy. But if individuals violated these laws, by either physical or ethical indiscretions, disease would inevitably follow. This revised religious outlook, together with the Enlightenment sense of personal freedom, led physicians to emphasize the individual's responsibility for his or her own health. Mental illness was seen as less a random form of supernatural punishment and more the product of individual action.

Reflecting Enlightenment faith in institutions to cure society's ills, the eighteenth-century American medical community followed British and European trends in establishing hospitals for the mentally ill. The gradual shift from the care of the insane by families and community to confinement in mental hospitals reflected the need for new forms of social control in times of rapid political and social change.

In colonial society, the family was the bedrock for the care of the sick and disabled; town officials expected, and if necessary compelled, relatives to provide for the support of their mentally ill kin. So long as they remained peaceable, the mad were left free to wander at will and to participate in daily life. Only when mad persons had no relatives or were completely impoverished did the community assume responsibility for them. In rural areas and small towns, the insane were boarded out in private households at public expense. In larger cities, they were sent to the poorhouse, or almshouse.

In retrospect, colonists appear surprisingly tolerant of the "distracted" ones in their midst. Colonial records are filled with examples of people who behaved in bizarre and disruptive ways yet were allowed to move about freely, and even to retain important positions of responsibility. During periods of madness, such individuals were watched and cared for, but as soon as they recovered, they rejoined the community. A striking example is the respect and forbearance shown James Otis (1725–1783), a prominent Boston lawyer who maintained his practice and a seat in the colonial assembly despite recurring periods of mad behavior (figs. 1.8, 1.9).

THE FOUNDING OF PENNSYLVANIA HOSPITAL

What quickly eroded familial or community tolerance toward the mad was violence. The founding of Pennsylvania Hospital, the first hospital in the original thirteen colonies, reflected this fear of the violent insane (fig. 1.10). In 1751 a group of prominent Philadelphia civic leaders, among them Benjamin Franklin, asked the colonial assembly to issue a hospital charter. Their petition, which Franklin wrote, began with a reference to the growing number of "lunatics" in the colony who "going at large are a terror to their neighbors, who are daily apprehensive of the violences they may commit" ("Petition for the Establishment of Pennsylvania Hospital," Archives of Pennsylvania Hospital). Although their first concern was the protection of society by confining this threat, the hospital's founders also hoped that medical treatment and decent care would restore reason to the insane.

During its first decades, the staff of Pennsylvania Hospital saw their patients more as animals than rational beings. (The association of madness with bestiality was so widespread that studio manuals for artists advised using an animal as a model for capturing the expression of a madman [fig. 1.11].) Kept separate from other hospital patients, lunatics were confined in barred cells in the basement of the building. Attendants, who were called "keepers," restrained particularly violent individuals using a "straitwaistcoat" or "mad shirt," or heavy arm and leg chains (figs. 1.12–1.14). Paintings such as Washington Allston's *Tragic Figure in Chains* accurately, if somewhat dramatically, represent the way eighteenth-century lunatics were enchained (fig. 1.15). Lunatic patients received medical treatment for their physical ailments, but little was done explicitly to restore their reason.

In 1773 the first American hospital devoted entirely to the confinement and care of mental patients was founded in Williamsburg, Virginia. Royal Governor Francis Fauquier, who, like Franklin, combined scientific and charitable interests, suggested a plan for the asylum in 1766 in a message to the House of Burgesses, an assembly elected by the colonists. He, too, prefaced his proposition with a reference to the threatening quality of the mad: "[They are] a poor unhappy set of people who are deprived of their senses and wander about the country, terrifying the rest of their fellow creatures"(speech to House of Burgesses, Nov. 6, 1766). The *Virginia Gazette,* a local newspaper, also characterized as dangerous the lunatics left free to roam the countryside.

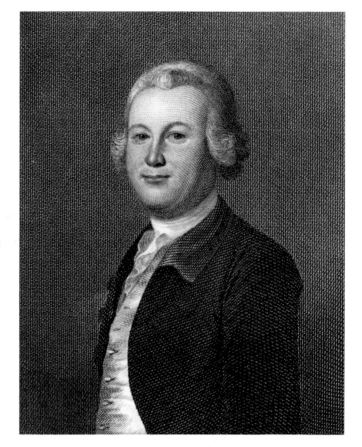

Fig. 1.8. James Otis, 1765, engraving by A. B. Durand from a painting by I. Blackburn, frontispiece to William Tudor, *The Life of James Otis of Massachusetts* (Boston, 1823).

James Otis, a prominent Massachusetts lawyer and politician, played a leading role in mobilizing resistance to British imperial policies in the 1760s. John Adams recalled him as one of the most influential figures of the Patriot Party.

After publishing an outspoken newspaper article about a customs commissioner in 1769, Otis was caned by the official. Contemporaries attributed his subsequent erratic behavior to this severe beating; in the winter of 1770, Otis became raving mad. During a violent outburst, he broke out all the windows in Boston's Old State House and fired guns from the windows of his lodging house.

Friends took Otis to the country to convalesce. Within a year he returned to his law practice and was reelected to the colonial assembly. Over the next few years, Otis alternated between periods of derangement and sanity; each time he recovered, he returned to his professional status. Eventually his condition worsened, and he went to live with a farmer named Osgood who boarded mad people on his large farm. Otis died there in 1783 after being struck by lightning during a summer thunderstorm.

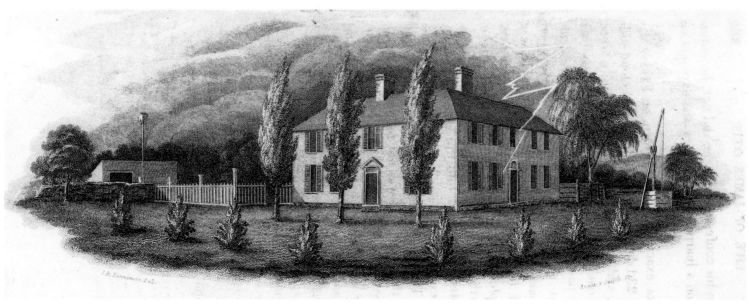

Fig. 1.9. "The Osgood Farm, Andover," in Tudor's *Life of James Otis*.

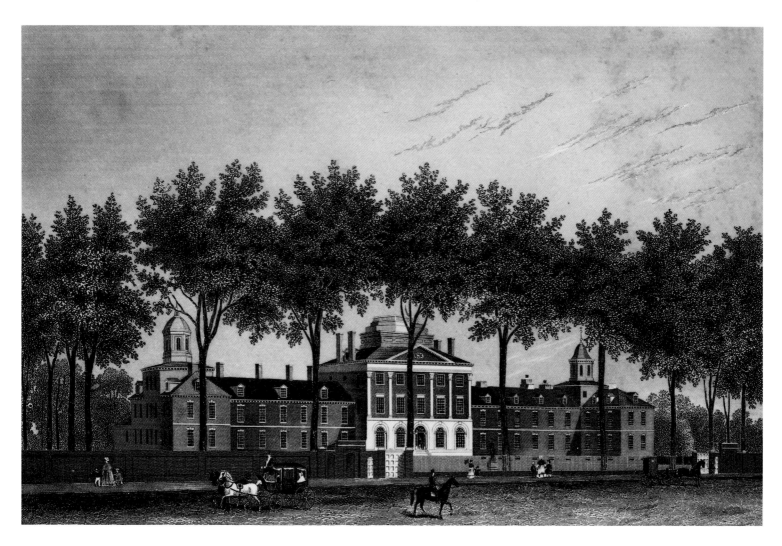

Fig. 1.10. "Pennsylvania Hospital," engraving by W. E. Tucker after a drawing by McArthur, in Thomas Morton, *The History of Pennsylvania Hospital* (Philadelphia, 1895).

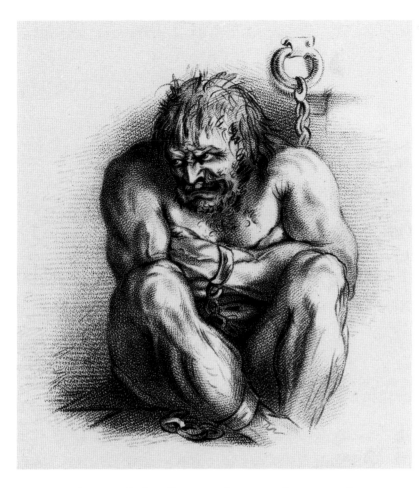

Fig. 1.11. "Madness," in Charles Bell, *Essays on the Anatomy of Expression in Painting* (London, 1806). The Oskar Diethelm Library, History of Psychiatry Section, Department of Psychiatry, Cornell University Medical College and The New York Hospital, New York.

"To learn the character of the human countenance when devoid of expression, and reduced to the state of brutality, we must have recourse to the lower animals. . . . If we should happily transfer their expression to the human countenance, we should, as I conceive it, irresistibly convey the idea of madness, vacancy of mind and animal passion" (pp. 155–56).

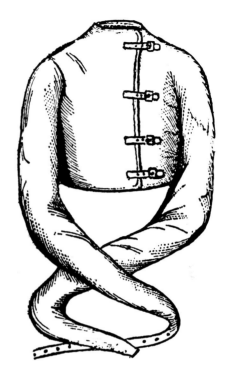

Fig. 1.12. Straitjacket, from a 19th-century catalogue of hospital supplies available from Walters Laboratories, New York. Library of the College of Physicians of Philadelphia.

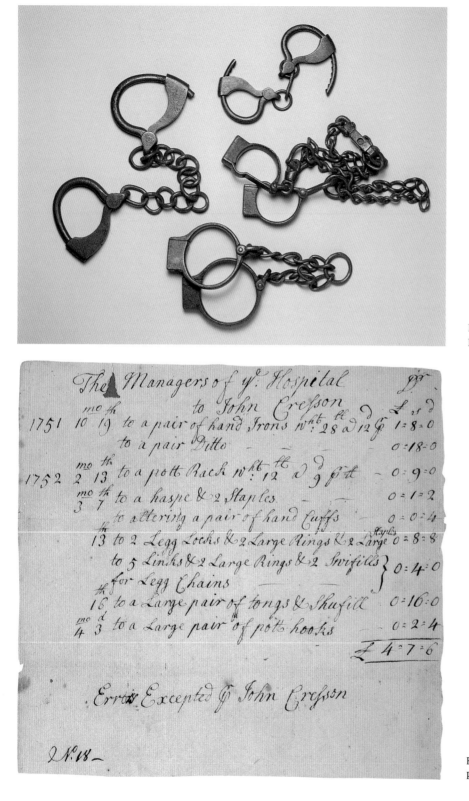

Fig. 1.13. Chains, late 18th century. Archives of Pennsylvania Hospital, Philadelphia.

Fig. 1.14. Bill for chains, 1751. Archives of Pennsylvania Hospital, Philadelphia.

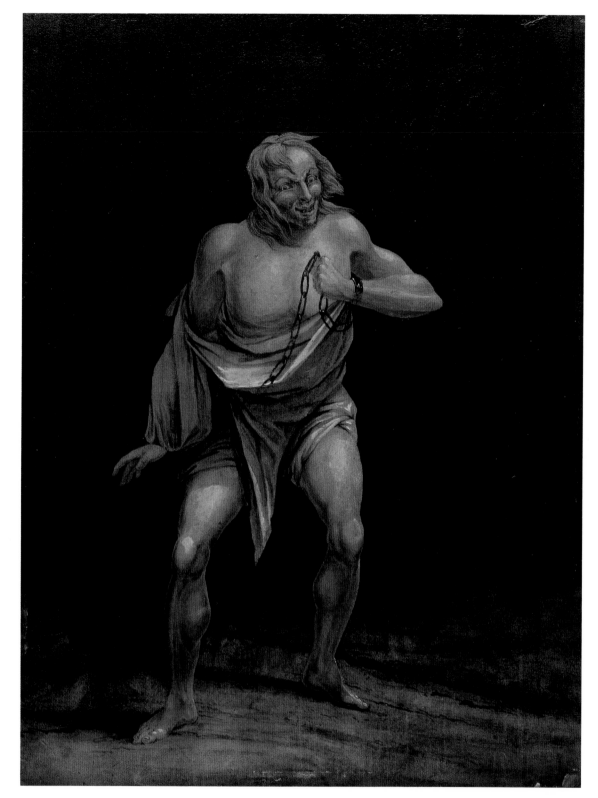

Fig. 1.15. Washington Allston, *Tragic Figure in Chains,* 1800, oil on paper mounted on wood, 12⅜ × 9½ in. Copyright Addison Gallery of American Art, Phillips Academy, Andover, Massachusetts (1941.24). All rights reserved.

American painter Washington Allston (1779–1843) was a key artistic link between European and American romanticism. Allston's sentimental, theatrical paintings on mythical and historical themes epitomized the burgeoning emphasis on feeling rather than reason and thought. Allston was inspired to create *Tragic Figure in Chains* when, in Boston in the 1790s, he saw a painting, entitled *Madness,* of a chained lunatic by British artist Robert Edge Pine (ca. 1760, known today only from an engraving by James McArdell).

Profiles of Two Patients at Pennsylvania Hospital

Known as the "Barn Burner," a farmer named George Kenton was admitted to Pennsylvania Hospital after he set fire to his barn to rid it of rats. An account of his condition was recorded in a casebook kept by Samuel Coates, a lay manager of the hospital from 1785 to 1825. Like many members of the hospital staff, Coates belonged to the Society of Friends, or Quakers, a religious sect that took seriously Jesus' injunction to care for the poor, the sick, and the imprisoned. Coates expressed his compassion by carefully recording the life histories and everyday activities of the lunatic inmates of the hospital.

About the "Barn Burner," Coates wrote:

"Burn down the barn and you'll have no more rats," so George said and was preparing to burn his dwelling down, but happily for his family, he was caught in attempting it and sent to the hospital; here he remained till he was greatly relieved. [After suffering a relapse, George voluntarily returned to the hospital, where he agreed to stay until he could catch a frigate to Mexico.] I queried with him, what was he going [to Mexico] for. He said to cut off the Spanish head and bring the ship full of dollars—a great voyage! I said; but, George, thy sword will not be wanted before the ship sails, let me have it till she goes. Well, you may take it Mr. Coates, till then it will do to cut off the

Fig. 1.16. "The Barn Burner," watercolor and ink on paper, in Samuel Coates, "Cases of Several Lunatics in the Pennsylvania Hospital," ca. 1785–1820. Archives of Pennsylvania Hospital, Philadelphia.

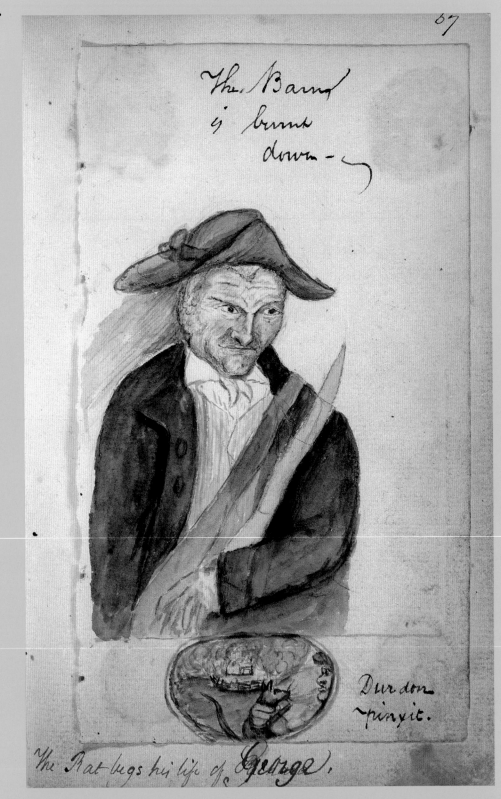

heads of turnip tops or weeds in the garden. Thus I possessed myself of George's sword (the very thing I wanted) which was a scythe, hung over his shoulders as appears in the picture with its wooden handle. George thus went quietly to his quarters for the remainder of his days. ("Cases of Several Lunatics in the Pennsylvania Hospital," ca. 1785–1820. Archives of Pennsylvania Hospital, Philadelphia, pp. 66–69)

Many of the stories Coates told reflect bonds of sympathy between the sane and insane; nearly all his characters were driven mad by human disappointments such as a love affair gone wrong or an "accumulation of trouble." Their lives continually reminded Coates of the "uncertainty and volatility of all human exaltation." In Coates's telling, even in the extremes of madness, the lunatics displayed admirable traits, such as scorn for pretension, devotion to art and poetry, and loyalty to friends and pets.

Richard Nisbett was treated at Pennsylvania Hospital by Benjamin Rush and physician John Parrish. Born in London and educated at Oxford, Nisbett practiced law in London for many years. An advocate for the humane treatment of African and West Indian slaves, he published a long treatise on the topic in 1779. Although respected in legal circles, Nisbett grew weary of law and emigrated from London to Philadelphia in the late eighteenth century, in search of a better life for his wife, Frances, and their six children. After a business venture failed, he made a final desperate attempt to support his family by working a tract of land in the woods near Philadelphia. Unaccustomed to manual labor and the hardships of farm life, he suffered a mental breakdown in the 1790s, which is described in an anguished letter from Frances Nisbett to her husband's physician.

> In the bitterness of affliction I am permitted to take up my pen to my much valued friend John Parrish. Oh my friend! . . . my dear, dear Richard is insane. Alas! It is but too true, he is, my dear friend, gone, I fear beyond all hope of being restored to reason. . . . This afternoon he seemed the most sad desponding being in the world, which fit of despair has continued till the present moment. Think what a life I lead when I am constantly on the watch that he should not injure himself. . . . Nothing but total neglect has taken place among my poor helpless children. My neighbors are kind and I fear they neglect their own work for us. But alas! Nothing seems to bear one pleasing aspect. (undated letter, Historical Society of Pennsylvania, Philadelphia)

Samuel Coates described Nisbett's admission to Pennsylvania Hospital:

> [Nisbett's] accumulation of trouble and distress he could bear no longer; his mental powers gave way; he grew low-spirited and finally became crazy and in this state, he was admitted into Pennsylvania Hospital [where] . . . I expect he will be likely to end his days. ("Cases," pp. 73–74)

On entering the hospital, Nisbett wrote a poem to his wife which contains the following lines:

> Tho' great my errors, great has been my
> grief,
> And Richard looks to Frances for relief.
> Think then in pity, love and tender care
> Upon the suffering, I am left to bear,
> And seek to set a wretched husband free
> Who loses but too much, in losing thee.
> (Historical Society of Pennsylvania, Philadelphia)

Some of Nisbett's friends complained that such lucid writing proved his sanity, warranting release, but Coates astutely observed "that he did and could write well and compose well at all times is very evident, but it is no less true, that he has written some thousand folio pages of travels and voyages he made with Cook and others, around the world, not one of which he ever performed and all of them show the disturbed state of his mind" ("Cases," p. 76). Nisbett always appended the sobriquet "Mariner" to his signature, and he recorded his fanciful travels and universe in drawings, such as *Map of the World* (fig. 1.17).

The alternating mental states of this very intelligent and disturbed man are manifested in the style and appearance of his poetry, some of which, like "Tranquility: An Ode" (fig. 1.18), is written with impeccable penmanship. Other examples, such as "Origin of Quick-Silver and Quick-Sand" (fig. 1.19), are written in a crude hand.

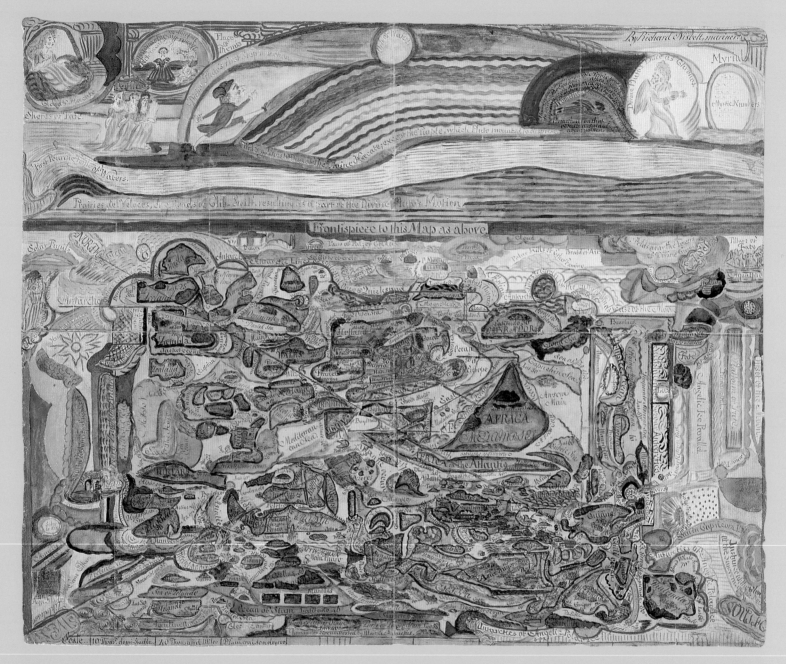

Fig. 1.17. Richard Nisbett, *Map of the World*, ca. 1815, watercolor, 19¼ × 24 in. The Historical Society of Pennsylvania, Philadelphia.

The upper portion of this map presents a realm of gods and wise men, ruled by the "Divine Pluto," and includes figures such as the Fates, Prometheus, and Confucius. Below, a map of the earth combines known and imaginary lands, including China, the "Antarctic of Angelic Polar Ice," Rhode Island, and "Zodiac Island." In re-

sponse to a question about his birthplace, Nisbett stated, "There is no such place in my maps, which are admired everywhere to be the most correct of any in the known world. It is true there once was a little island, falsely called Great Britain, but the Divine Alma sunk it 60 fathoms deep in the sea" ("Cases," p. 70).

Fig. 1.18. Richard Nisbett, "Tranquility: An Ode," ca. 1815, black ink on paper, 9½ × 5⅝ in. The Library Company of Philadelphia.

Fig. 1.19. Richard Nisbett, "Origin of Quick-Silver and Quick-Sand," ca. 1815, red and blue ink on paper, 8½ × 5¼ in. The Library Company of Philadelphia.

A Painting for Pennsylvania Hospital

Native Philadelphian Benjamin West was the leading painter of colonial America before his immigration to London during the American Revolution. In 1800 the managers of Pennsylvania Hospital commissioned West to create a monumental painting for their building. The artist proposed the subject of Christ healing the sick, and acknowledging that the painting was destined for a hospital that treated lunatics, he included an insane boy among the afflicted.

Despite the increasingly scientific approach to the treatment of madness within the medical community, the religiously tinged sentiments of the early nineteenth century are tellingly revealed in a letter West wrote to the hospital managers: "I have introduced a demoniac with his attendant relations, by which circumstance is introduced most of the maladies which were healed by our Saviour" (March 10, 1816, Archives of Pennsylvania Hospital, Philadelphia). Christ cures the insane boy by casting out demons—the ostensible cause of his derangement. The hospital staff evidently saw no contradiction in the implicit comparison of the healing powers of the Son of God with those of science and medicine.

In a pamphlet printed for the hospital, the managers offered their own interpretation of the painting and enunciated reason as the factor differentiating humankind from other creatures:

> This boy appears intended to represent the worst case of the worst malady that afflicts the human being—the most affecting and humiliating to think of. Man is distinguished from all other animals by his reason; and when that is perfectly alienated . . . he becomes, indeed, in some of his paroxysms, the perfect image of a demon. ("The Picture of Christ Healing the Sick in the Temple,"

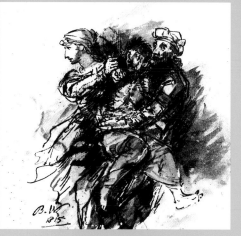

Fig. 1.20. Benjamin West, drawing for the demoniac boy in *Christ Healing the Sick,* 1815, ink and wash on paper, 6¼ × 5⅞ in. The Historical Society of Pennsylvania, Philadelphia.

Fig. 1.21. Benjamin West, drawing for the demoniac boy in *Christ Healing the Sick,* 1815, ink on paper, 5½ × 3¾ in. Delaware Art Museum, Wilmington, Samuel and Mary R. Bancroft Memorial.

Fig. 1.22. Benjamin West, drawing for the demoniac boy in *Christ Healing the Sick,* 1815, ink on paper, 10 × 6¾ in. Toledo Museum of Art, gift of Edward Drummond Libbey.

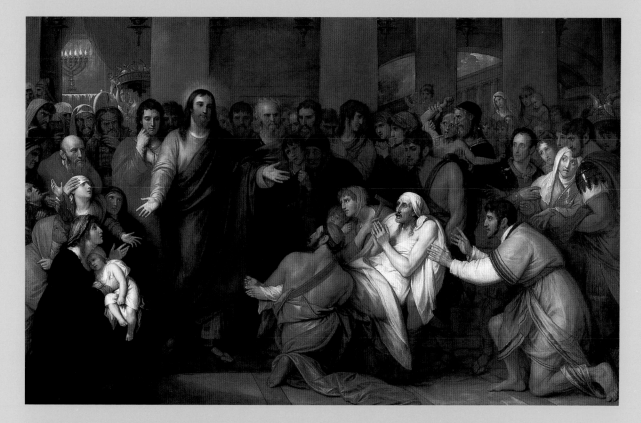

Fig. 1.23. Benjamin West, *Christ Healing the Sick,*
1815, oil on canvas, 10 × 15 ft. Pennsylvania Hospital,
Philadelphia.

Philadelphia, 1818, text by John Robinson.
Archives of Pennsylvania Hospital, Phila-
delphia)

A patient at the hospital, Richard Nisbett,
recorded his own interpretation of the picture,
which he saw in terms of the fanciful universe
he illustrated in a map (see fig. 1.17):

> The idea it is grounded upon is Confucius
> . . . receiving an unfortunate and almost
> famished Pennsylvanian, who, by wander-
> ing from his boarder, had got lost in the
> woods of China. . . . The fair Fatima, or
> female figure, accosting at the edge of the
> shoulder of the Confucius, had a great
> regard for Nisbett, and they lived and trav-
> elled together so long as he remained in
> China. (In Samuel Coates, "Cases of Several

Lunatics in the Pennsylvania Hospital,"
ca. 1785–1820, pp. 115–20. Archives of
Pennsylvania Hospital, Philadelphia)

Nisbett apparently identified Christ with
Confucius, who appears as a deity in his
imaginary universe, and the reclining man in
the right foreground, to whom Christ opens
his arms, with the unfortunate Pennsylvanian
returned from China. Nisbett also seems to
have taken the clean-shaven, long-haired man
behind Christ's shoulder for a female, "the fair
Fatima" who is "accosting," with overtones
of sexual solicitation. Nisbett perhaps knew
that Fatima was the daughter of the prophet
Mohammed, and the sound of her name may
have echoed that of his beloved wife, Frances.

When we learn that his fanciful voyages with
this woman took place in China, one won-
ders if Nisbett also identified himself with the
Pennsylvanian being received so warmly by
the deity, especially when we are reminded
that Nisbett also "got lost in the woods"—
his mental breakdown occurred on a farm
located in the woods near Philadelphia. If so,
Nisbett's confused mind has taken a circuitous
route to reach the same interpretation of the
painting that a sane patient might make—
identification with a sick person being miracu-
lously healed.

Christ Healing the Sick was unveiled at Penn-
sylvania Hospital in 1815 and remains on pub-
lic display to this day.

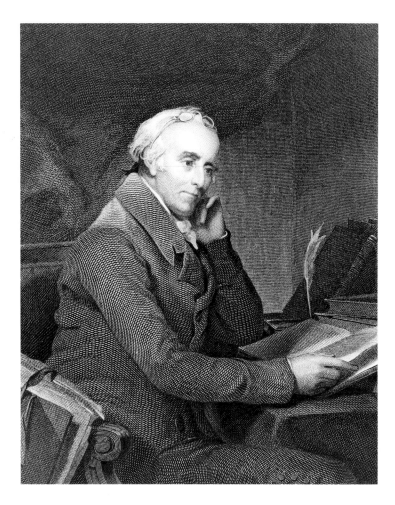

Fig. 1.24. Benjamin Rush, 19th century, engraving. The Oskar Diethelm Library, History of Psychiatry Section, Department of Psychiatry, Cornell University Medical College and The New York Hospital, New York.

After the American Revolution, the political and cultural leaders of the new nation agreed that a republican form of government depended upon the rationality and civic responsibility of each and every citizen. To that end, they set about refashioning family life and institutions such as schools, prisons, and hospitals to uphold republican virtues. Not surprisingly, madness —the ultimate loss of reason and self-control—was increasingly seen as a threat to social stability, and communities confined more and more lunatics to jails and almshouses. Several cities opened new hospitals with wards for the mentally ill; New York Hospital began to accept such patients in 1791, Maryland Hospital in 1798. In Boston, the McLean Asylum for the Insane, affiliated with Massachusetts General Hospital, opened in 1818.

Increased control of the insane through confinement was paralleled by growing confidence in science's ability to understand and cure insanity through more aggressive medical treatment. The career of Benjamin Rush, who was an attending physician at Pennsylvania Hospital from 1783 to 1813, exemplified this new impulse toward controlling and conquering disease (fig. 1.24). In this optimistic, postrevolutionary climate, Rush developed his "heroic treatment"; in addition, he designed a tranquilizing chair, to slow down fluid movement in hyperactive patients (fig. 1.25), and a gyrator, a horizontal board on which torpid patients were strapped and spun around to stimulate blood circulation. Rush also advocated recreation and amusements for patients on the theory that mental stimulation might help them recover their reason.

Under Rush's direction, the staff of Pennsylvania Hospital alternately viewed their patients as infantilized by their impaired minds or reduced to an animal-like state. Rush advised caretakers to try various psychological tactics to dissuade patients from their delusions and to compel them to behave. Institutional discipline was modeled on the parent/child relationship; the hospital was referred to as the "house" and all its patients as the hospital "family." Staff members would variously cajole, frighten, or punish the lunatics as if they were recalcitrant children. Rush also compared the maniacs to "the tiger, the mad bull, and the enraged dog." He wrote, "A man deprived of his reason partakes so much of the nature of these animals, that he is for the most part easily terrified, or composed, by the eye of the man who possesses his reason" (*Medical Inquiries*, p. 175). Some of Rush's tactics, such as

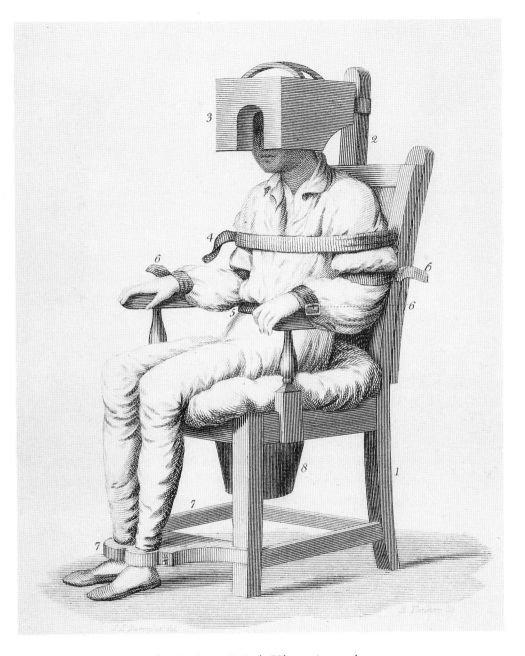

Fig. 1.25. "The Tranquilizing Chair," in Benjamin Rush, "Observations on the Tranquilizer," *The Philadelphia Medical Museum* (1811). Archives of Pennsylvania Hospital, Philadelphia.

Rush designed this chair to restrain and calm the patient without the jailhouse overtones of iron shackles. Fixed to the floor, the chair immobilized the patient with leather straps for arms and legs, and a headpiece stuffed with linen. A bucket for waste was placed under the chair.

Fig. 1.26. A couple viewing the lunatics, in Ebenezer Haskell, *The Trial of Ebenezer Haskell* (Philadelphia, 1869). Archives of Pennsylvania Hospital, Philadelphia.

William Malin, a longtime clerk and librarian at Pennsylvania Hospital, took an intense interest in its mad patients. In an 1828 report to the hospital board, he noted: "The morbid curiosity displayed by a majority of the visitors to the hospital is astonishing, and their pertinacity in attempting, and fertility in pretexts and expedients, to gain admission to the 'mad people' is not less so. Even females who have tears to bestow on tales of imaginary distress are importunate to see a raving madman, and do not hesitate to wound the diseased mind by the gaze of idle curiosity, by impertinent questions, and thoughtless remarks."

To give mental patients more privacy, the Pennsylvania Hospital managers founded a separate asylum in 1840 in a semirural area of west Philadelphia. A patient released from the new asylum drew this picture to show the ward where he had been confined. Although the drawing was made in the 1860s, decades after the practice of charging admission to view patients had been discontinued, it suggests a continued public interest in viewing lunatics, as well as the patient's perception of being seen as a spectacle. (For further discussion of Ebenezer Haskell, see p. 62.)

the use of a fixed stare and the shower bath, which amounted to dumping a bucket of water on the head to startle a patient, cast the caretaker in the role of animal tamer. The staff of Pennsylvania Hospital intermixed familial terms with criminal and bestial metaphors, referring to the patients as "inmates" and their rooms as "cells."

The ascription of a bestial nature to the insane is nowhere more evident than in the hospital's custom of allowing outsiders to come and gape at patients as if they were animals in a zoo, a practice found at other hospitals of the day (fig. 1.26). Throughout its early years, managers and physicians of Pennsylvania Hospital complained that the public was determined to breach the institution's privacy to get a look at its mad inmates. Alleging that no amount of security was sufficient to keep interlopers out, the hospital board, apparently unaware of the sanction implicit in its gesture, decided in 1762 to charge admission to discourage such visits. The admission fee was charged sporadically, but the custom of public visits continued at Pennsylvania Hospital as late as the 1830s.

The great and lasting popularity of visits to Pennsylvania Hospital to see the lunatics suggests that, even in the formative years of a new republic founded on the authority of reason, the American public was very curious about the irrational world of madness. As the promises of the Enlightenment were repeatedly broken throughout the nineteenth century, however, some Americans increasingly were tempted not just to look into this forbidden realm from a safe vantage point, but to unlock the gates.

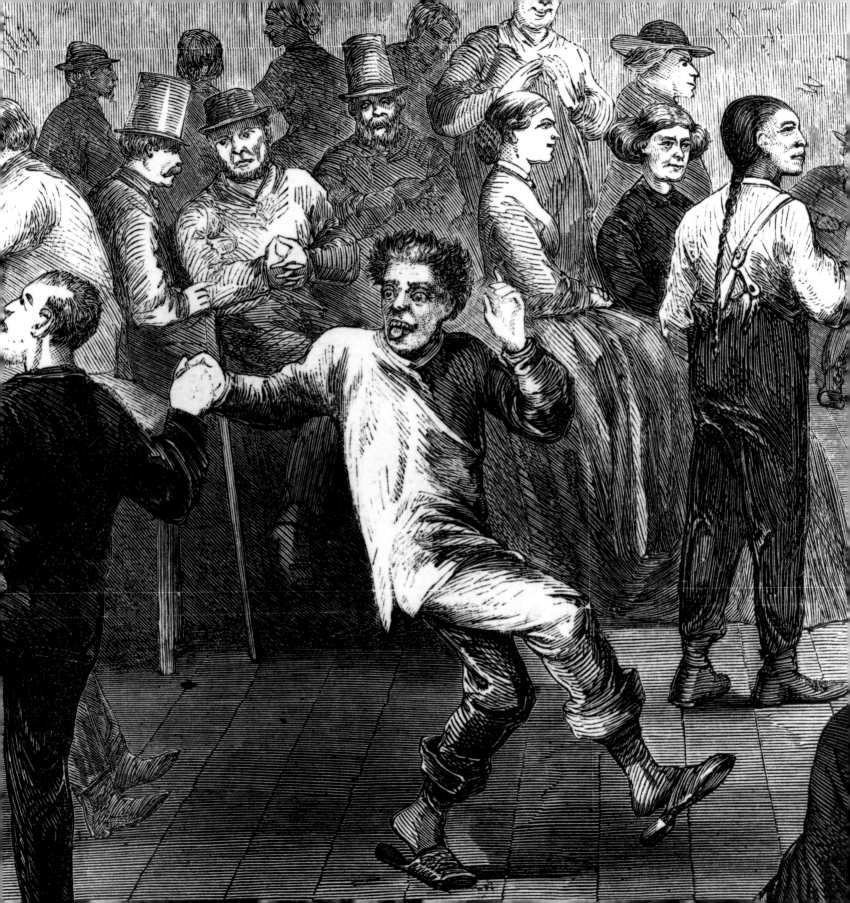

The Asylum in Antebellum America
The 1820s to the 1860s

ASYLUM REFORM

During the early nineteenth century, scientific understanding of the physical causes of insanity made little progress. The treatment of lunatics, however, improved dramatically as various reform movements swept Europe, Britain, and America in response to the social upheavals of the Industrial Revolution. Drawing on both secular and religious ideologies, a myriad of newly founded reform societies and social institutions—from temperance clubs to penitentiaries—attempted to strengthen individual discipline and to preserve social control. Asylums established throughout the West to provide humane treatment for the insane were based less on any medical advances than on simple Christian charity and common sense.

The most influential physician advocate of change was the Frenchman Philippe Pinel (1745–1826). In the wake of the French Revolution, Pinel sought to improve the institutional care of the insane in Parisian hospitals. Pinel emphasized the importance of the emotional causes of mental disease and called for more careful diagnosis and observation. Through his writings, particularly the *Traité médico-philosophique sur la manie* (1801), Pinel's arguments for reform became widely disseminated in England and the United States.

At the same time, several well-publicized exposés of English hospitals and almshouses generated public outcry; the chief target was the oldest insane asylum in London, Bethlem Royal Hospital, also known as Bethlehem Hospital and colloquially as "Bedlam." The infamous case of an American kept in chains there for more than ten years prompted demands for asylum reform (fig. 2.1).

Moral Treatment

The most fundamental and far-reaching reform of patient care developed in response to another case of abuse in England. A Quaker woman named Hannah Mills was admitted in 1790 to the Asylum for the Insane in York, England, where her fellow Quakers were not allowed to visit her. When she died six weeks later, they were profoundly troubled by suspicions of mistreatment. The incident prompted some Yorkshire Friends, chief among them William Tuke, to propose establishment of an asylum to care for Quakers. The York Retreat opened in 1796 under Tuke's guidance.

Although physicians looked after Retreat patients, Tuke believed that a purely medical approach to mental illness was doomed to failure. Recognizing insanity as a disruption of the mind and spirit, they supported treatment by psychological methods, or what the Quakers then called moral treatment. In the eighteenth and nineteenth centuries, the term "moral" referred to emotional and spiritual experiences, as opposed to sensory experience of the "material" world. The staff at the Retreat assumed that all mad persons retained their spiritual worth and some remnant of their reason; their "inner light" could be dimmed but never extinguished by disease. Asylum treatment needed first and foremost to appeal to and sustain the patient's essential humanity.

The Retreat staff dispensed with the frequent bleedings and purgings common to medical therapies in other asylums. Instead they instituted a regime of exercise, work, and amusements that treated patients like sane adults who were expected to behave

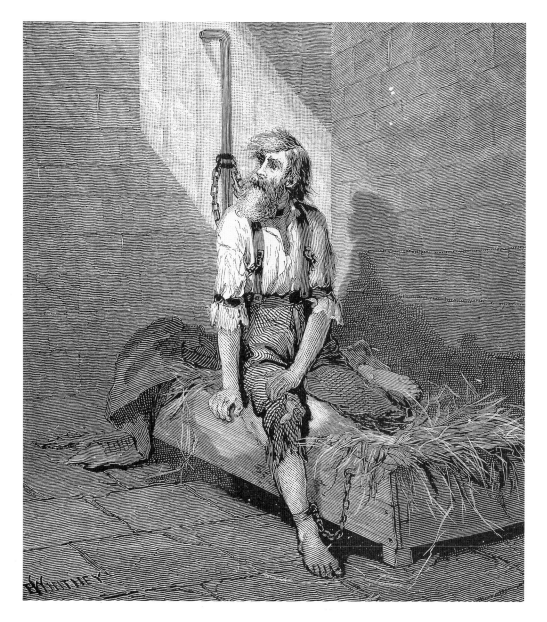

Fig. 2.1. "Norris in Chains," in William P. Letchworth, *The Insane in Foreign Countries* (New York, 1889). The Oskar Diethelm Library, History of Psychiatry Section, Department of Psychiatry, Cornell University Medical College and The New York Hospital, New York.

An American sailor, James Norris, was committed to London's Bethlem Hospital in 1800. He was restrained in an iron harness riveted to an upright bar by twelve-inch-long chains, which allowed him almost no movement. After spending some ten years in this device, Norris was discovered in 1814 by reformers who made his case a cause célèbre in both England and America. Norris was released the following year but died soon after from a lung disease contracted during his confinement.

according to basic societal norms. Patients were to remain neatly clothed, perform chores in a responsible manner, eat politely at a table, and sit quietly at religious services. The staff believed that this regimen would help disordered minds return to normal. But even when no cure was possible, the Quakers found a measure of success in using moral treatment to get asylum patients to live at the highest level of humanity possible for them.

Moral Treatment Comes to America

Through close connections between the English and American Society of Friends, accounts of the remarkable improvement in patients treated at the York Retreat soon reached the United States. *The Description of the Retreat near York,* written by Samuel Tuke, the founder's grandson, was published in both England and America in 1813. Several years later, in 1817, an American

counterpart to the York Retreat was established in Frankford, Pennsylvania, a few miles northeast of Philadelphia. The Asylum for the Relief of Friends Deprived of Their Reason, better known simply as the Friends Asylum, helped to introduce moral treatment to America, and over the next several decades, many more asylums adopted its principles.

In comparison to the almshouse, jail, or older-style asylums, the new hospitals provided a vastly superior form of confinement. Families and communities could hand over the care of troublesome individuals to such institutions with less guilt. At the same time, the new asylums held out the promise of a possible cure. Early advocates of moral treatment fervently believed that if the mentally ill were exposed to the asylum regimen early in their illness, they could be completely restored to health. The combination of relief from the responsibility of care for an insane relative and the potential for his or her cure was a powerful incentive for family members to consider asylum treatment.

Following the Quaker example, these early American mental hospitals adopted a daily course of exercise, work, and amusement which became the foundation of moral treatment in the United States. At the Pennsylvania Hospital for the Insane, for example, affluent patients typically rose at 6 A.M. and had breakfast; after physicians made ward rounds, patients went outside for a walk or amused themselves with books and games. A bowling alley, a calistheneum, a miniature railroad, and a little museum of "natural curiosities" were available for patient use. Lunch was followed by a similar period of light activity, including carriage rides around Philadelphia's city park, and attendants entertained patients with exercise classes and sporting events (figs. 2.2–2.4). At night, patients attended lectures, lantern slide entertainments, concerts, and dances, which became known popularly as "lunatic balls" (see pp. 42–45). Private hospitals tended to have far more elaborate programs and facilities for amusing patients than did their public counterparts. Few state hospitals could match the array of entertainments available at private hospitals, yet all but the poorest institutions tried to provide some program of patient activities.

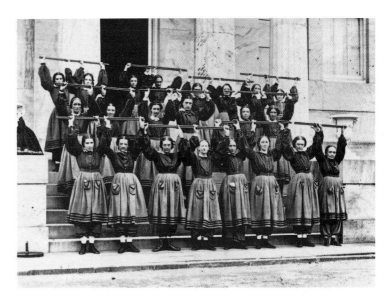

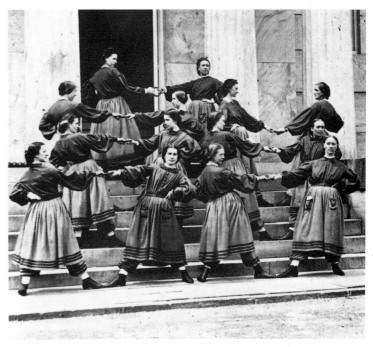

Fig. 2.2. Nurses exercising on the steps of Pennsylvania Hospital for the Insane, Philadelphia, mid-19th century. Archives of Pennsylvania Hospital, courtesy Atwater Kent Museum, Philadelphia.

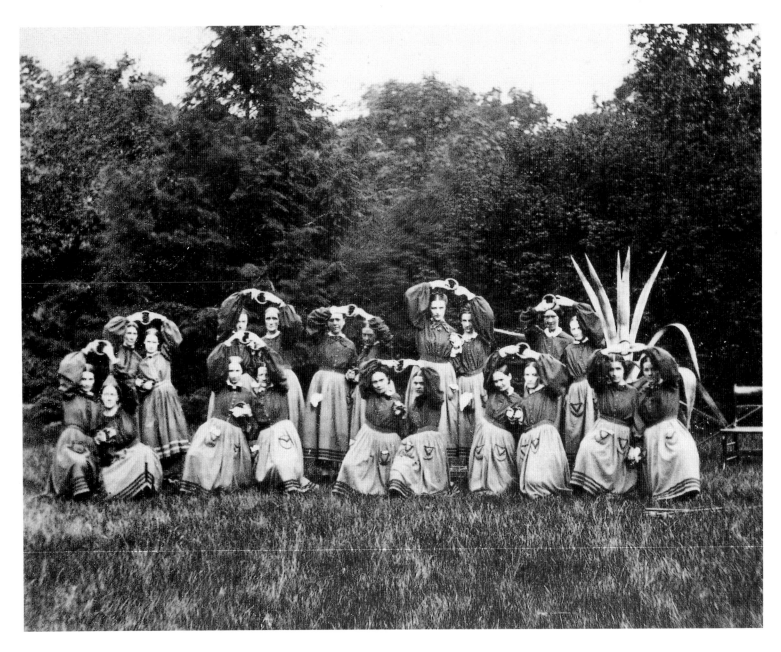

Fig. 2.3. Nurses' exercise group at Pennsylvania Hospital for the Insane, Philadelphia, mid-19th century. Archives of Pennsylvania Hospital, courtesy Atwater Kent Museum, Philadelphia.

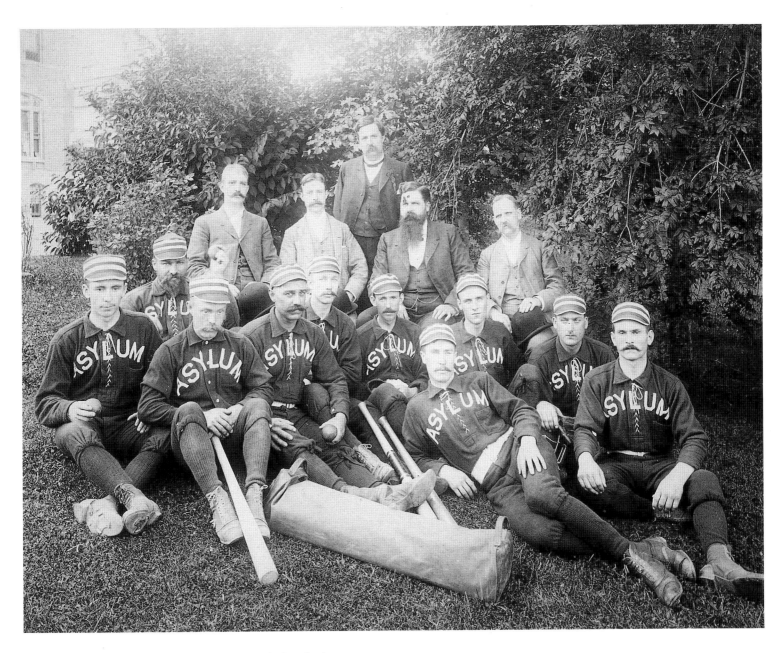

Fig. 2.4. Asylum baseball team at State Homeopathic Asylum for the Insane, Middletown, New York, late 19th century. Courtesy Elizabeth Eckert, Middletown.

The Lunatic Ball

The image of the "lunatic ball" became associated with the nineteenth-century reformed asylum, much as the "madman in chains" had been linked with the early colonial hospital. Although male and female patients lived in separate wards, they came together to dance, an entertainment allowed within the regime of moral treatment (figs. 2.5, 2.6).

Perhaps the best-known description of a lunatic ball was written by Charles Dickens, who had a great interest in the vagaries of the human mind. (On a trip to the United States in 1842, he went to the Friends Asylum and the Pennsylvania Hospital for the Insane in Philadelphia, as well as asylums in Hartford, Connecticut, and on Long Island, New York.) On a visit to St. Luke's Hospital, London, in December 1851, he witnessed lunatics dancing around a Christmas tree. Dickens noted the improvements over the old days of chains and straitjackets:

> As I was looking at the marks in the walls of the galleries, of the posts to which the patients were formerly chained, sounds of music were heard from a distance. The ball had begun, and we hurried off in the direction of the music. . . . There were the patients usually found in such asylums, among the dancers. . . . But the only chain that made any clatter was Ladies' Chain [part of a square dance], and there was no straighter waistcoat in company than the polka-garment of the old-young woman with the weird gentility, which was of a faded black satin, and languished through the dance with a love-lorn affability and condescension to the force of circumstances, in itself a faint reflection of Bedlam. ("A Curious Dance Round a Curious Tree," London, 1860)

The lunatic ball offered rich metaphorical associations to the American public. Within Western tradition, fools and clowns, who are frequently portrayed as harmlessly deranged, are often dancers. Dancing is associated with certain mental illnesses, with the erratic movements of one possessed by a demon, and with

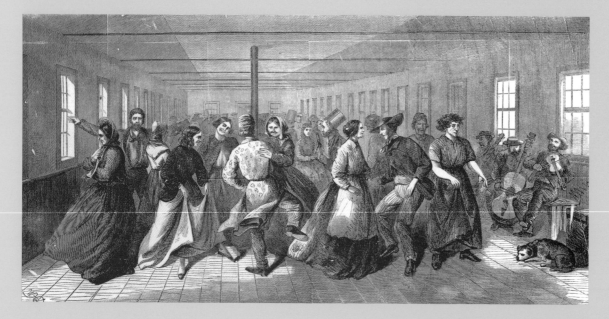

Fig. 2.5. "Dancing by Lunatics," *Harper's Weekly,* Dec. 2, 1865. The Oskar Diethelm Library, History of Psychiatry Section, Department of Psychiatry, Cornell University Medical College and The New York Hospital, New York.

The New York press reported that a lunatic ball took place at the New York City Lunatic Asylum on Blackwell's Island on November 6, 1865. "The patients of the asylum were the dancers, 'tripping the light fantastic toe' after a fashion even more fantastic than Milton dreamed of in 'L'Allegro.'. . . A prominent fiddler, himself a patient, is lost in ecstasy in the sounds which he produces" (p. 765).

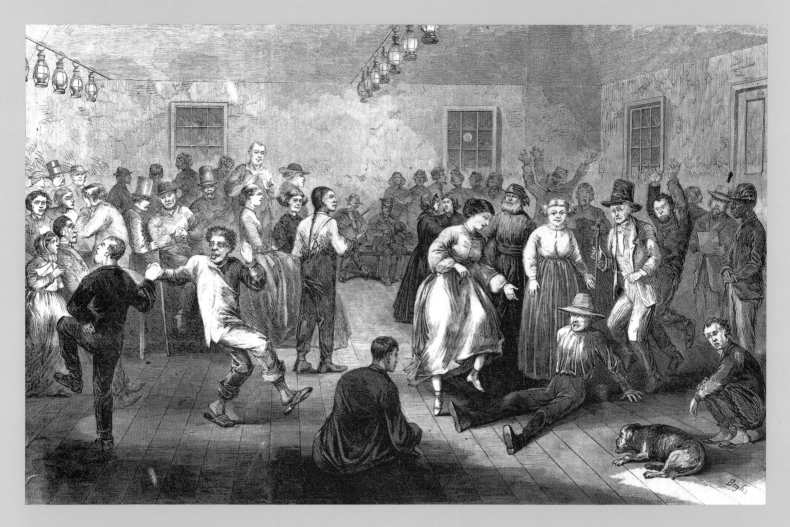

Fig. 2.6. "Ball of Lunatics at the Asylum, Black-well's Island," *Frank Leslie's Weekly*, Dec. 9, 1865. The New York Academy of Medicine Library.

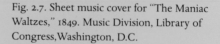

Fig. 2.7. Sheet music cover for "The Maniac Waltzes," 1849. Music Division, Library of Congress, Washington, D.C.

certain neurological conditions (such as chorea, or St. Vitus's dance) that produce spasmodic movement of the limbs. Dancing also occurs as therapy for mental duress. As American society moved away from an Enlightenment faith in reason, the public's imagination may have been captivated by the romantic notion of a ball—a formal event staged with strict social decorum—in which the dancers have abandoned their reason (fig. 2.7). Whereas most images associated with moral treatment (stately hospital facades, well-behaved patients) did not fire the public imagination, the dancing madman became a powerful metaphor for the nineteenth-century psyche.

The lunatic ball, where patients and staff sometimes danced together, offered an occasion to speculate on another common theme —the difficulty of drawing a line between the sane and insane. Edgar Allan Poe, who, like Dickens, followed the currents of asylum medicine, set his story "The System of Doctor Tarr and Professor Fethers" in an asylum in which the patients and staff reversed roles "after the superintendent . . . grew crazy himself, and so became a patient" (fig. 2.8). The employees of the New York State Lunatic Asylum in Utica regularly sponsored their own balls, to which some patients were invited, and a musical performance by attendants is

recorded in the 1844 annual report of the Eastern Lunatic Asylum of Virginia at Williamsburg: "We owe many thanks to the gentlemen composing the band of the 'Williamsburg Guards,' for the delightful musical entertainments which their kindness has given to the inmates of the asylum." Nineteenth-century observers noted the equalizing effect of the asylum dance floor, as in the allegory of the dance of death, in which king and pauper become equal partners.

Fig. 2.8. Illustration in Edgar Allan Poe, "The System of Doctor Tarr and Professor Fethers" (1845), *Nouvelles Histoires Extraordinaires* (Paris, 1884).

Debate over Restraints

In the 1830s some English asylum doctors began to renounce the use of physical restraints as inimical to moral treatment. The best-known advocate of nonrestraint was John Conolly, who in 1839 instituted a nonrestraint system at the Hanwell Asylum, outside London, which substituted calming measures such as isolation or sedation in place of straitjackets. Although some English physicians continued to believe in the value of physical restraints, Conolly's philosophy became the guiding principle of English asylum medicine in the nineteenth century.

At odds with mainstream English asylum practice, American doctors continued to use restraint in the context of moral treatment. If patients persisted in self-injury, violence toward others, or in what doctors referred to as "filthy habits," such as masturbation or feces-smearing, patients were likely to be physically restrained with straitjackets or other devices (figs. 2.9–2.12). In justifying the use of straitjackets, American doctors claimed that their patients were more difficult to control than their English counterparts; as the citizens of a republic, Americans simply did not obey orders as meekly as did the British. American doctors considered a straitjacket or muffs preferable to manual restraint, which could injure the patient or attendant; confinement in seclusion, where unsociable habits could be reinforced; or sedation with potentially dangerous drugs such as chloral hydrate, a derivative of chloroform.

This debate over restraints led to sharply critical exchanges between American and English specialists, whose thinking was otherwise very close in the nineteenth century. Some British critics speculated that the long practice of slavery had made Americans insensitive to the psychological damage done by physical bondage. John Charles Bucknill, a leading English authority on insanity, characterized the American argument as a "spread-eagle apology for the bonds of freemen" (*The Lancet*, March 25, 1876, p. 457). For their part, the Americans felt the British took too many risks with patient safety.

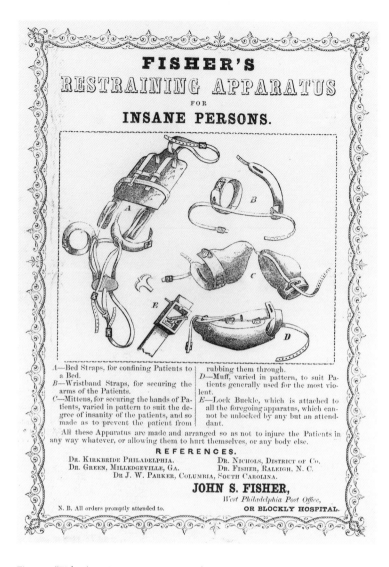

Fig. 2.9. "Fisher's Restraining Apparatus for Insane Persons," 1840–60, broadside.

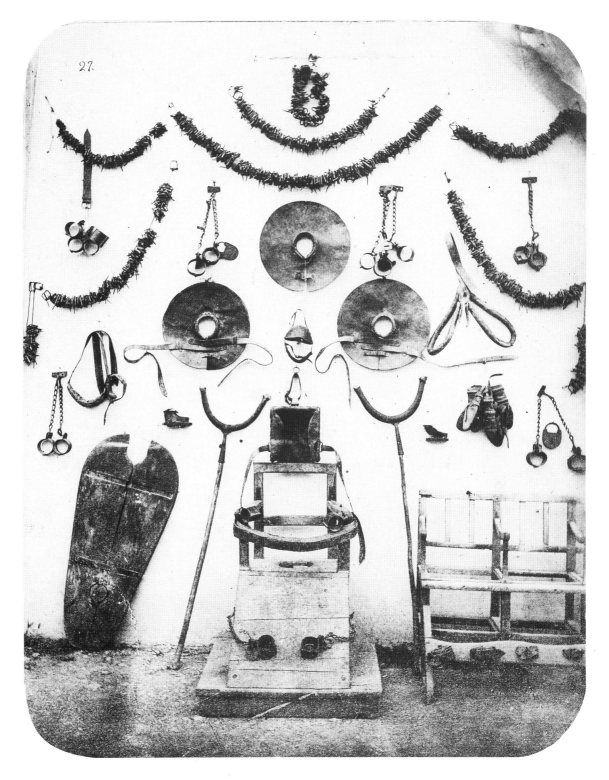

Fig. 2.10. Restraints, 19th century.
Archives of the American Psychi-
atric Association, Adolf Meyer
Collection, Washington, D.C.

Fig. 2.11. Utica crib, ca. 1880. Archives of the Western Lunatic Asylum of Virginia, Staunton, courtesy Western State Hospital.

Patients who refused to stay in bed might be placed in a crib-bed. The first so-called protection bed was reportedly devised by a French physician named Aubanel in 1845. In the United States, the bed was known as the Utica crib because the New York State Lunatic Asylum at Utica used a version built with rungs, making it look like a child's crib. In the early 1880s, when the Utica asylum employed more than fifty such beds, superintendent John Gray was criticized by other asylum doctors for excessive restraint.

THE CRIB

Fig. 2.12. Cartoon of a patient in a Utica crib, detail of "Our Insane Asylums—Glimpses of Life among Patients of a New York Institution," source unknown, 1882, engraving on newsprint. Healy Collection, The New York Academy of Medicine Library.

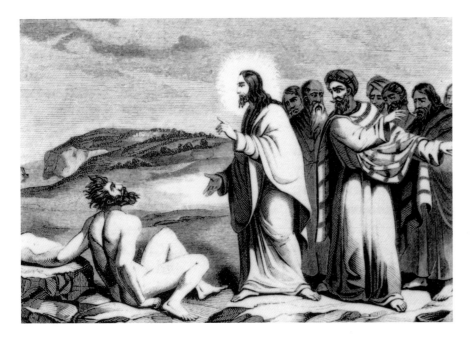

Fig. 2.13. "Christ Casting Out the Unclean Spirit," Mark 5:2–17, illustrated by John G. Chapman, *The Holy Bible* (New York, 1843). American Bible Society, New York.

Engraver John G. Chapman (1808–1889) designed 1,400 plates for Harper's great American family Bible of 1843. In this plate, he illustrated the New Testament story of Christ exorcising demons from a man who "always, night and day . . . was in the mountains, and in the tombs, crying, and cutting himself with stones." Christ commanded the devils to depart the afflicted man and allowed them to possess a nearby herd of swine. The possessed pigs "ran violently down a steep place into the sea, they were about two thousand: and they were choked in the sea."

The Role of Religion

Although asylum reform was strongly motivated by religious sentiments, most doctors were eager to establish a strictly secular, medical basis for moral treatment. These physicians, who embraced the Enlightenment worldview, wanted their new specialty of asylum medicine to have the same scientific status as other areas of medical practice, such as surgery.

Many in the general public, however, continued to believe that madness was symptomatic of possession by the devil. Most Christians, especially evangelical Protestants, took biblical accounts of Christ casting out demons as literal statements of fact (fig. 2.13). Also popular were fictional accounts of demoniac possession, such as Washington Irving's 1824 tale of the miser who sold his soul to the devil, "The Devil and Tom Walker" (fig. 2.14). Thus when citizens became deranged and were admitted to an asylum, it is not surprising that some believed they were possessed by a devil or being punished for their sins.

Asylum doctors disapproved of religious revivalism on the grounds that such excitement endangered the brain (fig. 2.15). In the mid-eighteenth century, America had been swept by recurring waves of revivalism, known as the First Great Awakening, during which traditions of Calvinism and Anglicanism, imported from England in the seventeenth century, splintered into various Protestant denominations. An upsurge of revivals in the 1820s, the Second Great Awakening, brought a new evangelical spirit to the fore in many congregations. In *Observations on the Influence of Religion upon the Health and Physical Welfare of Mankind* (1835), Amariah Brigham, superintendent of the New York State Lunatic Asylum, Utica, warned: "If a number of people be kept for a long time in a state of great terror and mental anxiety, no matter whether from a vivid description of hell and fears of 'dropping immediately into it,' or from any other cause, the brain and nervous system [are] . . . likely to be injured" (p. 269).

Partly from a desire to meet the religious needs of their patients, most asylums held nonsectarian church services. Patients were taught that they were ill, not sinful, and they were encouraged to view the deity as a nonjudgmental and loving parent. Although critical of revivalism, no asylum superintendent wanted to be considered an atheist in an era when a properly restrained religiosity was a requisite of respectability. Thus the regime at nineteenth-century mental hospitals incorporated a subtle mix of science and religion (figs. 2.16, 2.17).

Fig. 2.14. John Quidor, *Tom Walker's Flight,* ca. 1856, oil on canvas, 25 × 34 in. Rockefeller Collection of American Art, Fine Arts Museums of San Francisco.

John Quidor, a romantic painter with a theatrical flare, based his painting on Washington Irving's "The Devil and Tom Walker" (1824), the tale of a miserly broker who sold his soul to the devil. The story is set in colonial Boston, where people were "accustomed to witches and goblins and tricks of the devil in all kinds of shapes." Quidor depicted the moment when the devil claimed Tom's soul: "'Tom, you're come for.'. . . The black man whisked him like a child into the saddle, gave the horse a lash, and away he galloped, with Tom on his back, in the midst of a thunderstorm."

Fig. 2.15. "From 'Revivals' to Lunatic Asylums Is But a Step," cover of *Puck*, vol. 7, no. 178, Aug. 4, 1880. The Oskar Diethelm Library, History of Psychiatry Section, Department of Psychiatry, Cornell University Medical College and The New York Hospital, New York.

Fig. 2.16. "Dr. Mettaur's Headache Pills," with endorsements from the clergy, 19th century, chromolithograph. Bella C. Landauer Collection of Business and Advertising Art, The New-York Historical Society.

Fig. 2.17. *Hymns for the Ohio Lunatic Asylum* (Columbus, 1848). Ohio Historical Society, Columbus.

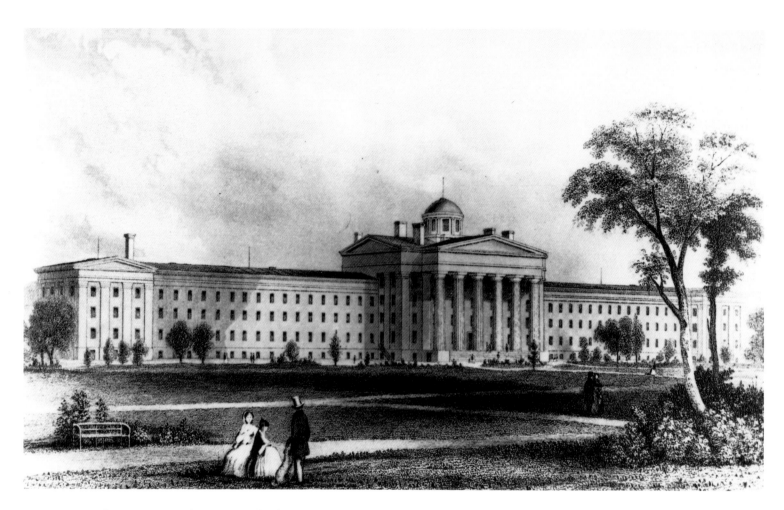

Fig. 2.18. New York State Lunatic Asylum, Utica, mid-19th century, engraving. Archives of New York State Lunatic Asylum, Utica, courtesy Mohawk Valley Psychiatric Center.

The architecture of the Utica asylum, the first state mental hospital in New York, was typical of the imposing neoclassical style of nineteenth-century hospitals.

The Beginning of the State Hospital System

The earliest American asylums that provided moral treatment were private, nonprofit institutions similar to the Friends Asylum. The Connecticut Retreat for the Insane (known as the Hartford Retreat) opened in Hartford in 1817. Other early asylums were offshoots of general hospitals: Massachusetts General Hospital opened the McLean Hospital for the Insane in 1818; New York Hospital founded the Bloomingdale Asylum in 1824. Pennsylvania Hospital opened a new wing for lunatics in 1796 and eventually opened a separate asylum, the Pennsylvania Hospital for the Insane, on the outskirts of Philadelphia in 1841.

The managers of these early asylums, filled with optimism about the curative potential of moral treatment, boasted impressive, if overstated, cure rates: for example, the Hartford Retreat reported in 1827 that more than 91 percent of its recent cases had been discharged as cured; in 1843 the Ohio Lunatic Asylum in Columbus claimed that its cure rate had reached 100 percent. In the first flush of enthusiasm for moral treatment, such assertions were accepted with little skepticism, and annual reports painted a glowing picture of everyday life in the asylum.

The value of private institutions offering moral treatment seemed so obvious that reformers began to appeal to state legislators to build public hospitals based on the same therapeutic principles. Asylum supporters made a good case that such institutions were both economical and humane: cures based on moral treatment were less costly than the long-term care of chronic patients. The first state to be swayed by these arguments was Massachusetts, which opened the Massachusetts State Lunatic Hospital at Worcester in 1833. State hospitals were also founded at Augusta, Maine, in 1840, and Utica, New York, in 1843 (fig. 2.18). Considering that at the time state governments expended very little on public welfare, it is remarkable that some of their earliest and largest allocations were made to build and maintain mental hospitals. The expansion of the state hospital system was propelled by asylum reformers such as Dorothea Dix (1802–1887), who worked closely with the superintendents of the new asylums to persuade legislators to establish more public institutions (fig. 2.19).

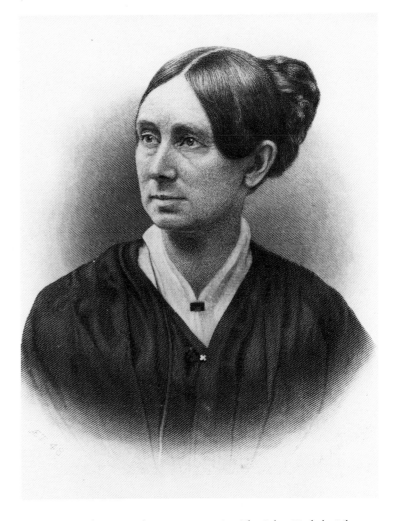

Fig. 2.19. Dorothea Dix, 19th century, engraving. The Oskar Diethelm Library, History of Psychiatry Section, Department of Psychiatry, Cornell University Medical College and The New York Hospital, New York.

Dorothea Dix was the most influential asylum reformer of the antebellum period. A deeply religious woman who suffered herself from depression, Dix found her life's calling in improving the care of the insane poor. In 1843 she sent a message to the Massachusetts legislature in which she described her mission: "I come as the advocate of helpless, forgotten, insane, idiotic men and women; of beings sunk to a condition from which the most unconcerned would start with real horror; of beings wretched in our prisons, and more wretched in our almshouses" ("Memorial to the Legislature of Massachusetts 1843," *Old South Leaflets*, 6, no. 148, Boston, n.d., p. 2).

The Founding of the American Psychiatric Association

The first generation of asylum doctors came primarily from rural, Protestant backgrounds; few were wealthy, and most saw asylum work as a secure living, free from the competitiveness of private medical practice. American medical schools offered no specialized training in the treatment of mental illness, so asylum doctors acquired their knowledge and experience on the job. A number were members of the Society of Friends, reflecting the continued association between the Quakers and asylum reform.

In 1844 Samuel Woodward, superintendent of the Massachusetts State Lunatic Hospital at Worcester, invited the heads of the twenty-three existing American mental hospitals to attend a meeting in Philadelphia to form a new organization whose mission would be to improve the professional care of the mentally ill. The thirteen individuals who made the trip became the founders of the Association of Medical Superintendents of American Institutions for the Insane (AMSAII), later renamed the American Psychiatric Association (fig. 2.20). The *American Journal of Insanity (AJI),* edited by Amariah Brigham, became AMSAII's official publication. Later renamed the *American Journal of Psychiatry,* it remains the official voice of American psychiatry to this day.

The Asylum as a Microcosm of Society

Although asylum doctors claimed that moral treatment was applicable to all human minds, their implementation of it varied according to a patient's gender, class, and race. Nineteenth-century medical theory uncritically incorporated and validated the social biases of the era which viewed male and female, rich and poor, white and black, as fundamentally different and unequal categories of humanity. As a result, the asylum community developed in mirror image to the social behavior, stratification, and prejudices of society at large.

Class and gender differences shaped the physical layout and daily schedule of the asylum. Men and women were housed in separate wings or buildings; wealthy patients were invited to bring furniture from home to decorate their rooms in the style to which they were accustomed. The day's activities varied according to the patient's class; lawyers and bankers were encouraged to read and play games, while farmers and laborers were assigned work in the kitchen, laundry, or gardens. Although women of all classes performed more similar household chores, differences in their rank and education were also accommodated.

To offset low government appropriations, state hospitals included more labor in the daily schedules of working class patients. But schemes to make patients pay their own way by working on the asylum farm or in its workshops met with limited success. Hospital superintendents complained that it was difficult to get a good day's labor from patients who were often too sick to work, or who resented having to labor while more affluent patients did not.

Class and gender distinctions in asylum treatment were slight in comparison to the racial divide that existed between white and black patients. Because medical authorities linked mental derangement with advanced civilization, they tended to assume that the more "childlike," dependent races, including Indians and African Americans, suffered less frequently from insanity and therefore did not need asylum care. When nonwhites did become mentally ill, they were not welcome in white asylums. With rare exceptions, both northern and southern asylum doctors regarded racial segregation as a mark of superior management. According to Thomas Kirkbride, superintendent of the Pennsylvania Hospital for the Insane, "The idea of mixing up all color and classes, as seen in one or two institutions in the United States, is not what is wanted in our hospitals for the insane" (*AJI,* 1855, vol. 12, p. 43).

Because the number of free blacks in the North was relatively small, northern asylums had few African-American applicants. Some private asylums, including the Friends Asylum, simply did not admit blacks, while others, like the Pennsylvania Hospital for the Insane, discreetly kept quiet about their admission. State mental hospitals accepted African Americans more openly, but placed them in segregated wards or separate buildings where they had fewer amenities than white patients. Most commonly, public officials assumed that the expense of hospital treatment was wasted on blacks, who were confined instead in jails and almshouses, where they received decidedly inferior care.

In the antebellum South, asylum superintendents had to confront issues of race and treatment more frequently and directly. Laws regarding the care of insane slaves date back to the early

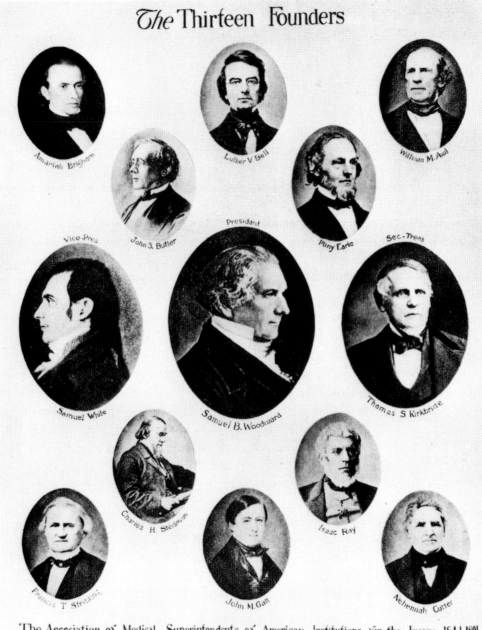

Fig. 2.20. Founders of the American Psychiatric Association, early 20th century, photogravure. Archives of the American Psychiatric Association, Washington, D.C.

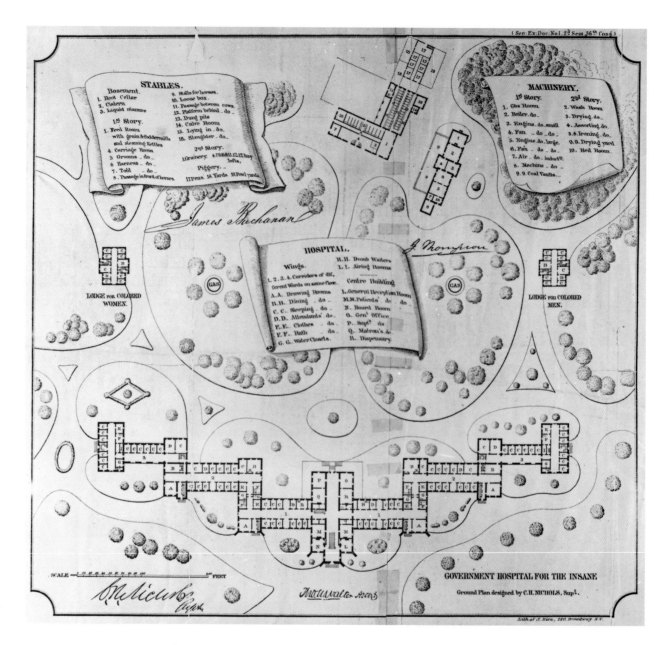

Fig. 2.21. Plan of the Government Hospital for the Insane, Washington, D.C., 1857. Archives of the Government Hospital for the Insane, courtesy St. Elizabeths Museum, Department of Health and Human Services, Washington, D.C.

The Government Hospital for the Insane, Washington, D.C., which opened in 1855, was the first federally funded mental hospital. This 1860 layout diagrams the separate buildings for "colored" men and women (upper right and left). The plan was signed by President James Buchanan and the hospital's designer and superintendent, C. H. Nichols. In the scientific spirit of the times, Nichols precisely specified the distance between buildings for patients of different races: "Lodges for the colored insane should not be less than two hundred nor more than four hundred feet from the main edifice. . . . Any distance within that range would exceed an objectionable proximity, but not the pale of an easy inspection" (C. H. Nichols, "Proceedings from the Tenth Annual Meeting of the Association of Medical Superintendents of American Institutions for the Insane," *AJI*, 1855, vol. 12, p. 89). The Government Hospital (also called St. Elizabeths Hospital) maintained segregated wards until the Supreme Court desegregation rulings of the mid-1950s.

1700s and constitute some of the earliest legislation passed in the colonies. By the nineteenth century, the demand for institutional care for blacks was considerable. As in the North, the willingness to accept African-American patients in southern asylums varied from institution to institution. Some asylums refused all black patients; some would take free blacks but not slaves. Those asylums that did accept black patients tended, as in the North, to put them in segregated and inferior quarters (fig. 2.21). Likewise, many blacks suffering from mental disease were housed in jails or almshouses.

The Eastern Lunatic Asylum of Virginia in Williamsburg was a rare exception. The asylum admitted free blacks from its opening in 1773 and under John M. Galt, superintendent there from 1841 to 1862, integrated some of its wards. The state legislature consistently appropriated less support to Galt's biracial institution than to the Western Lunatic Asylum of Virginia in Staunton, which refused black patients and concentrated on an affluent white clientele. Outside the South, leaders of the profession also took a dim view of Galt's philosophy. When Thomas Kirkbride criticized Galt for allowing the races to mix at Eastern Lunatic Asylum, no colleagues came to Galt's defense.

Galt was in accord with other asylum doctors, however, in believing that the institution of slavery protected blacks from the mental pressures of freedom which could lead to insanity. In his 1848 annual report Galt noted:

> The proportionate number of slaves who become deranged is less than that of free coloured persons, and less than that of whites. From many of the causes affecting the other classes of our inhabitants, they are somewhat exempt; for example, they are removed from much of the mental excitement to which the free population of the Union is necessarily exposed in the daily routine of life; not to mention the liability of the latter to the influence of the agitating novelties of religion, the intensity of political discussion, and other elements of the excessive mental action which is the result of our republican form of government. Again, they have not the anxious cares and anxieties relative to property, which tend to depress some of our free citizens. The future, which to some of our white population may seem dark and gloomy, to them presents no cloud on the horizon. ("Report of the Eastern Asylum in the City of Williamsburg," Virginia, 1848, p. 25)

Irish immigrants also faced widespread prejudice in antebellum society. Arriving in American cities at a time when decent housing and well-paying jobs were already in short supply, they met with great hostility from native-born Americans of all classes. In an overwhelmingly Protestant society, their Roman Catholicism evoked particular suspicion. Because their families were either back in Ireland or desperately poor, immigrants who became destitute or ill often ended up in public welfare institutions. The high percentage of first- and second-generation Irish immigrants in public mental hospitals was often cited as proof of their social and biological inferiority.

Protestant asylum physicians and staff found the practice of moral treatment to be complicated by their religious and cultural differences from the Irish, whom they often characterized as particularly depraved and offensive. Echoing their sentiments about black patients, some asylum superintendents felt that the Irish should be cared for in separate wards to avoid distressing the "better class" of patients. Merrick Bemis, superintendent of the Massachusetts State Lunatic Hospital at Worcester, wrote of the Irish in the hospital's annual report for 1858: "Opposite in religion and all the notions of social life, it would not be well to class the two races in the same wards, where each must bear from the other what was considered troublesome and offensive while in health" (p. 57). Isaac Ray, superintendent of the Maine Insane Hospital, even proposed establishing an "Irish asylum," with all Irish patients and staff, as a way of addressing the needs of these new immigrants (*North American Review,* 1856, vol. 82, pp. 95–96).

PUBLIC REACTION TO THE REFORMED ASYLUM

The sheer size of asylums built during the nineteenth century, when large buildings themselves were still unusual, aroused public curiosity. Opinions of asylum reform were shaped not only by hospital annual reports, which sought to advertise an institution's virtues, but also by visitor and patient accounts, which did not always present asylum life so favorably.

On the positive side, asylum supporters stressed the improved, more sympathetic tone of moral treatment, which engendered a sense of superiority and progress over colonial-era confinement. An 1846 broadside, circulated to attract out-of-state customers to the Eastern Lunatic Asylum of Virginia, proclaimed: "Institutions for the insane were formerly little more than mere places of confinement . . . [however] the humane principles which modern science has revealed are now fully and entirely established." In

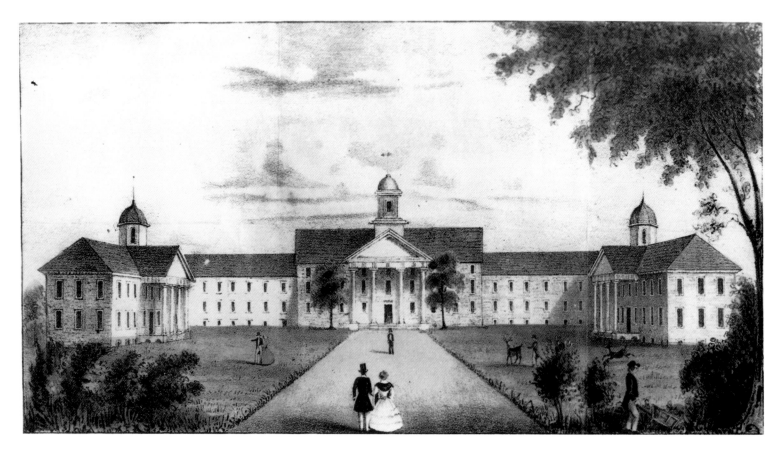

Fig. 2.22. Eastern Lunatic Asylum of Virginia, Williamsburg, 1846, broadside illustration. Galt Papers, Swem Library, College of William and Mary, Williamsburg, Virginia.

this advertisement (which does not mention that the hospital was integrated), the hospital building is depicted as a pleasant retreat surrounded by gardens through which well-dressed couples stroll (presumably relatives visiting a loved one); a well-behaved patient tends a flower bed (fig. 2.22). The facade of the building follows the prevailing principles of asylum architecture developed by Thomas Kirkbride at the Pennsylvania Hospital for the Insane and widely copied in the United States. In an attempt to make the asylum resemble a hotel, offering a comfortable, domestic atmosphere for those far from home, the window bars were made in ornamental, cast-iron designs, and the guard wall was discreetly incorporated into the landscaping.

The reflections of a reporter who visited the New York City Lunatic Asylum on Blackwell's Island in 1859 also stressed improved care: "I remember, when a boy, having been taken to visit an insane asylum, in which the patients groveled in filth, darkness, and cold. . . . But the asylum on Blackwell's Island is, throughout, perfect in respect of cleanliness, order and comfort" ("A Visit to the Lunatic Asylum on Blackwell's Island," *Harper's Weekly,* March 19, 1859, p. 185). The reporter sympathetically described the condition and delusions of several of the patients (fig. 2.23). Unfortunately, conditions at the Blackwell's Island asylum quickly deteriorated, and in the late 1880s, it was the subject of a famous exposé by the reporter Nellie Bly (see p. 123).

THE MILLIONAIRE.

CRAZY MOTHER AND HER DAUGHTER.

Fig. 2.23. "The Millionaire" and "Crazy Mother and Her Daughter," in "A Visit to the Lunatic Asylum on Blackwell's Island," *Harper's Weekly,* March 19, 1859, pp. 184–85. The Oskar Diethelm Library, History of Psychiatry Section, Department of Psychiatry, Cornell University Medical College and The New York Hospital, New York.

Left. The Millionaire: "[This patient, who works as a boatman] is satisfied that Prince Albert of England is an impostor, and that he is the lawful husband of Queen Victoria, who, faithless creature, avails herself of certain legal quibbles to defraud him of his legitimate marital rights" (p. 184).

Right. Crazy Mother and Her Daughter: "Dr. Ranney [the ward physician] stated that the bulk of his female patients were immigrant girls (Irish), who had been deluded, seduced, cheated, and otherwise ill-used on arrival here; and who, on realizing their miserable condition, had gone mad from the shock of disappointment" (p. 185).

Patient Critiques of the Asylum

Despite numerous positive reports on asylum conditions, many citizens suspected that the new institutions hid terrible abuses behind their walls. Firsthand accounts published by disgruntled former patients fueled rumors of inhumane practices. Usually committed against their wishes, many patients did not believe they were insane and resented their treatment by relatives and physicians. In an account of his confinement at the Maine Insane Hospital, *Three Years in a Madhouse!* (Augusta, 1852), Isaac Hunt told of force feedings overseen by doctors he found sadistic (fig. 2.24). Ebenezer Haskell, a patient at Pennsylvania Hospital for the Insane, questioned his family's motives for committing him and, after escaping several times, sought a jury trial to determine his sanity and the legality of his commitment. Haskell won the case against the asylum in 1868. His memoirs documented what he perceived to be the horrors of the "Philadelphia madhouse," such as humiliating baths and abuses at the hands of attendants. The illustrations from his book, *The Trial of Ebenezer Haskell* (1869), suggest how the hospital looked to a patient unconvinced of its therapeutic purpose (figs. 2.25, 2.86).

Records left by patients describing their asylum experiences vary from letters expressing appreciation for the restoration of their sanity to bitter lawsuits against hospital and family. The complaints often centered around wrongful confinement: to commit a relative in the mid-nineteenth century, families needed only to obtain a certificate from one physician (in some states, two) testifying that the individual was insane. Patient-advocates such as Haskell, whose family got their dentist to sign his certificate of insanity, decried the ease with which families could dispose of unwanted kin and take their property.

The most famous wrongful confinement controversy in nineteenth-century America involved Elizabeth Packard, an Illinois woman committed in 1860 to an asylum in Jacksonville by her clergyman-husband. Packard insisted that her husband was only punishing her for holding unorthodox spiritualist views. Upon her release, she sued her husband for wrongful confinement and won. Packard also convinced the Illinois state legislature to investigate the asylum's superintendent, Andrew McFarland, whose dismissal was recommended. (The asylum's board of managers refused to comply.) Packard led a national

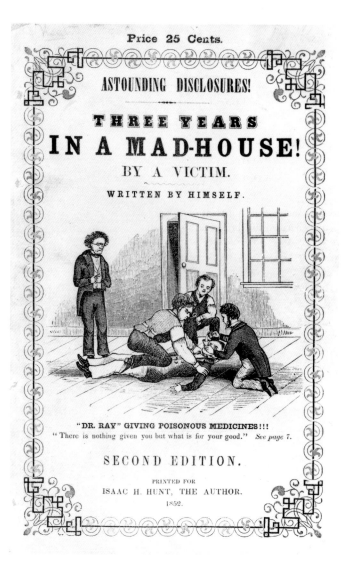

Fig. 2.24. "Dr. Ray Giving Poisonous Medicines!" cover of Isaac H. Hunt, *Three Years in a Madhouse!* (Augusta, 1852). The Oskar Diethelm Library, History of Psychiatry Section, Department of Psychiatry, Cornell University Medical College and The New York Hospital, New York.

The standing figure on the cover of this patient exposé is Isaac Ray, superintendent of the Maine Insane Hospital. The author admits that he was "a wild maniac" when he entered the asylum: "I was a perfectly deranged man, laboring under strong fever of the brain, or great and uncontrollable mental excitement, of which, under humane treatment, I should have recovered, and no doubt returned to my business in full possession of my mental and physical faculties" (pp. 4–5). But Hunt complained that he was forced to take medicines that weakened and worsened him.

Fig. 2.25. "The Spread Eagle Cure," in Ebenezer Haskell, *The Trial of Ebenezer Haskell* (Philadelphia, 1869). The Oskar Diethelm Library, History of Psychiatry Section, Department of Psychiatry, Cornell Medical College and The New York Hospital, New York.

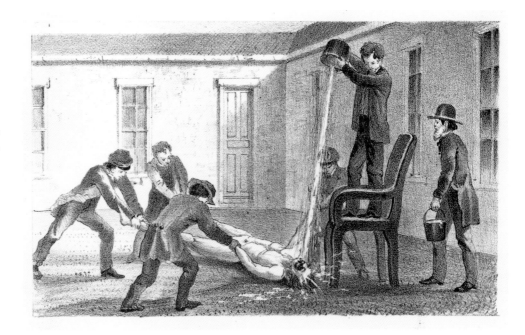

Former patient Ebenezer Haskell claimed to have witnessed abusive treatment while confined to Pennsylvania Hospital for the Insane:

> The spread eagle cure is a term used in all asylums and prisons. A disorderly patient is stripped naked and thrown on his back, four men take hold of the limbs and stretch them out at right angles, then the doctor or some one of the attendants stands up on a chair or table and pours a number of buckets full of cold water on his face until life is nearly extinct, then the patient is removed to his dungeon cured of all diseases. (p. 43)

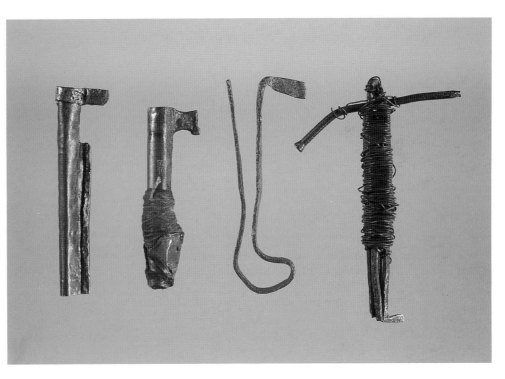

Fig. 2.26. Keys made by patients trying to escape the Winnebago State Hospital, Wisconsin, 19th century. Archives of the Winnebago State Hospital, courtesy Winnebago Mental Health Institute.

"How can I Live without my Children!" See page 85.

| No. 1.—Abducting my Babe. See p. 48. | No. 2.—Abducting my Daughter. See page 40. |
| No. 3.—My Isaac's parting kiss. See page 50. | No. 4.--Abducting my George. See p. 50. |

Fig. 2.27. "How Can I Live without My Children!" in Elizabeth Packard, *Modern Persecution, or Insane Asylums Unveiled* (Hartford, 1873). The Oskar Diethelm Library, History of Psychiatry Section, Department of Psychiatry, Cornell University Medical College and The New York Hospital, New York.

crusade to guarantee that commitment hearings took place before a jury and that patients could send and receive correspondence; these "Packard laws" were passed in several states in the 1860s and 1870s. Packard particularly criticized the legal disadvantages of married women, who could lose their children and their property if committed by an unscrupulous husband. Her crusade won support from the women's rights movement of her day (fig. 2.27).

THE SEARCH FOR CAUSES OF INSANITY

Nineteenth-century medical authorities sought both physical and behavioral causes of mental illness. If an asylum physician hypothesized that a patient's melancholy had a physical basis in, for example, weak nerve fibers, he then looked for behavioral causes of this weakness, such as a brain overtaxed by business worries, overindulgence in masturbation, or intemperance. Thus their theories about the underlying causes of insanity operated at two levels, the physical and the cultural. Modern psychiatrists continue to use such a multicausal model, differentiating among the physiological, psychological, and social precipitants of mental illness. For example, while today they think schizophrenia may originate in a hereditary defect in brain chemistry, they emphasize that other factors, such as work-related stress, pathological family dynamics, or dynamic abuse may trigger its onset.

Physical Causes of Insanity

Between the late eighteenth and the early nineteenth century, changing conceptions of nature had a profound impact on the medical sciences. The model of the universe as a static, inanimate clock gave way to the notion of nature as an organic, interconnected system. The change can be seen clearly in the contrast between Newtonian science, with its billiard-ball universe based in mathematics, and Darwinian science, with its evolutionary worldview based in biology. This shift, however, had limited effect on research on mental illness until late in the nineteenth century. Although patient care in reformed asylums vastly improved early in the century, asylum medicine produced few scientific insights into the causes of insanity.

Clinical research in the mid-1800s consisted primarily of linking bedside observations with autopsy reports. In other areas of medicine, correlating symptoms in life with pathological appearances after death produced dramatic new understandings of how specific diseases affect certain organs; for example, patients with consumption have characteristic tubercles in their lungs, and patients with typhoid develop distinctive lesions in their digestive systems. The search for similar physical correlations in the brains and nervous systems of insane patients, however, proved largely unsuccessful. In only a fraction of cases did postmortem examinations of the insane show signs of organic disease; for example, in the condition known as general paralysis or paresis, whose symptoms include slurred speech and a dragging walk, brain tissue showed striking pathological changes. (Not until the late nineteenth century was the underlying relationship between paresis and syphilis clearly established.) But in most cases of insanity, asylum physicians found that postmortem examinations revealed no pathological signs, and in general, the physical causes of insanity remained a mystery.

Brain Anatomy and the Nervous System

In the absence of pathological clues to insanity's nature, physicians drew upon what knowledge they had about the brain and nervous system to guide their treatments of mental illness. By the early 1800s, they had mapped the gross anatomy of the brain and understood the critical role the nervous system played in conveying sensory information to and from different parts of the body (figs. 2.28–2.30). Reworking the old humoral theory, doctors envisioned the nervous system as the connecting link between mind and body. The tension or laxity of nerve fibers gradually replaced the flow of bodily fluids as the key to maintaining health. Physicians suggested that too much or too little stimulation of delicate nerve fibers could derange the normal functioning of the brain. Both mental and physical disturbances could produce the same effect: for example, strong emotions could deplete the storehouse of nervous energy in the brain, or disturbances caused by a diseased organ, particularly the stomach, could be communicated to the brain.

In portraying the brain as the master organ of the mind, nineteenth-century medical authorities betrayed their social prejudices. The comparative study of brain anatomy was widely used in the era as a "scientific" proof of the superiority of white Euro-American culture. Anatomists routinely misinterpreted,

Fig. 2.28. Model of the brain, 19th century, House of Auzoux, Paris, painted papier-mâché. Mütter Museum, College of Physicians of Philadelphia.

The Calvaria removed.

a,b,c *The external Lamina of the Dura Mater* d,e,f *Lacerations corresponding to the Sutures* h *Cerebral Eminences* i,k,l,m *Meningeal Arteries* n *Longitudinal Sinus* o *Internal Smooth Lamina of the Dura Mater* p *Arachnoid Coat* q *Pia Mater* r *Cineritious Substance* S *Section of the Integuments* t *Temporal Muscle* u *Section of the Calvaria.*

The Hemispheres separated, to exhibit the Vertical Walls. Falx. & Corpus Callosum.

The Dura Mater on the left removed from a *The Hemisphere of the Cerebrum* b *Its Convolutions* c *Glandulæ Pacchioni* d *Veins* e *Vertical Walls* f *Corpus Callosum* g *Raphe* h *Falx* i *Inferior Longitudinal Sinus* k *Superior Longitudinal Sinus.*

Vertical section of the Hemisphere. Corpus Callosum, Septum Lucidum, &c.

e *Vertical Walls of the Hemisphere* f *Extremities of the Cerebral Arteries* d *Veins of the Brain* i *Vertical Section of the Corpus Callosum* k *Septum Lucidum* l *Fornix* m *Plexus Choroides* n *Thal.¹ nervi Opt.¹* o *Tænia Striata* p *Corp.¹ Striatum* q *Foramen of Monro* a *Sup.ʳ Longitudinal Sinus* b *Inf.ʳ Longitudinal Sinus* v *Falx*

Base of the Cranium.

Fig.1 a *Junction of the Torcular, Sup.ʳ Long.¹ &* Lateral sinus f — g *Occipital Falx & Sinus* h *Tentorial Origins* i *Cibriform Plate. Fig.2* i *Pituitary gland & Circular sinus* k *Cavernous sinus* r *Inferior Petrous sinus* s *Superior Petrous sinus*

Fig. 2.29. Illustrations in Alexander Ramsey, *Description of the Plates of the Brain* (Edinburgh, 1812). Archives of Pennsylvania Hospital, Philadelphia.

Turning the pages of this book, one sees deeper into the brain, in some cases through holes (which appear black in these illustrations) cut through the pages to the next level.

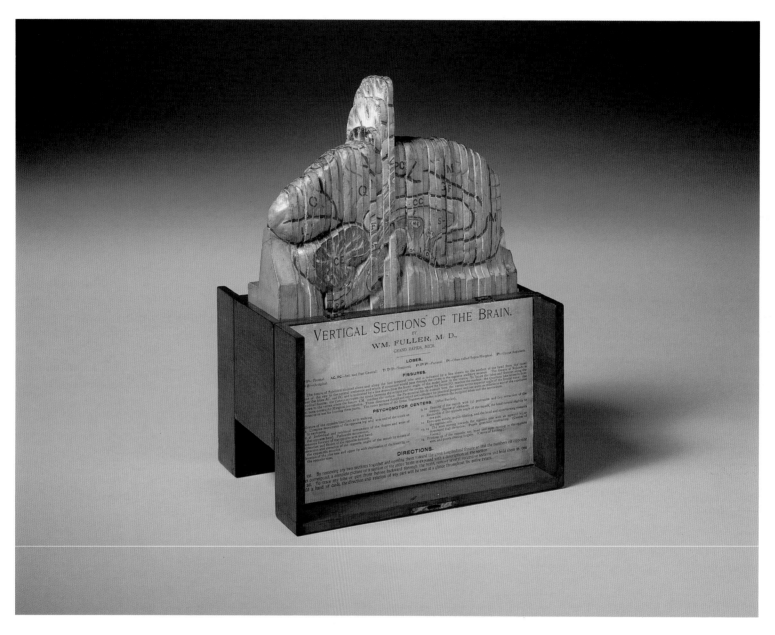

Fig. 2.30. Vertical sections of the brain, by William Fuller, 19th century, painted wood and photographs, with removable sections. Mütter Museum, College of Physicians of Philadelphia.

The vertical sections of this carved wood model slide up to reveal photographs of the brain, which were made from corresponding slices of brain tissue.

TABLE,

Showing the Size of the Brain in cubic inches, as obtained from the measurement of 623 Crania of various Races and Families of Man.

RACES AND FAMILIES.	No. of Skulls.	Largest I. C.	Smallest I. C.	Mean.	Mean.
MODERN CAUCASIAN GROUP.					
TEUTONIC FAMILY.					
Germans,	18	114	70	90	
English,	5	105	91	96	92
Anglo-Americans,	7	97	82	90	
PELASGIC FAMILY.					
Persians,					
Armenians,	10	94	75	84	
Circassians,					
CELTIC FAMILY.					
Native Irish,	6	97	78	87	
INDOSTANIC FAMILY.					
Bengalees, &c.	32	91	67	80	
SEMITIC FAMILY.					
Arabs,	3	98	84	89	
NILOTIC FAMILY.					
Fellahs,	17	96	66	80	
ANCIENT CAUCASIAN GROUP.					
PELASGIC FAMILY.					
Græco-Egyptians,	18	97	74	88	
NILOTIC FAMILY.					
Egyptians,	55	96	68	80	
MONGOLIAN GROUP.					
CHINESE FAMILY.	6	91	70	82	
MALAY GROUP.					
MALAYAN FAMILY.	20	97	68	86	85
POLYNESIAN FAMILY.	3	84	82	83	
AMERICAN GROUP.					
TOLTECAN FAMILY.					
Peruvians,	155	101	58	75	
Mexicans,	22	92	67	79	79
BARBAROUS TRIBES.					
Iroquois,					
Lenapé,	161	104	70	84	
Cherokee,					
Shoshoné, &c.					
NEGRO GROUP.					
NATIVE AFRICAN FAMILY.	62	99	65	83	83
AMERICAN-BORN NEGROES.	12	89	73	82	
HOTTENTOT FAMILY.	3	83	68	75	
ALFORIAN FAMILY.					
Australians,	8	83	63	75	

From the Catacombs (label at left of Ancient Caucasian Group rows)

Fig. 2.31. Chart comparing skulls of different races, in Samuel George Morton, *Catalogue of Skulls of Man and the Inferior Animals* (Philadelphia, 1849). Archives of Pennsylvania Hospital, Philadelphia.

The profound racism of Samuel George Morton, professor of anatomy at the prestigious Philadelphia Medical College and president of the Academy of Natural Science, Philadelphia, was not unusual; he concluded discussion of this table with the remark that the Caucasian brain was, on average, at least nine cubic inches larger than that of the Negro.

Fig. 2.32. "Profile of Negro, European, and Oran Outan," in Robert Knox, *The Races of Man* (London, 1850). National Library of Medicine, Bethesda.

Physician Robert Knox used calibrations of facial angles to argue that the Negro skull was anatomically more similar to an ape (here the anthropoid orangutan of Borneo) than a Caucasian skull.

Fig. 2.33. Comparison of an Irishman with a terrier, in James Redfield, *Comparative Physiognomy* (New York, 1852). New York Academy of Medicine Library.

Physician James Redfield extended physiognomy to animals. He expressed his prejudice against the Irish by comparing them to dogs: "Among the Irish, the community takes to dirt-digging more naturally than to anything else" (p. 264).

and even falsified, data on brain size and capacity to justify the subordination of certain ethnic groups, nonwhites, and women (figs. 2.31–2.33). This distasteful tradition of "mismeasuring" the brain only ended in the present century, when researchers conclusively showed that brain size is determined by overall body size, not gender or race, and has no direct relationship to intelligence.

Physiognomy and Personality Types

Swiss theologian Johann Kasper Lavater (1741–1801) formulated the rules of physiognomy, whereby a person's character and personality were evaluated on the basis of facial features. Always of more general than medical interest, physiognomy became especially popular in the early nineteenth century in combination with phrenology, a new theory of brain anatomy which extended the evaluation of character from the face to the shape of the entire head (see pp. 183–90). Drawing on the humoral theory, physiog-

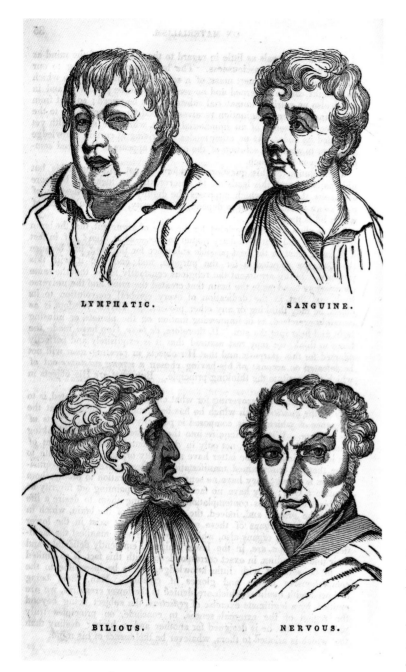

Fig. 2.34. "Lymphatic, Sanguine, Bilious, Nervous," in George Combe, *Outlines of Phrenology* (Boston, 1838). General Research Division, The New York Public Library, Astor, Lenox, and Tilden Foundations.

nomists distinguished four facial types associated with the traditional temperaments: nervous (melancholic), bilious (choleric), lymphatic (phlegmatic), and sanguine (fig. 2.34). Complex charts were produced as guides to reading the subtle contours of the human face (figs. 2.35, 2.36).

Reading the patient's facial expression and overall appearance was an important part of the diagnostic process. Physicians differentiated the three main forms of insanity recognized in the early to mid nineteenth century—mania, melancholia, and dementia —on the basis of physiognomy as well as behavior (fig. 2.37). When derangement was manifested as excitement and marked delusions, and the patient's face appeared vibrant and lively, the illness was termed mania. A nervous temperament and a downcast expression coupled with extreme dejection and passivity signaled melancholia. Patients suffering from mania or melancholia sometimes deteriorated even further into dementia, an unresponsive state in which the face was empty of expression.

Using a patient's appearance as a diagnostic guide, which was common to physiognomy, phrenology, and all versions of the humoral theory, led to the popularity of illustrated guides for physicians which, after the 1830s, were enhanced by the invention of photography. The lithographs in Allan MacLane Hamilton's *Types of Insanity* (1883), showing typical maniacs, melancholics, and demented patients, were based on photographs of patients (fig. 2.38).

The cast of characters from the humoral theory—especially the raving maniac and the depressed melancholic—continued to appear in nineteenth-century popular settings. Although the accepted etiologies for these disorders changed over the years, the basic personality types embodied in the humoral theory were transposed to new contexts, much as in the retelling of an ancient myth. Sophisticated urban audiences of the mid nineteenth century viewed colonial-era practices and notions, such as the chaining of maniacs or possession of melancholics by the devil, as outmoded and comic. For example, the sheet music for the 1840 song "The Maniac" bears the illustration of an agitated, wild-eyed fiend; the music itself is a frenzied rage (fig. 2.39). The melancholic depicted by satirist George Cruikshank in *The Blue Devils* is tormented not by ravages of depression but by a demoniac, Dickensian cast: a bill collector, a pregnant woman, an attorney, a physician, and an undertaker (fig. 2.40).

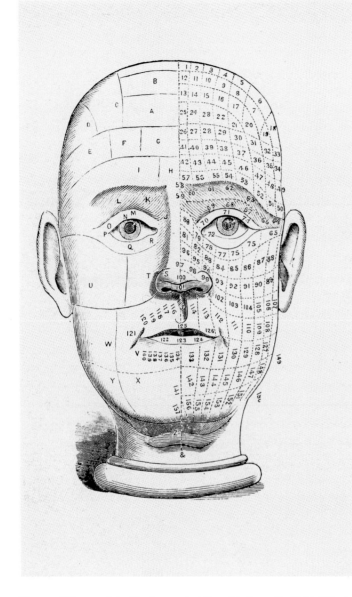

DR. REDFIELD'S NOMENCLATURE.

NAMES OF THE PHYSIOGNOMICAL SIGNS

ACCORDING TO DR. REDFIELD'S SYSTEM.

[The Numbers refer to corresponding ones on the diagrams.]

1. Benevolence.
2. Kindness.
3. Gratitude.
4. Respect.
5. Immortality-Belief.
6. Romance.
7. Poetry.
8. Enthusiasm—Hope.
9. Sublimity.
10. Imitation.
11. Example.
12. Discovery.
13. Analysis.
14. Metaphor.
15. Analogy.
16. Causality *a priori*.
17. Wit.
18. Imagination.
19. Resemblances.
20. Contrast.
21. Association.
22. Induction *a posteriori*.
23. Correspondence.
24. Comparison.
25. Combination.
26. Time.
27. Events.
28. Duration.
29. Velocity.
30. Prevision.
31. Plan.
32. Eloquence.
33. Somnambulism.
34. Repulsiveness.
35. Activity.
36. Instinctiveness.
37. Expressiveness.
38. Attractiveness.
39. Memory.
40. Consciousness.
41. Voluntariness.
42. Place.
43. Direction.
44. Distance.
45. Momentum
46. Colors.
47. Order.
48. Music.
49. Reaction.
50. Lightness.
51. Numbers.
52. Shape.
53. Fluidity.
54. Weight.
55. Size.
56. Forms.
57. Consistence.
58. Command.
59. Nouns.
60. Adjectives.
61. Substitution.
62. Climbing.
63. Enjoyment.
64. Participles.
65. Medicine.—65, A. Wave motion.

66. Conjunctions.
67. Contest.
68. Resistance.
69. Subterfuge.
70. Adverbs.
71. Sympathy.
72. Verbs.
73. Interjections.
74. Prepositions.
75. Construction.
76. Shadow.
77. Machinery.
78. Molding.
79. Weaving.
80. Architecture.
81. Attack.
82. Clothing.
83. Water.
84. Leaping.
85. Watchfulness.
86. Protection.
87. Hurling.
88. Whirling.
89. Sleep.
90. Repose.
91. Rest.
92. Caution.
93. Suspicion.
94. Gain
95. Economy.
96. Relative Defense.
97. Self-Defense.
98. Confiding.
99. Concealment.
100. Correspondence.
101. Discovery.
102. Inquisitiveness.
103. Responsibility.
104. Concert.
105. Politeness, Simulation.
106. Surprise.
107. Exclusiveness.
108. Love of Life.
109. Rapacity.
110. Resistance.
111. Subterfuge.
112. Destructiveness.
113. Filial Love.
114. Parental Love.
115. Concentration.
116. Comprehension.
117. Application.
118. Gravity.
119. Magnanimity.
120. Precision.
121. Cheerfulness.
122. Ostentation.
123. Envy.
124. Hatred.
125. Adhesiveness.
126. Approbation.
127. Preserving.
128. Enjoyment.
129. Climbing.
130. Substitution.
131. Equality.

132. Fraternity.
133. Sociality.
134. Travel.
135. Home.
136. Patriotism.
137. Philanthropy.
138. Jealousy.
139. Meanness.
140. Sadness.
141. Congeniality.
142. Desire to be Loved.
143. Desire to Love.
144. Violent Love.
145. Ardent Love.
146. Fond Love.
147. Love of Beauty.
148. Faithful Love.
149. Republicanism.
149*a.* Responsibility.
149*b.* Caution.
150. Resolution.
151. Perseverance.
152. Severity.
153. Abstraction.
154. Self-Control.
155. Determination.
156. Willingness.
157. Engrossment.

————

A. Parental Love.
B. Self-Love, Superciliousness.
C. Fatuity, Filial Love.
D. Reform and Triumph.
E. Faith and Immortality.
F. Hope and Enthusiasm.
G. Charity.
H. Justice, Arbitration.
I. Conscience.
J. Eminence, Gratitude, and Kindness.
K. Penitence.
L. Confession.
M. Historical Truth.
N. Prayer.
O. Rapture.
P. Collating and Punctuality.
Q. Mathematical Truth, Humility, Apology.
R. Fiction, Wonder, Self-Justification.
S. Example and Influence.
T. Admiration.
U. Sleep.
V. Excursiveness.
W. Hospitality.
X. Buoyancy.
Y. Acquisitiveness.
Z. Economy, Submission, Subserviency.
&. Independence and Firmness.

Fig. 2.35. "Names of the Physiognomical Signs," in James Redfield, "Physiognomical System," in S. R. Wells, *New System of Physiognomy* (New York, 1866). New York Academy of Medicine Library.

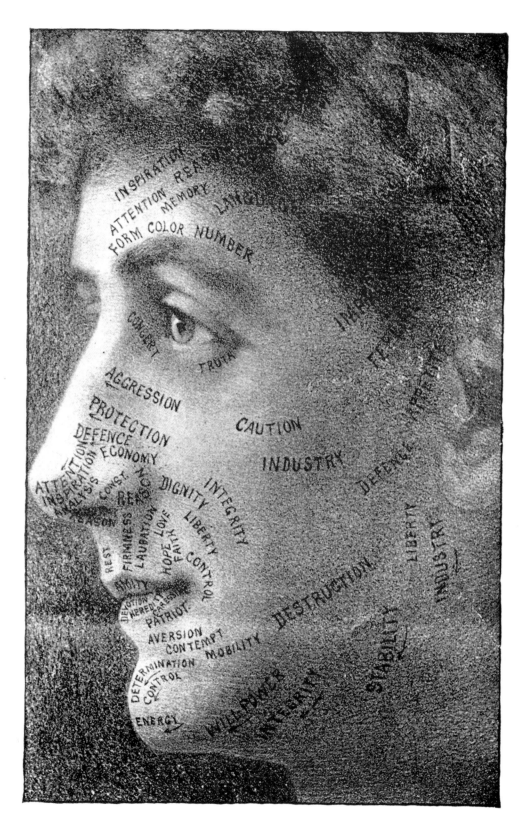

Fig. 2.36. Face of a woman with physiognomical regions indicated, in Holmes W. Merton, *Descriptive Mentality* (Philadelphia, 1899). Ohio Historical Society, Columbus.

Fig. 2.37. Frontispiece illustrating diagnostic categories, in John Charles Bucknill and Daniel H. Tuke, *A Manual of Psychological Medicine* (London, 1858). Archives of Pennsylvania Hospital, Philadelphia.

Intended to aid doctors in diagnosing mental patients, these illustrations manifest (from the top and clockwise): "acute mania, acute suicidal melancholia, secondary dementia, congenital imbecility, primary dementia, general paralysis," and "monomania of pride" (center).

Fig. 2.38. "Mania," "Melancholy," and "Dementia," lithographs after photographs in Allan MacLane Hamilton, *Types of Insanity* (New York, 1883). The Oskar Diethelm Library, History of Psychiatry Section, Department of Psychiatry, Cornell University Medical College and The New York Hospital, New York.

Illustrated diagnostic guides were used throughout the nineteenth century. Physician Allan MacLane Hamilton prepared these typical cases, based on photographs of particular patients at Ward's Island Asylum, New York:

Left. Mania: "[He] has been on Ward's Island eleven years. He is incoherent and excitable, but quite tractable. . . . [He] is clownish in his behavior, and sings at the top of his voice."

Center. Melancholy: "Duration of insanity seven months. She hears voices commanding her not to eat, and it is often necessary to feed her with the tube. . . . There is rarely any play of facial expression and she takes no notice of those about her."

Right. Dementia: "He is profoundly demented, and is dirty, stupid, and careless. His disease has lasted nineteen years, and followed melancholia."

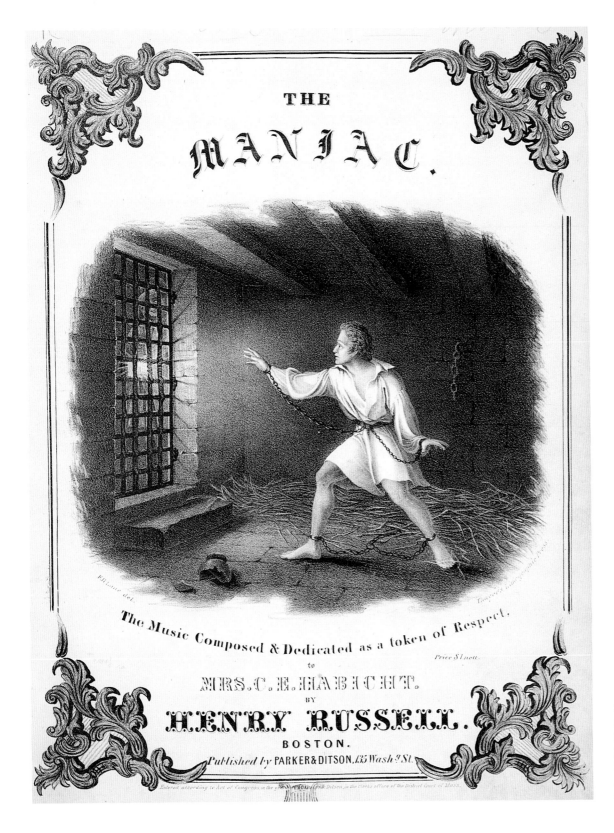

Fig. 2.39. Fitz Hugh Lane, sheet music cover for "The Maniac," by Henry Russell, 1840. The Music Division, The New York Public Library for the Performing Arts, Astor, Lenox, and Tilden Foundations.

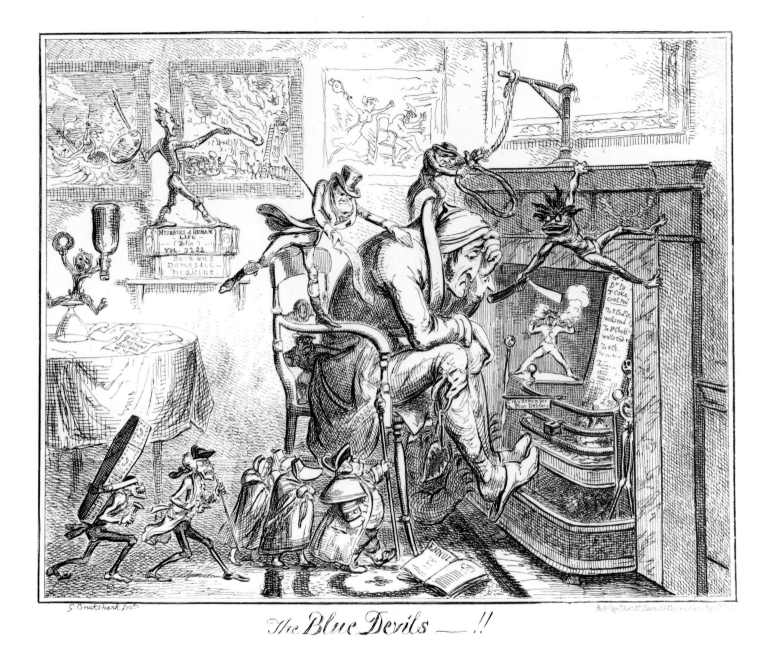

The Blue Devils —!!

Fig. 2.40. George Cruikshank, *The Blue Devils,* 1835, etching. National Library of
Medicine, Bethesda.

Fig. 2.41. "King Lear," in *The American Shakespeare* (New York, 1878).

Fig. 2.42. "Hamlet," in *The American Shakespeare* (New York, 1878).

The first great American-born Shakespearean actor, Edwin Forrest, poses here as King Lear in a mad rage. A contemporary who saw Forrest perform Lear described the actor's melodramatic mania:

> His eyes flashed and faded and reflashed. He beat his breast as if not knowing what he did. His hands clutched wildly at the air as though struggling with something invisible. Then, sinking on his knees, with upturned look and hands straight outstretched towards his unnatural daughter, he poured out, in frenzied tones of mingled shriek and sob, his withering curse half adjuration, half malediction. (William R. Alger, *Life of Edwin Forrest, The American Tragedian,* Philadelphia, 1877, vol. 2, p. 786)

Typical of educated men of their day, asylum doctors were well versed in art and literature, especially the British tradition. The works of Shakespeare, with their insightful focus on extreme and bizarre mental states, had a particular appeal. Amariah Brigham, editor of the *American Journal of Insanity,* expressed a view common to his asylum colleagues when he remarked that he had seen all the characters in Shakespeare in the wards of the New York State Lunatic Asylum (*AJI,* 1859, vol. 16, p. 415). Like the medical materialist Benjamin Rush before him, Brigham was echoing the traditional association of madness and genius, which the Bard himself expressed in *A Midsummer Night's Dream:*

> Lovers and madmen have such seething brains,
> Such shaping fantasies, that apprehend
> More than cool reason ever comprehends.

Between 1844 and 1865, the *American Journal of Insanity* published no fewer than twelve articles in which member physicians discussed and "diagnosed" mad characters in Shakespearean plays. All concurred that King Lear (fig. 2.41) was a maniac, "driven to madness by the unexpected ingratitude of his daughters," and displaying "maniacal wildness and disorder" (Isaac Ray, "Shakespeare's Delineations of Madness," *AJI,* 1847, vol. 3, p. 291). Hamlet (fig. 2.42) was a complex case of "melancholic madness, of a delicate shade, in which the reasoning faculties, the intellect proper, so far from being overcome or even disordered [were] rendered more active and vigorous, while the will, the moral feelings, the sentiments and affections, [were] the faculties which seem alone to suffer from the stroke of disease" (A. O. Kellogg, "William Shakespeare as a Physiologist and Psychologist," *AJI,* 1859, vol. 16, p. 414). Shakespeare's many fools, such as Bottom, who wears "an ass's head" and is "crowned the king of donkeys" in *A Midsummer Night's Dream,* or Simple, Feeble, and Touchstone (fig. 2.43), were all mentally deficient persons presented for the entertainment of their more intelligent brethren. While condemning the once-popular practice of viewing asylum patients as a form of entertainment, physicians joined the audiences entranced by theatrical presentations of maniacs, melancholics, and fools (A. O. Kellogg, "Shakespeare's Delineations of Mental Imbecility, as Exhibited in His Fools and Clowns," *AJI,* 1861–63, 4-part series, vols. 18–19).

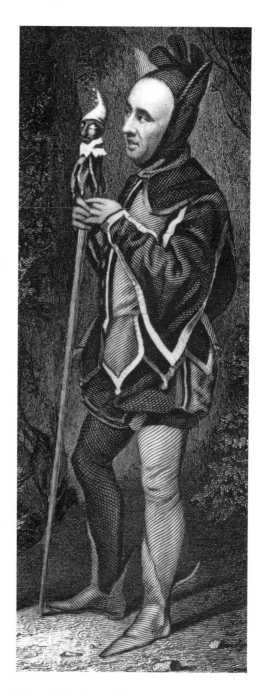

Fig. 2.43. "Touchstone" from *As You Like It,* in *The American Shakespeare* (New York, 1878).

This fool's socially degraded position and mental peculiarities make him an impartial judge who acts as a touchstone of the qualities of men.

Moral Insanity

A new diagnostic category that gained widespread use in the nineteenth century illustrates the widening scope of behaviors and ideas labeled as insane. Patients who behaved sanely most of the time but became irrational and obsessive on specific subjects, usually politics or religion, were called "monomaniacs." Because their insanity was related to only one topic, they were considered only partially insane. In 1835 the English physician James Prichard invented the term "moral insanity" to describe a form of monomania in which people recognized the difference between right and wrong yet lacked the will power to resist their evil impulses.

Political foes adopted monomania and moral insanity as weapons in their abolitionist battles. John Brown was viewed by his contemporaries as a rational man maddened by the existence of slavery. When Brown was brought to trial for one of his violent abolitionist acts, his attorney offered an insanity defense based on monomania. Meanwhile, some commentators in the popular press tried to undermine Abraham Lincoln's opposition to slavery by dismissing the president as "insane" (see pp. 81–82).

A fictional example of monomania is Herman Melville's portrayal of Captain Ahab in *Moby Dick* (1851). An otherwise intelligent sailor, Ahab went "crazy" and was overcome by "frantic morbidness" whenever he saw the white whale. Using Ishmael as his mouthpiece, the author revealed Ahab's obsession: "The White Whale swam before him as the monomaniac incarnation of all those malicious agencies which some deep men feel eating in them" (fig. 2.44).

Fig. 2.44. Ahab and Moby Dick, etching by I. W. Taber, in Herman Melville, *Moby Dick* (New York, 1899 edition). Department of Rare Books and Special Collections, Princeton University Libraries.

The Abolitionist as Madman

By the 1850s the debate over slavery had become increasingly acrimonious and violent. Moderates in both the North and South often blamed popular unrest on radical abolitionists whom they considered to be mentally unstable fanatics. The case of the white abolitionist John Brown brought the linking of insanity and political extremism to national prominence.

In 1859 Brown instigated an armed slave insurrection in Virginia. He planned to seize weapons from the federal armory at Harper's Ferry and to create a revolutionary army composed of black slaves and white abolitionists. On October 16, Brown led a small biracial band in an attack on the armory, which they held for less than two days before surrendering to a company led by Colonel Robert E. Lee. Brown and six of his men were captured; the rest died in the attack or escaped.

Although Brown insisted he was sane, many observers felt his actions were prima facie evidence of madness. For example, Amos Lawrence, a New England philanthropist, pleaded clemency for Brown with the governor of Virginia, Henry A. Wise, on the grounds that Brown was a monomaniac and totally deranged on the subject of slavery.

Radical abolitionists challenged the assertion that Brown was a madman, pointing out that those fighting injustice were often judged insane by the complacent and corrupt. In a speech entitled "The Lesson of the Hour," Boston abolitionist Wendell Phillips noted that many northerners shared Brown's anti-slavery convictions. "Call them madmen if you will," he concluded, but in a nation tainted by the sins of slavery, it was "[h]ard to tell who's mad" (reprinted in James Redpath, *Echoes of Harper's Ferry*, Boston, 1860, pp. 57–58).

Fig. 2.45. Thomas Hovenden, *Last Moments of John Brown*, 1884, oil on canvas, 77⅜ × 63¼ in. The Metropolitan Museum of Art, New York, gift of Mr. and Mrs. Carl Stoeckel, 1897 (97.5).

Brown himself refused to plead insanity to save his own life. Convicted of murder, treason, and conspiring with slaves, he was sentenced to death. In a desperate effort to save him, one of his lawyers, George Hoyt, collected legal affidavits from Brown's relatives and friends certifying that insanity ran in his mother's family, and that Brown himself

Fig. 2.46. "The Republican Party Going to the Right House," cartoon by Nathaniel, 1860, lithograph. Museum of American Political Life, University of Hartford, Connecticut.

Drawn during the presidential campaign of 1860, this cartoon shows Lincoln going not to the White House, but to the "right" house for an abolitionist—a lunatic asylum. He is followed there by his mad supporters: a suffragette, a free black, and a drunken Irishman.

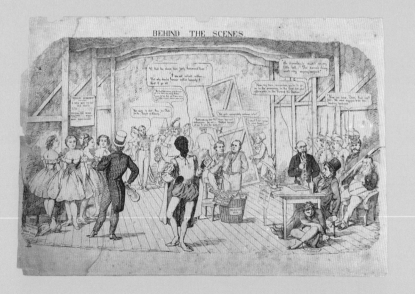

Fig. 2.47. "Behind the Scenes," cartoon by Adalbert Volck, ca. 1860, engraving. Museum of American Political Life, University of Hartford, Connecticut.

In this rare Confederate cartoon, President Lincoln prepares to go on stage as a black Othello, "the mad Moor."

had shown signs of mental disease. A brother-in-law testified that his pursuit of "wild and desperate projects" was evidence of "an unsound mind" (affidavits for insanity plea, John Brown Papers, Library of Congress).

Hoyt and leaders of the Republican Party hoped that the madness plea, besides saving Brown's life, would calm the fears of southerners. If Brown's acts were viewed as the result of insanity, rather than his abolitionist convictions, the South might be less likely to secede from the Union. Acceptance of the insanity plea also might discredit Brown and minimize the abolitionists' efforts to make him a martyr. Governor Wise drew up orders for Brown to be examined by the superintendent of the state lunatic asylum but then countermanded them. Ultimately Wise ruled that Brown was sane, and his execution was carried out on December 2, 1859.

John Brown went to his death composed and confident. In a letter to a well-wisher, written a few days before his execution, he observed: "I may be very insane . . . but if that be so, insanity is like a very pleasant dream to me. I am not in the least degree conscious of my ravings, of my fears, or of any terrible visions whatever; but fancy myself entirely composed, and that my sleep, in particular, is as sweet as that of a healthy, joyous little infant" (*Life and Letters of John Brown*, ed. F. B. Sanborn, Boston, 1885, p. 609).

Compared with John Brown, Abraham Lincoln was a conservative on the subject of slavery. Lincoln did not believe in racial equality or immediate emancipation, but he did oppose further expansion of slavery into the western territories. Still, in the heat of the 1860 presidential election, which was dominated by the slavery debate, many southerners were convinced that Lincoln's election would result in at least partial emancipation. Thus they proclaimed Lincoln to be as "mad" on the subject as more radical abolitionists.

Phrenology

Moving beyond physiognomy's vague association of facial types with humoral dispositions, phrenology gained enormous influence in both medical circles and popular culture because it provided a direct causal link between brain anatomy and particular human behaviors. Phrenology claimed that the cerebral cortex is divided into discrete regions, each linked to a specific personality trait, emotion, perception, or form of reasoning. Ever since the late-seventeenth-century philosopher John Locke proposed that humans were born with a mental tabula rasa, or blank slate, epistemologists and physicians had debated the connection between sense perception and the structure of the brain. Does sensory experience of events over time create the mental category of time? Are infants born with an innate faculty that causes certain sensations to be perceived as temporal? In the late eighteenth century, the so-called Scottish common-sense school of philosophy argued persuasively that humans were born with an innate brain structure containing certain mental faculties, such as language and reasoning, which were gradually developed through experience and education, much as muscles are strengthened through exercise.

The anatomical investigations of the Austrian physician Franz Joseph Gall (1758–1828) confirmed the common-sense school theory by mapping the location of different mental faculties in specific regions of the cerebral cortex. The emotional regions included propensities to be loving as well as destructive, and the sentiments of self-esteem and hope. The perception of time, language learning, and the reflective comprehension of causality resided in the intellectual region. Gall's student Johann Casper Spurzheim (1776–1832) expanded the therapeutic possibilities of the theory, for which he invented the term "phrenology," derived from the Greek word for mind. He stressed that repeated exercise of a mental faculty, such as self-esteem or language, could alter the size and strength of the corresponding areas of the brain, not only improving human character and intellect but literally changing the shape of the skull. Although Gall and Spurzheim were at pains to disassociate themselves from physiognomy, which they felt was unscientific, the popular practice of phrenology usually included visual analysis of the subject's facial features.

In America, phrenology was popularized by the brothers Orson S. and Lorenzo N. Fowler, and the writer George Combe.

Orson Fowler founded the publishing house of Fowler and Wells in New York; he became editor of the *American Phrenological Journal* in 1841. The Fowlers coedited the *Water-Cure Journal* and helped promote the work of Combe, author of several widely read books including *A System of Phrenology* (1834; fig. 2.48) and, for the art lover, *Phrenology Applied to Painting and Sculpture* (1855; see also fig. 2.49). The Fowlers produced phrenological busts as a diagnostic tool for physicians and as a prop for lay practitioners, who held public lectures followed by skull readings (figs. 2.50, 2.51). Many phrenological pamphlets were aimed at a general audience. With the *Self-Instructor in Phrenology,* for example, the user could chart his or her own skull dimensions and related character traits (fig. 2.52). One could even get phrenological advice on how to select a dog according to the shape of its skull (fig. 2.53).

Nineteenth-century American literature reflects the enormous influence of phrenology. Edgar Allan Poe expressed his enthusiasm for the topic in reviewing a phrenological publication: "Phrenology . . . has assumed the majesty of a science; and, as a science, ranks among the most important which can engage the attention of thinking beings" (review of L. Miles, *Phrenology,* 1835, in *Southern Literary Messenger,* 1835–36, vol. 2, p. 286). In "The Fall of the House of Usher," Poe used notions from physiognomy and phrenology to characterize Roderick Usher. According to George Combe, the physiognomy of the melancholic—"nervous temperament is indicated by fine thin hair, small muscles, thin skin, paleness of countenance, and brightness of eye" (*Lectures on Phrenology,* New York, 1839, p. 113)—and a large phrenological region of ideality (located near the temples) indicated fine intellectual, especially poetic, ability (*System of Phrenology,* pp. 303–306). Poe described Usher as having "a cadaverousness of complexion; an eye large, liquid, and luminous beyond comparison; lips somewhat thin and very pallid but of a surprisingly beautiful curve; a nose of a delicate Hebrew model, but with a breadth of nostril unusual in similar formations; a finely molded chin, speaking, in its want of prominence, of a want of moral energy; hair of a more than web-like softness and tenuity;—these features, with an inordinate expansion about the regions of the temples, made up altogether a countenance not easily to be forgotten" (fig. 2.54).

Herman Melville was more skeptical of popular science, yet in *Moby Dick* his writing reflects a familiarity with both phrenology and physiognomy, which he often used for comic effect, as

Fig. 2.48. "Names of the Phrenological Organs," frontispiece in George Combe,
A System of Phrenology (Boston, 1834).

Fig. 2.49. Rembrandt Peale, *Washington before Yorktown*, 1824–25, oil on canvas, 139 × 121 in. Corcoran Gallery of Art, Washington, D.C., gift of the Mount Vernon Ladies' Association.

During a trip to America in 1839–40, phrenologist George Combe visited Rembrandt Peale's studio and viewed the artist's portrait of George Washington. He later analyzed the first president's skull:

> The picture appeared to me to possess much merit as a work of art; and the likeness has been pronounced to be faithful. Washington's head as here delineated, is obviously large; and the anterior lobe of the brain is large in all directions; the organ of Benevolence is seen to rise, but there the moral organs disappear under his hair. The temperament is bilious-sanguine; the action of the muscles of the mouth strongly express Secretiveness and Firmness, and the eyes bespeak these qualities combined with Cautiousness. The general expression of the countenance is that of sagacity, prudence and determination. (*Notes on the United States of America during a Phrenological Visit*, Edinburgh, 1841, p. 339)

Fig. 2.50. Phrenological head, by L. N. Fowler, mid-19th century, porcelain, 11 in. high. Courtesy Mrs. Eric T. Carlson.

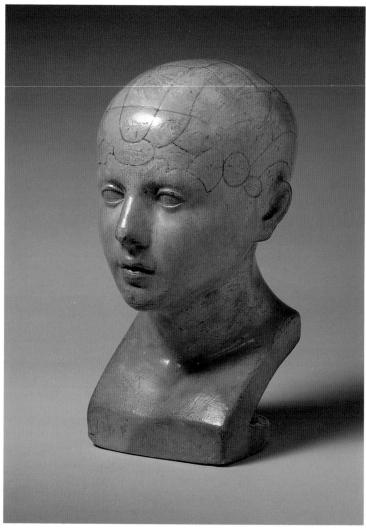

Fig. 2.51. Phrenological head, ca. 1900, earthenware, 13⅛ in. high. Courtesy Mrs. Eric T. Carlson.

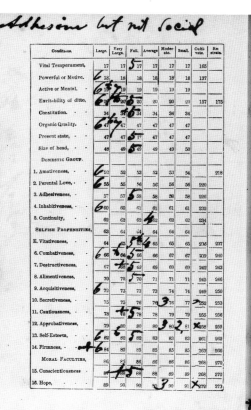

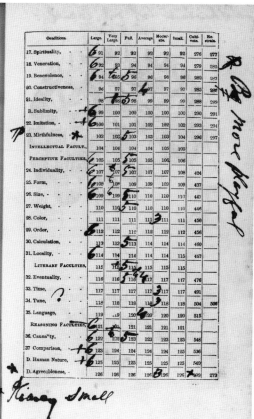

Fig. 2.52. Phrenological chart, in O. S. Fowler and L. N. Fowler, *Self-Instructor in Phrenology* (New York, 1857). The Oskar Diethelm Library, History of Psychiatry Section, Department of Psychiatry, Cornell University Medical College and The New York Hospital, New York.

In a spirit of self-improvement, members of the general public went to phrenologists for skull readings. Participants paid a small sum for a pamphlet such as this in which to record and interpret their skull dimensions.

Domestic (or Improved) Dog, with Benevolence, &c

Wild Dog or Wolf—no Benevolence, &c.

Fig. 2.53. Comparison of canine skulls, in F. Coombs, *Popular Phrenology* (1841). Library of the College of Physicians of Philadelphia.

Dog lovers were advised to select a pet with a large region of benevolence, which is located at the top of the skull.

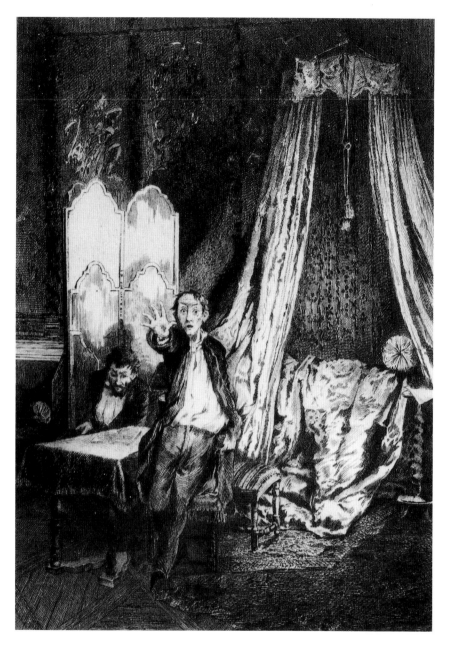

Fig. 2.54. Illustration in Edgar Allan Poe, "The Fall of the House of Usher"(1839), *Nouvelles Histoires Extraordinaires* (Paris, 1884).

Roderick Usher responds in disbelief at the sight of his sister, Madeleine, whom he had "put too early in her tomb." At this moment his "mind began its rapid descent."

in this analysis of the features and skull of the great white whale (here referred to as the leviathan):

> To scan the lines of his face, or feel the bumps on the head of this leviathan; this is a thing which no physiognomist or phrenologist has as yet undertaken. Such an enterprise would seem almost as hopeful as for Lavater to have scrutinized the wrinkles on the rock of Gibraltar. . . . Therefore, though I am but ill qualified for a pioneer, in the application of these two semi-sciences to the whale, I will do my endeavor. . . . In the great sperm whale, this high and mighty god-like dignity inherent in the brow is so immensely amplified, that gazing on it, in that full-front view, you feel the deity and the dread powers more forcibly than in beholding any other object living in nature. . . . In profile, you plainly perceive that horizontal, semi-crecentric depression in the forehead's middle, which, in man, is [a] mark of genius.

Walt Whitman had a phrenological analysis done by Lorenzo Fowler in 1849, when the poet was twenty-nine years old; Whitman was so proud of the flattering analysis that he had it reproduced in the second edition of *Leaves of Grass* (1859). After assigning numerical dimensions to regions of his subject's brain, along with a summary of corresponding character traits, Fowler expanded on the young poet's personality: "You can easily pass from one thing to another and you prefer short comprehensive speeches to long yarns. . . . You are no hypocrite but are plain spoken and are what you appear to be at all times." In *Leaves of Grass,* Whitman included these lines:

> Who are you indeed who would talk or sing to America?
> Have you studied out the land, its idioms and men?
> Have you learn'd the physiology, phrenology, politics,
> geography, pride, freedom, friendship of the land?

What is striking about these examples from the popular writings of Poe, Melville, and Whitman is that the authors felt confident that their readers knew enough about phrenology and physiognomy to understand their references. Such literary allusions, along with the frequent use of phrenology in cartoons and other popular contexts, suggest that its principles were widely known to nineteenth-century American audiences (figs. 2.55, 2.56).

Although asylum doctors distanced themselves from popular applications of phrenology, they were quick to appreciate the causal link phrenology provided between brain anatomy and behavior. The theory allowed a role for both heredity and experience in explanations of insanity: individuals were endowed at birth with a certain store of emotional and intellectual faculties,

Fig. 2.55. "A Symbolic Head," in Holmes W. Merton, *Descriptive Mentality* (Philadelphia, 1899). Ohio Historical Society, Columbus.

but they could increase the size of a specific brain region through mental exercise and education. Phrenology also provided physicians with an explanation for certain abnormal behaviors: excessive aggression was put down to a large region of destructiveness, incoherent speech was linked to a small region of language, the inability to understand cause and effect was attributed to a small region of causality, and so on. Amariah Brigham, superintendent of the New York State Lunatic Asylum, went so far as to commission a "phrenological hat"—a device that outlined the circumference of a patient's skull (fig. 2.57).

Social Causes of Insanity

Civilization

Nineteenth-century doctors repeatedly cited the pressure of civilization, specifically the stress of life in burgeoning American cities, as a social cause of madness. City life was thought to break the individual's bond with nature and to overtax a nervous system bombarded by jarring stimuli. In response to the relentlessly rational, competitive, conflict-ridden world of nineteenth-century capitalism, Americans sought to escape the city and to reconnect in nature with the more passionate, intuitive, primitive parts of the mind. Especially as negative aspects of the new nineteenth-century political and industrial order became manifest—growing poverty, urban pollution, class and racial conflicts—the middle class, wishing to throw off the constraints of society, developed a longing for nature and sought to transcend reason. This cluster of attitudes is at the core of romanticism, a literary, artistic, and philosophical movement that originated in the eighteenth century and dominated the arts and culture of the 1800s until mid-century.

Fig. 2.56. Phrenological head, by Asa Ames (attrib.), 1847–50, polychromed pine, 16⅜ × 13 × 7⅛ in. Museum of American Folk Art, New York, bequest of Jeanette Virgin.

Asa Ames (1824–1851), from the upstate New York town of Evans (near Buffalo), sculpted portraits with stark expressions and precise, linear patterns of hair and drapery in the American shipcarving tradition. Ames may have carved this phrenological bust of a girl for Dr. Harvey Martin, who, according to town legend, cared for Ames before his death from tuberculosis at age twenty-seven.

Fig. 2.57. Phrenological hat, mid-19th century. Archives of the New York State Lunatic Asylum, Utica, courtesy Mohawk Valley Psychiatric Center.

Superintendent Amariah Brigham commissioned a Parisian hatmaker to construct this device as an aid in phrenological diagnosis. Based on an adjustable hatmaker's mold, the "hat" conformed to the shape of a patient's head. The tiny prongs of a complex lever system beneath the lid outlined the circumference of the head onto tracing paper. Brigham regularly placed these tracings, along with his diagnoses, in the New York State Lunatic Asylum casebooks.

Fig. 2.58. Thomas Cole, *Niagara Falls,* 1830, oil on panel, 18⅞ × 23⅞ in. The Art
Institute of Chicago, Friends of the American Art Collection, 1946.396.

The questioning of religious authority during this era by both revivalists and secular humanists left many Americans in a state of spiritual confusion. For some, the deification of nature provided an alternative to the organized church. Nature came to be worshiped as sublime by romantic poets, as the source of grandeur by American landscape painters, and as the truth beyond reason of transcendental philosophers. American poet William Cullen Bryant (1794–1878) addressed the Almighty in "A Forest Hymn" (ca. 1821–25):

> Thou art in the soft winds
> That run along the summit of the trees
> In music: thou art in the cooler breath
> That from the inmost darkness of the place
> Comes, scarcely felt; the braky trunks, the grounds,
> The fresh moist ground, are all instinct with thee.
> Here is continual worship;—Nature, here,
> In the tranquility that thou dost love,
> Enjoys thy presence.

In 1836 landscape artist Thomas Cole (1801–1848) described Niagara Falls, which he had painted some years earlier (fig. 2.58):

> Niagara! That wonder of the world!—where the sublime and the beautiful are bound together in an indissoluble chain. In gazing on it we feel as if a great void had been filled in our minds—our conceptions expand—we become part of what we behold! . . . In its volume we conceive immensity; in its course, everlasting duration; in its impetuosity, uncontrollable power. ("Essay on American Scenery," 1836)

In his seminal essay "Nature" (1836), Ralph Waldo Emerson (1803–1882) described a moment in the woods as a religious experience:

> Standing on the bare ground,—my head bathed by the blithe air, and uplifted into infinite space,—all means of egotism vanishes. . . . I am nothing. I see all. The currents of the Universal Being circulate through me; I am part and parcel of God.

The word "romanticism" is not literary in origin, as is often claimed, but was first introduced in connection with English-style informal gardens designed in reaction to the geometric regularity and strict decorative rules of French landscaping. The English garden evolved with an irregular, picturesque, "unplanned" appearance, in which man was free to relate to nature spontaneously, a viewpoint reflected in the romantic landscapes of English painters John Constable (1776–1837) and J. M. W. Turner (1775–1851).

The concept of the therapeutic landscape guided early asylum design. Nineteenth-century physicians believed that the transition from rural to urban life exacerbated mental distress, and in the new asylum they tried to counter the effects of such adversity by incorporating the curative aspects of nature into moral treatment. Designers of American asylums adopted the English style in landscaping their hospitals (fig. 2.59). Thomas Kirkbride described the therapeutic value of such extensive, informal pleasure gardens in his annual report for 1842:

> It should never be forgotten, that every object of interest that is placed in or about a hospital for the insane, that even every tree that buds, or every flower that blooms, may contribute in its small measure to excite a new train of thought, and perhaps be the first step towards bringing back to reason, the morbid wanderings of the disordered mind. (p. 47)

Kirkbride also tried to strengthen his patients' bonds with nature by showing them lantern slides of landscape scenes during the asylum's evening entertainments (figs. 2.60, 2.61). Isaac Ray, superintendent of Butler Hospital for the Insane in Providence, Rhode Island, described the beneficial effects of landscape in 1846:

> Grounds thus arranged are capable, if anything in nature is, of arresting the attention of the violent and excited, diverting the melancholic from their distressing fantasies, furnishing inexhaustible occupation and delight to the convalescent, and touching, in all, even the least cultivated and refined, that strong feeling of sympathy with nature, which often survives the wreck of all other feelings. ("Observations on . . . Insane Hospitals," *AJI*, 1846, vol. 2, p. 312)

A similar attitude toward nature prompted the planning of large urban parks to combat the stress of life in mid-nineteenth-century American cities. The country's leading landscape architect, Frederick Law Olmsted (1822–1903), who together with Calvert Vaux designed New York's Central Park in the late 1850s, extolled nature's therapeutic effects: "The enjoyment of scenery employs the mind without fatigue and yet exercises it, tranquilizes it and yet enlivens it and thus, through the influence of the mind over the body, gives the effect of refreshing rest and reinvigoration to the whole system" (*The Papers of Frederick Law Olmsted*, ed. Victoria Post Ranney, Baltimore, 1990, vol. 5, p. 504). Besides public parks, Olmsted's distinguished career included several commissions for asylum grounds: the Connecticut Retreat for the Insane, Hartford (1860), which was featured in an 1870 book

Fig. 2.59. Plan for the grounds and gardens of Pennsylvania Hospital for the
Insane, ca. 1860, lithograph. Archives of Pennsylvania Hospital, Philadelphia.

The superintendent of the Pennsylvania Hospital for the Insane, Thomas
Kirkbride, was the acknowledged American authority on asylum design.
His linear layout for the building, which in this plan is shown surrounded
by informal gardens, was widely copied in asylum construction during the
mid-nineteenth century.

Fig. 2.60. *Niagara Series—Winter under the Banks,* ca. 1875, American Photo-Relief Publishing Company, Philadelphia. Atwater Kent Museum, Philadelphia.

Fig. 2.61. *Mt. Watkins, Yosemite, California,* ca. 1874, M. M. Hazeltine (attrib.), Kilburn Brothers, Littleton, New Hampshire. Atwater Kent Museum, Philadelphia.

On a typical evening in an asylum practicing moral treatment, patients were invited to view lantern slides of landscape photography. Produced on glass plates, the images were projected onto a wall using a lantern, a precursor of modern slide projection, which reportedly delighted its audiences.

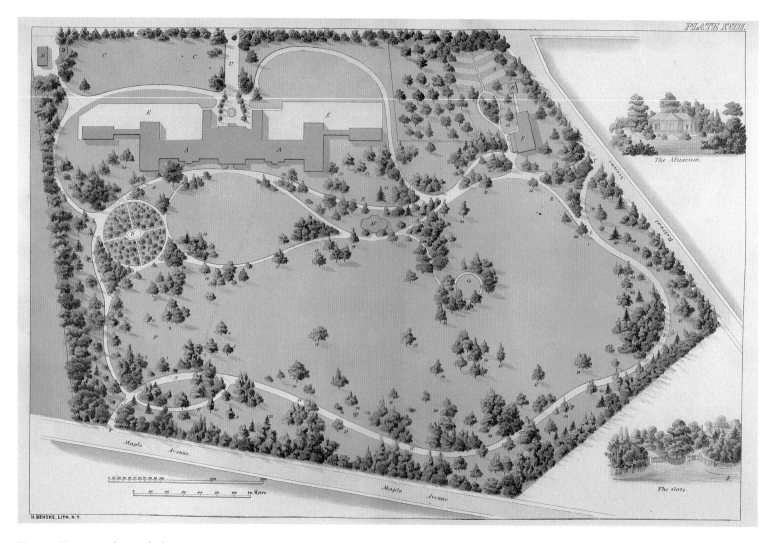

Fig. 2.62. *"Retreat Park, Hartford, Connecticut,"* in Jacob Weidenmann,
Beautifying Country Homes: A Handbook of Landscape Gardening (New York,
1870), pl. 18. Olin Library, Cornell University.

Remarks by John S. Butler, superintendent of Hartford Retreat, accom-
pany this illustration of Frederick Law Olmstead's landscape design:

> As the genius of the sculptor brings out the graceful statue from the
> shapeless block, so here has the same artistic power produced from the
> small meadow a combination of beautiful effects, whose existence was
> unknown, and of which we may well be proud. The drive which gives
> the public an opportunity of observing these pleasant changes with-
> out exposing ourselves to interruption or intrusion, is exerting a happy
> influence abroad, in making it evident that the externals of a lunatic
> asylum need not be repulsive, and may lead to reflection that its inner
> life is not without its cheerful, home-like aspects.

Fig. 2.63. Thomas Cole, *The Course of Empire: Desolation,* 1836, oil on canvas, 39¼ × 63¼ in. The New-York Historical Society.

on Victorian gardens (fig. 2.62); the Bloomingdale Asylum, New York City and White Plains, New York (1860–61, 1894); Hudson River State Hospital, near Poughkeepsie (late 1860s); and the Buffalo State Hospital, New York (early 1870s).

At certain extremes of romanticism—especially in the visual and performing arts—communing with nature loses its spiritual and therapeutic overtones and assumes a decidedly destructive edge. A longing to annihilate civilization seems to seethe just below the surface, especially in French romanticism, which developed during the long period of relative peace between Waterloo and the First World War, but less in American romanticism, which was interrupted by the real destruction of the Civil War. In painting, this menacing attitude toward civilization, especially the city itself, is signaled by the presence of ruins in certain American landscapes. A dramatic example is Thomas Cole's "The Course of Empire," a series of five monumental paintings that ends with *Desolation* (1836), in which crumbling buildings are not charmingly picturesque, but ominous and threatening (fig. 2.63).

Creativity and Madness

Paralleling this nihilistic attitude toward civilization, in certain quarters a destructive attitude toward rationality itself emerged. One sees this trend in the romantic notions of the "sublime" and the "mad genius" which began to emerge in the eighteenth cen-

tury during the height of severe rationalism. Certain English authors, such as Edmund Burke, advocated a new sensibility based in intuition, and a new sublime art that would overwhelm reason and "fill the spirit with an agreeable horror" (*A Philosophical Enquiry into the Origins of Our Ideas of the Sublime and Beautiful,* London, 1756). British author Frances Reynolds, sister of painter Joshua Reynolds, defined the sublime as the "pinnacle of beatitude, boarding on horror, deformity, madness! an eminence from whence the mind, that dares to look forward, is lost!" (*Enquiry Concerning the Principles of Taste and the Origin of Our Ideas of Beauty,* London, 1785). By the early nineteenth century in England and America, the transition from an aesthetic position of rigid materialism to a mystical communion with nature, tinged with visions, magic, and other irrational impulses, is represented by romantic personalities such as Edgar Allan Poe. In the fictional voice of the narrator of the 1842 short story "Eleonora," Poe described the importance of exalted moods verging on madness for those seeking insight into irrational realms, where the "light ineffable" burns.

> I am come of a race noted for vigor of fancy and ardor of passion. Men have called me mad; but the question is not yet settled, whether madness is or is not the loftiest intelligence—whether much that is glorious—whether all that is profound—does not spring from disease of thought—from moods of mind exalted at the expense of the general intellect. They who dream by day are cognizant of many things which escape those who dream only by night. In their grey visions they obtain glimpses of eternity. . . . They penetrate, however rudderless or compassless, into the vast ocean of the "light ineffable."

Despite the predominantly rationalistic approach of asylum medicine, many doctors viewed their patients' creativity through this romanticizing prism. Pliny Earle, superintendent of Bloomingdale Asylum, wrote in "The Poetry of Insanity": "It is well known that insanity not infrequently develops, or gives greater activity to powers and faculties of the mind, which, prior to its invasion, had remained either dormant or but slightly manifested. . . . Wonderfully exemplified as is the power of imagination in the annals of poetry, it is no less so in the records of insanity" (*AJI,* 1844–45, vol. 1, pp. 197, 208). This article, published in the first volume of the *American Journal of Insanity,* was part of an ongoing discussion of patient writing and artwork, especially their therapeutic uses. Creative writing by patients was commonly published, and the New York State Lunatic Asylum,

Fig. 2.64. *The Opal,* published by the patients of the New York State Lunatic Asylum, July 1859. The Oskar Diethelm Library, History of Psychiatry Section, Department of Psychiatry, Cornell University Medical College and The New York Hospital, New York.

Fig. 2.65. Diversions and handicrafts made by patients at Pennsylvania Hospital for the Insane, mid-19th century. Archives of Pennsylvania Hospital, Philadelphia.

Utica, even produced a patient-edited literary journal, *The Opal,* in the 1850s (figs. 2.64, 2.65). Physicians strongly encouraged patient writing because they felt this creative output was a vestige of the patient's humanity. As Earle described it: "In the bosom of the maniac, still burns the beacon-fire that lights him onward to his home in heaven, bright as the flaming pillar, which through Egyptian darkness, led Israel's children to the promised land" (p. 194).

Asylum doctors and lay phrenologists also expressed their opinions of the psychological peculiarities of creative artists. For example, the *American Journal of Insanity* published several articles on the psychology of genius (e.g., A. Brigham, "Insanity Illustrated by Histories of Distinguished Men and by the Writings of Poets and Novelists," 1844–45, vol. 1), and phrenological studies of artists and writers commonly appeared in professional journals (fig. 2.66). Edgar Allan Poe himself described his working habits in terms that associated his most creative moments with periods of mania:

> I am excessively slothful, and wonderfully industrious—by fits. There are epochs when any kind of mental exercise is torture, and when nothing yields me pleasure but solitary communion with the "mountains & the woods"—the "altars" of Byron. I have thus rambled and dreamed away whole months, and awake, at last, to a sort of mania for composition. Then I scribble all day, and read all night, so long as the disease endures. (letter to James Russell Lowell, June 2, 1844)

Today there is powerful evidence that the link between certain mental disorders and artistic achievement is real. Many recent studies by psychiatrists and neurologists have shown that professional artists suffer disproportionately high rates of mood disorders, especially manic depression and severe depression.

The writing and artwork of mentally ill patients continue to be of interest to psychiatrists, especially in diagnosis and what is today called art therapy. Recent attempts to present examples of the so-called art of the insane in art museums and publications have, however, only underlined their novelty value in the art world. Lasting artistic productions result from the interaction of irrational impulses with rational, historically conscious style, not blind emotion alone.

Fig. 2.66. Edgar Allan Poe, illustration accompanying an anonymous analysis, *Phrenological Journal* (March 1850).

> His phrenological development, combined with the fiery intensity of his temperament, serve to explain many of the eccentricities of this remarkable man. . . . He inherited in sublimated embodiment all of organization that his mother possessed, together with all that unearthly intensity and ethereality which her profession as an actress awakened. . . . He was from the very nature of his organization a wandering star, which could be confined to no orbit and limited to no constellation in the sphere of the mind. (pp. 87–89)

Fig. 2.67. Illustration of skulls, in J. C. Spurzheim, *Phrenology, in Connection with the Study of Physiognomy* (Boston, 1836), pl. 13. General Research Division, The New York Public Library, Astor, Lenox, and Tilden Foundations.

The author, a physician associated with the Royal College of Physicians in London, described these skulls: 1) a "cannibal of Brasil" with a very low frontal region; 2) a member of the "savage tribe of Wabash in North America," whose "forehead, strictly speaking, is very small"; 3) a "Hindoo" skull; and 4) an ancient Greek, "certainly a nation, the greatest number of whose inhabitants were endowed with such a cerebral organization [that it] would excel in many ways, and become the model for other nations to imitate" (p. 122).

Freedom

A desire to recapture the uncivilized, natural dimensions of the human spirit—those attributes stunted by an overly rational, industrial society—precipitated the romantic attraction to primitive cultures and far-off lands. American landscape paintings that include Indians as "noble savages" are prime examples of this phenomenon (see fig. 2.58). Whites, who believed themselves to have greater intellects than savages, longed in vain to merge with nature; their "superior" minds, paradoxically, would deny them full understanding of the exotic wilderness. This conflict was the inevitable result of a model of society and brain anatomy based on simplistic oppositions—civilization/wilderness, citizen/savage, intellect/passion, male/female—a paradigm that appeared throughout cultural productions and medical literature of the time. For example, romantic landscape paintings were typically done from a distant, elevated perspective, from which the viewer could never enter the faraway wilderness.

In medical and popular literature, comparative brain anatomy invariably presented intellectual faculties as being in inverse proportion to animal drives; Caucasians were dominated by intellect, savages by passion (fig. 2.67). Economic and political motivations for annihilating Indians and enslaving Africans are not enough to explain the extremely brutal suppression and segregation of these groups, or the lack of resolve among white reformers to combat acknowledged oppressions. Psychologically, nonwhites came to represent for many nineteenth-century Americans the repressed primitive regions of the mind—their withered passions—which were antithetical to Western civilization. The yearning of whites to attain the spirit of the noble savage, by definition, could not be satisfied; many Anglo-Americans instead developed a mixture of arrogant superiority and jealous loathing.

Reflecting racial attitudes found throughout nineteenth-century American society, practitioners of asylum medicine repeatedly claimed that political freedom caused insanity in primitive peoples. Many asylum doctors, who associated civilization with higher intellect, argued that savages could not become free citizens of a democratic society without becoming deranged. It followed, then, that society should guard against unleashing these irrational forces—in the case of African Americans, by the institution of slavery, and for Native Americans, by confinement to reservations.

The 1840 Census

In 1840 the United States government, alarmed by the growing number of destitute and disabled citizens needing public assistance, began to record the number of Americans with physical and mental infirmities, including insanity. The census, conducted by the office of the Secretary of State, John Calhoun, revealed a strange fact: there were almost no insane slaves in the South, but as one moved north, the rate of insanity among free blacks increased dramatically. Pro-slavery advocates seized upon this data to argue that emancipation would harm African Americans and American society. According to Calhoun, an ardent defender of slavery from South Carolina: "The data on insanity revealed in this census is unimpeachable. From it our nation must conclude that the abolition of slavery would be to the African a curse instead of a blessing" (letter to J. W. Jones, Speaker of the House, Feb. 8, 1845).

Although physicians were as divided over abolition as the rest of the country, Calhoun could certainly find medical confirmation of his opinions. Samuel A. Cartwright, a professor of medicine specializing in "diseases of the Negro" at the University of Louisiana (now Tulane University), argued that slavery was justified on both anatomical and biblical authority. In 1851 the Medical Association of Louisiana commissioned Cartwright to prepare a report on African Americans, in which he stressed what he termed "the great primary truth, that the Negro is a slave by nature, and can never be happy, industrious, moral or religious, in any other condition than the one he was intended to fill." Cartwright went on to claim that several forms of mental illness were peculiar to blacks, including an obsessive desire for freedom—a "flight-from-home madness"—for which Cartwright invented the

Fig. 2.68. James McCune Smith, 19th century photograph. Photographs and Prints Division, Schomberg Center for Research in Black Culture, The New York Public Library, Astor, Lenox, and Tilden Foundations.

Fig. 2.69. Frederick Douglass, frontispiece to
Frederick Douglass, *My Bondage and My Freedom*
(New York, 1855). General Research Division, The
New York Public Library, Astor, Lenox, and Tilden
Foundations.

term "drapetomania," from the Latin *drapeta*, meaning fugitive. According to Cartwright, any slave who attempted to run away more than twice was insane ("Report on the Diseases and Physical Peculiarities of the Negro," *The New Orleans Medical and Surgical Journal*, 1851, vol. 7, pp. 707–708).

Two northern physicians, Edward Jarvis of Massachusetts and James McCune Smith of New York, challenged the accuracy of the 1840 census. They pointed out that eight towns in Maine were listed as having both all-white populations and twenty-seven free black residents, all of whom were counted as insane. The census also recorded 133 insane black patients at the all-white Massachusetts State Lunatic Hospital in Worcester (Jarvis, "Statistics of Insanity in the United States," *Boston Medical and Surgical Journal*, 1842, and Smith, "Memorial to the United States Senate," 1844).

By 1844 evidence of fraud had become so embarrassing that John Quincy Adams, then a member of the House of Representatives, chaired a congressional investigation of the census results. In a gesture remarkable for either its cynicism or naiveté, Adams charged Calhoun's staff with the responsibility of carrying out the investigation; not surprisingly, they confirmed their original findings. Despite the protests of Jarvis, Smith, and many others in the medical community, the bogus figures remained the official tally of the 1840 census and perpetuated false insanity rates for free blacks for decades to come. In 1851, for example, the *American Journal of Insanity* published an article whose author relied on the spurious data to decry: "Who would believe it without the facts in black and white, before

his eyes, that every fourteenth colored person in the state of Maine is either an idiot, or lunatic?" ("Startling Facts from the Census," *AJI*, 1851, vol. 3, p. 154).

James McCune Smith led the challenge against the 1840 census findings and summarized the fraudulent data in his "Memorial to the United States Senate" of 1844. The son of a New York merchant and a runaway slave, Smith attended the African Free School until he was eighteen years old. Barred from entering an American university because he was black, Smith sailed to Scotland and enrolled at the prestigious University of Glasgow, where he received B.A. and M.D. degrees, and then returned to New York to practice medicine. In a letter to the editor of the *New York Tribune*, Smith wrote about the 1840 census: "Freedom has not made us 'mad.' It has strengthened our minds by throwing us upon our own resources."

The black abolitionist Frederick Douglass (1818–1895) offered a slave's perspective on the psychological impact of bondage and freedom in his autobiography. He described being beaten by his cruel owner, Covey:

> I was broken in body, soul and spirit. My natural elasticity was crushed, my intellect languished, the disposition to read departed, the cheerful spark that lingered about my eye died, the dark night of slavery closed in upon me; and behold a man transformed into a brute! . . . I was sometimes prompted to take my life, and that of Covey, but was prevented by a combination of hope and fear. (*My Bondage and My Freedom*, New York, 1855, p. 219)

In striking contrast to the opinion of white politicians and physicians that freedom would overtax and damage the black brain, Douglass wrote a dramatic account of the exhilarating psychological impact of resistance and freedom. One day, when Covey picked up the whip to flog him, Douglass hit his master and the two men fought hand-to-hand.

> He only can understand the effect of this combat on my spirit, who has himself incurred something, hazarded something, in repelling the unjust and cruel aggressions of a tyrant. Covey was a tyrant, and a cowardly one, withall. After resisting him, I felt as I had never felt before. It was a resurrection from the dark and pestiferous tomb of slavery, to the heaven of comparative freedom. I was no longer a servile coward, trembling under the frown of a brother worm of the dust, but, my longcowed spirit was roused to an attitude of manly independence. I had reached the point at which I was not afraid to die. (p. 247)

After later escaping to the North, Douglass came to know many prominent abolitionists, including James McCune Smith, who would write the introduction to his autobiography. Fifteen years after he led the fight against the 1840 census, Smith expressed a deep optimism about American society: "The son of a self-emancipated bond-woman, I feel joy in introducing you to my brother, who has rent his own bonds. . . . It is an American book, for Americans, in the fullest sense of the idea. It shows that the worst of our institutions, in its worst aspect, cannot keep down the energy, truthfulness, and earnest struggle for the right" (p. xxxi).

The Trail of Tears

The idea that freedom causes insanity among primitive people led to the corollary that as long as primitive people were "protected" from civilization—either in slavery or on a reservation—they were immune to insanity.

In 1845 the editor of the *American Journal of Insanity* described "the exemption of Cherokee Indians and Africans from insanity": "Dr. Lillybridge, of Virginia, who was employed by the government as the medical officer to superintend the removal of the Cherokee Indians, in 1827–8 and 9, and who saw more than twenty thousand Indians, and much inquired about their diseases, informs us he never saw or heard of a case of insanity among them" (Amariah Brigham, vol. 1, pp. 287–88). The "removal" of the tribe from the Gulf States to Oklahoma occurred along the infamous "Trail of Tears," the winter route along which four thousand Cherokee died.

Phrenologist George Combe provided an anatomical rationalization for relocating Indians from tribal lands without fear of mental distress: "*Concentrativeness:* Observation proves that this is a distinct organ [of the brain which] . . . is large in those animals and persons who are extremely attached to their country, while others are readily induced to migrate. Some tribes of American Indians and Tartars wander without fixed habitation" (*A System of Phrenology*, 5th ed., Edinburgh, 1843, p. 211; fig. 2.70).

Fig. 2.70. "Concentrativeness," in George Combe, *A System of Phrenology*, 5th ed., Edinburgh, 1843. National Library of Medicine, Bethesda.

This illustration compares the large region of "concentrativeness" in the skull of a European, Scottish poet Robert Burns, with the "small concentrativeness" of an unidentified Indian, who was thus "induced to wander."

Passion

As urbanization and industrialization transformed the traditional family economy of white rural America, early nineteenth-century men and women took on unaccustomed roles. Among the business and professional classes, men went out to work while their wives remained at home. A new cult of domesticity emphasized a woman's responsibility for the emotional and moral nurturance of her husband and children. Middle-class male/female relationships came to be defined within the framework of romantic love, in which the heroic male strove to conquer business and professional foes, while the queen of his heart remained in his castle. In contrast, among the working classes, whole families entered factories or turned their homes into sweatshops; thus for working-class women, economic survival rather than domesticity or romance dictated their roles as wives and mothers.

Religious and scientific authorities sought to uphold the new middle-class family by portraying its structure as biblically and biologically preordained. A carefully ordered family life was seen as the social ballast needed to stabilize the greater political and social fluidity of democratic society. The increased attention given to equality among white men stood in sharp contrast to the heightened paternalism toward women. Both sexes were taught that God had decreed men's hegemony over women, and that transgressions of appropriate gender roles would lead to physical and mental illness.

Physicians followed these definitions of gender roles in ascribing different causes for mental illness in male and female patients (fig. 2.71). Men's illnesses were thought more likely to be brought on by intemperance, prolonged study, intense application to business, or sexual indulgence (masturbation), all dangers associated with the competitive, uncertain world of mid-century capitalism (figs. 2.72, 2.73). A woman's mental illness was more typically attributed to domestic difficulties, the physical stresses of childbirth and nursing, intense emotions (fright, grief, nostalgia), uncontrolled passion, or even tight lacing of her corset (figs. 2.74, 2.75).

Uncontrolled passion as a cause of insanity had a supposedly higher incidence in female patients. Its diagnosis mirrored prevailing gender roles in several ways. Victorian women were often portrayed as the passive objects of aggressive male sexual desire; many medical authorities described excessive passion in a woman

TABLE VIII.—*Showing the supposed causes of insanity in 2207 cases.*

	M.	F.	T.		M.	F.	T.
Ill health of various kinds	183	166	349	Nostalgia	—	3	3
Intemperance	135	12	147	Stock speculations	2	—	2
Loss of property	69	23	92	Want of employment	25	2	27
Dread of poverty	2	—	2	Mortified pride	2	1	3
Disappointed affections	17	20	37	Celibacy	1	—	1
				Anxiety for wealth	1	—	1
Intense study	21	5	26	Use of opium	3	5	8
Domestic difficulties	16	45	61	Use of tobacco	5	—	5
Fright	10	17	27	Puerperal state	—	85	85
Grief, loss of friends, &c.	35	68	103	Lactation, too long continued	—	3	3
Intense application to business	17	—	17	Uncontrolled passion	4	7	11
				Tight lacing	—	1	1
Religious excitement	44	38	82	Injuries of the head	17	3	20
Political excitement	5	—	5	Masturbation	20	—	20
Metaphysical speculations	1	—	1	Mental anxiety	56	59	115
				Exposure to cold	3	1	4
Want of exercise	5	2	7	Exposure to direct rays of the sun	18	—	18
Engagement in a duel	1	—	1	Exposure to intense heat	—	1	1
Disappointed expectations	4	5	9	Unascertained	490	423	913

Fig. 2.71. Table showing supposed causes of insanity by sex, in *Report of the Pennsylvania Hospital for the Insane* (Philadelphia, 1853). Archives of Pennsylvania Hospital, Philadelphia.

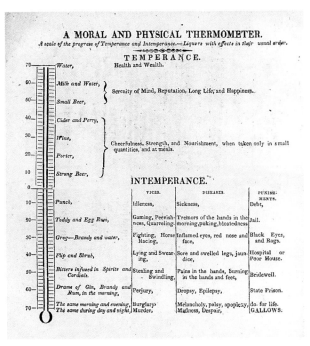

Fig. 2.72. "A Moral and Physical Thermometer," in Benjamin Rush, *An Inquiry into the Effects of Ardent Spirits upon the Human Body and Mind* (Exeter, 1819). The Oskar Diethelm Library, History of Psychiatry Section, Department of Psychiatry, Cornell University Medical College and The New York Hospital, New York.

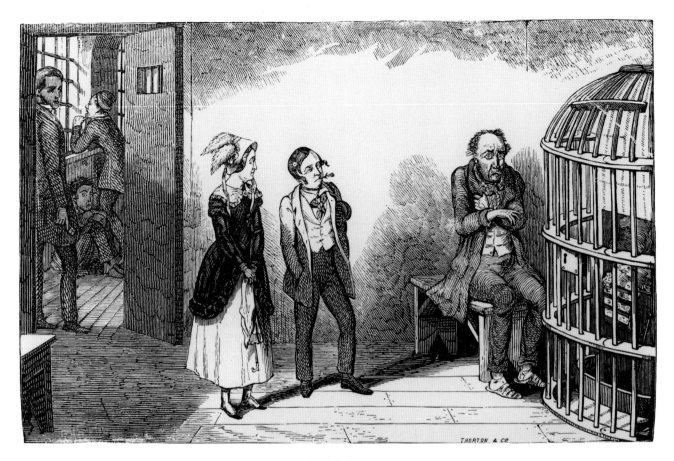

Fig. 2.73. "The bottle has done its work with the Latimers; it . . . has left the father a hopeless maniac," in T. S. Arthur, *Six Nights with the Washingtonians* (Philadelphia, 1871). The Oskar Diethelm Library, History of Psychiatry Section, Department of Psychiatry, Cornell University Medical College and The New York Hospital, New York.

The temperance movement developed as a nonmedical way to confront alcohol abuse. It produced popular novels such as *Six Nights with the Washingtonians,* which warned against overindulgence with images such as this.

Fig. 2.74. "Remarks on Tight Lacing," in L. N. Fowler, *The Principles of Phrenology and Physiology Applied to Man's Social Relations* (New York, 1842). The Oskar Diethelm Library, History of Psychiatry Section, Department of Psychiatry, Cornell University Medical College and The New York Hospital, New York.

On the left is an outline of the Venus de Medici, according to L. N. Fowler a timeless beauty with a natural waist; on the right is "a modern exquisite, fashionable, tight-laced lady . . . an unnatural monstrosity" (p. 102).

Fig. 2.75. "The American and French Fashions Contrasted," in *The Water Cure Journal,* vol. 12, Oct. 1851, p. 91. New York Academy of Medicine Library.

Women's rights advocates, who linked the corset with social bondage, supported dress reform. Amelia Bloomer, editor of the temperance journal *Lily,* popularized the short skirt with pantaloons shown on the left. "Bloomers" were introduced at water cure establishments, where they could be worn in the company of other women.

Fig. 2.76. Illustration of a woman's body, showing her "region of insanity," in Joseph R. Buchanan, *Outlines of Lectures on the Neurological System of Anthropology* (Cincinnati, 1854). The Oskar Diethelm Library, History of Psychiatry Section, Department of Psychiatry, Cornell University Medical College and The New York Hospital, New York.

In this diagram, Buchanan identified a woman's "region of insanity" in the area of her reproductive organs, which he described as follows: "The selfish or evil propensities are located below the waist. . . . The organ of baseness lies along the posterior margin of the abdomen, and between the ribs and ilium, connecting above with irritability and below with melancholy, through which it approximates the region of mental derangement." In a jarring anachronism, the illustrator imposed his medical map on a lithograph of Praxiteles' Aphrodite of Knidos (ca. 350 B.C.).

No.2.

The Affectionate Female.
No. 3

Fig. 2.77. "The Affectionate Female," in O. S. Fowler, *Matrimony: or Phrenology and Physiology Applied to the Selection of Suitable Companions for Life* (New York, 1842). The New York Academy of Medicine Library.

In addition to the region of "amativeness," Fowler advised suitors to pay special attention to a woman's region of "domestic propensity" (the back of the skull).

as both physiologically and psychologically dangerous. An illustration in a mid-nineteenth-century medical text labels a woman's reproductive organs as her "region of insanity" (Joseph R. Buchanan, *Outlines of Lectures on the Neurological System of Anthropology*, Cincinnati, 1854; fig. 2.76). Another medical man traced one cause of insanity in women to the onset of puberty (M. S. Pallen, "Some Suggestions as Regard to the Insanities of Females," *American Journal of Obstetrics*, 1877, vol. 10). While stereotypes of Victorian society have popularized this image of the passionless woman, the historical reality was far more complex. Both medical authorities and popular writers continued to portray female sexual drives as normal. Phrenologist Orson Fowler insisted that "amativeness is created in the female head as well as in the male" (*Sexual Science*, 1870, p. 680), and he published a guidebook to help men find an "affectionate female" (*Matrimony: or Phrenology and Physiology Applied to the Selection of Suitable Companions for Life*, New York, 1842; fig. 2.77). Enough evidence of marital pleasuring exists in the private diaries and letters of middle-class couples to suggest that the advice of Fowler and others fell on receptive ears.

Still, female sexuality, particularly when unconstrained by the marital authority of the male, remained a source of anxiety in nineteenth-century society. A strong religious dimension colored the changing attitudes toward female sexuality. In earlier eras,

women—from Delilah to Lady Macbeth—often were seen as extremely passionate creatures, using their treacherous charms to wield extraordinary power over men. Nineteenth-century Protestantism relied on women to be moral exemplars and stressed female moral and spiritual endowments. Religious texts commonly suggested that Christianity had raised the status of women from mere sexual objects to a higher spiritual plane. Christian women were "exalted above human nature, raised to that of angels" (*The Female Friend, or the Duties of Christian Virgins*, Baltimore, 1809, pp. 40–42). The exaltation process, however, entailed an implicit disarmament of women's primitive, sexual power over men. Many women embraced a disinterested modesty for a gain in self-respect. Once that modesty was cast aside, female passion was described by both medical and religious authorities as a dangerous threat to a woman's mental health.

In the delineation of gender roles, women were thought to be governed more by sentiment and emotion than rational men, and to be more prone to emotional breakdown. Elihu Vedder's personification of madness as a beautiful, barefoot woman wandering in the wilderness captures this romantic ideal of the fragile female psyche (fig. 2.78). In the new middle-class family ideal, a woman was considered incomplete without her children and husband, on whom she was totally dependent; their loss could bring on uncontrollable grief and drive her insane. In popular

Fig. 2.78. Elihu Vedder, *The Lost Mind,* 1864–65, oil on canvas, 39⅛ × 23¼ in. The Metropolitan Museum of Art, New York, bequest of Helen L. Bullard, in memory of Laura Curtis Bullard, 1921 (21.132.1).

Fig. 2.79. Fitz Hugh Lane, sheet music cover for "The Mad Girl's Song," by Henry Russell, 1840. The Music Division, The New York Public Library for the Performing Arts, Astor, Lenox, and Tilden Foundations.

The lyrics tell of a young woman whose lover has died on a distant, snowy battlefield. Mad with grief, she sings a song to her new love, the North Wind, which carried away her lover's last breath. Now she only finds comfort in clutching the cold wind to her breast.

presentations of romantic love, the character of the love-crazed, self-sacrificing woman, who goes mad with grief without her man, played well to nineteenth-century audiences (fig. 2.79).

Masturbation

The conviction that masturbation caused insanity in men (many physicians assumed women did not indulge in the "secret vice") provides a striking example of the medical establishment's endorsement of a moral prohibition. In 1766 Swiss physician S. A. A. D. Tissot's *Onanism, A Study of the Illnesses Caused by Masturbation* was published in English. This study (named for Onan, who sinned by "spilling his seed," according to the biblical story in Genesis) promoted the idea that masturbation caused everything from adolescent acne to adult insanity. Benjamin Rush's dire pronouncement on the topic, published in 1812, was typical of views held by American asylum physicians throughout the century: "When indulged in an undue or a promiscuous intercourse with the female sex, or in onanism, [the sexual appetite] produces seminal weakness, impotence, dysury [difficulty in urination], tabes dorsalis [uncoordinated movement], pulmonary consumption, dyspepsia, dimness of sight, vertigo, epilepsy, hypochondriasis, loss of memory, manalgia [dementia], fatuity, and death" (*Medical Inquiries and Observations upon the Diseases of the Mind,* Philadelphia, 1812, p. 347).

Nineteenth-century medical case books and professional journals frequently cited masturbation as a cause of insanity. In a discussion of a young man who had experienced a general loss of muscle control, seizures, and periods of delirium, one physician concluded:

> I was at no loss to ascribe all the symptoms to the habit of masturbation. On requesting a private interview, I drew from the unfortunate young man a full confession, which completely confirmed my diagnosis. . . . This was the first moment in his life that he had thought of harm or danger in the indulgence! While conversing with him, he seemed convinced of the cause of his ill health, and expressed, with a sort of despairing madness, his resolution to "go and sin no more." In view of the imbecile and delirious state of his mind, I expressed to his father my opinion of the cause of his sickness, and advised his immediate removal to the lunatic hospital. (A. Hitchcock, "Insanity and Death from Masturbation," *Boston Medical and Surgical Journal,* 1842, pp. 285–86)

ALTERNATIVE MEDICINES AND SELF-HELP CURES

In the nineteenth century, "regular" medicine, as represented by professional organizations such as the American Medical Association (founded in 1846) and the Association of Medical Superintendents of American Institutions for the Insane, had many competitors. Various medical sects offered treatment to those anxious to avoid insane asylums run by conventional physicians. The Thomsonians, named after their founder, Samuel Thomson, and other "botanic" physicians prescribed only herbal remedies such as red pepper and lobelia. Homeopaths, who followed the doctrines of the German physician Samuel Hahnemann, used minute doses of drugs to restore the body to health. Sectarians had their own medical schools and journals; homeopaths even established a state insane asylum in Middletown, New York.

Health Food

The early leaders of the health food movement promised that dietary reform and healthful living could relieve a variety of nervous conditions. Sharing a faith in the healing power of nature, they promoted the consumption of "natural food" eaten in an unrefined, raw state. Evangelical Protestantism provided the theme of redemption through purification, which health food advocates interpreted literally as cleansing the body inside and out.

Sylvester Graham (1794–1851), a Presbyterian minister from New England, is considered the father of the American health food industry. Beginning in the 1830s, he advocated eating large amounts of unbolted wheat flour, made into "Graham crackers," and promoted chastity, because the loss of semen was debilitating and led to madness, even death. Samuel Woodward, the founding president of the American Psychiatric Association, wrote the introduction to a book in which Graham urged young men to abstain from masturbation. According to Woodward, "The evil of which [this book] treats . . . is more extensively sapping the foundation of physical vigor and moral purity, in the rising generation, than is generally apprehended even by those who are awake to the danger" (Introduction to Sylvester Graham, *A Lecture to Young Men on Chastity,* Boston, 1839).

After Graham's death, the health food movement in America was dominated by physician John Harvey Kellogg (1852–1943), who founded the Battle Creek Sanitarium in Michigan in 1876. He advocated eating natural foods, such as whole grain cereals, to attain a purified body. For example, he recommended cleansing the alimentary canal with a high-fiber diet and daily enemas. Kellogg opposed all sexual activity as unclean and, like his medical colleagues, especially warned against the harmful effects of masturbation on the nervous systems of young men: "In the insane asylums of the country may be seen hundreds of these poor victims in all stages of physical and mental demoralization" (J. H. Kellogg, *Plain Facts for Old and Young: Embracing the Natural History and Hygiene of Organic Life,* Burlington, Iowa, 1888, p. 236). Despite the professed asexuality of health food advocates such as Kellogg, some of their nineteenth-century advertisements sent, no doubt unconsciously, a strongly erotic message (fig. 2.80).

The Water Cure

Sufferers of milder forms of mental debility might turn to hydropathy or the "water cure." In the decades from 1840 to 1870 water-cure establishments, offering the nineteenth-century equivalent of spa treatment, sprang up all over the eastern United States (fig. 2.81). "Taking the cure" included drinking mineral-laden waters, bathing in water of different temperatures, inhaling steam, and applying cold or hot water compresses to various parts of the body. Once mastered, these same treatments could be duplicated at home.

The water cure was particularly popular among middle-class women. Hydropathic practitioners, many of whom were women, portrayed their methods as better suited to delicate female physiology than the harsh chemicals and bleedings practiced by regular physicians. Water-cure resorts allowed affluent women to escape oppressive domestic routines and to pamper their bodies in the company of other women.

By the late nineteenth century, health seekers began to patronize more recreationally oriented resorts in scenic areas such as the Catskills, in upstate New York, and the New Jersey seashore. But hydropathy, renamed "hydrotherapy," remained a popular form of treatment for nervous conditions, especially depression. No doubt responding to its continued appeal, many mental hospitals added hydrotherapy to their therapeutic regimen in the second half of the century (fig. 2.82).

Fig. 2.80. Kellogg's Corn Flakes advertisement, ca. 1880, chromolithograph. Bella C. Landauer Collection of Business and Advertising Art, The New-York Historical Society.

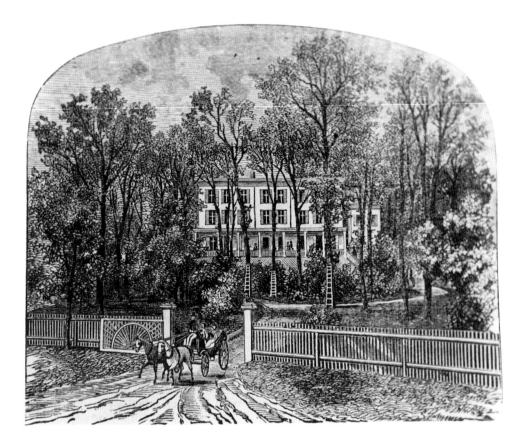

Fig. 2.81. "Binghamton Water Cure, New York," 19th century, advertisement. Broome County Historical Society.

Fig. 2.82. Continuous flow tubs, late 19th century. Archives of the State Homeopathic Asylum for the Insane, Middletown, New York, courtesy Middletown Psychiatric Center.

Patent Medicines

Herbal teas and tonics had long been part of the domestic medicine practiced by wives and mothers, who passed valued recipes from one generation to the next. But as American society became more affluent and sophisticated, home remedies were gradually overshadowed by a wide array of commercially manufactured patent medicines. American colonists began importing English patent medicines in the late seventeenth century. In the burst of cultural nationalism following the revolution, American-made elixirs soon rivaled the British brands. Innovative advertising and marketing techniques further expanded the market for patent medicines after the Civil War.

Until the passage of the first pure food and drug acts in the early 1900s, patent medicine makers were not obligated to guarantee the safety or efficacy of their remedies. Many of their fancifully named elixirs combined potentially addictive amounts of alcohol, opiates, and other chemical substances.

Patent medicines promised to relieve a long list of symptoms associated with nervousness and mental distress, such as sick headache, fatigue, heart palpitations, dyspepsia, and depression. General tonics and cordials supposedly worked by "purifying" the blood or relieving stomach irritation. Other remedies claimed to provide direct nourishment to the brain, in the form of "brain food," or to soothe an irritated or depleted nervous system. Still other compounds aimed at the female reproductive organs, popularly thought to be the cause of most mental disorders in women. Besides appealing to the many Americans suspicious of physicians, patent medicines were inexpensive and convenient. When most nineteenth-century Americans felt "low" or "blue," they first reached for a familiar patent medicine remedy (figs. 2.83–2.85).

Fig. 2.83. "Brain Salt," 19th-century, trade card. Bella C. Landauer Collection of Business and Advertising Art, The New-York Historical Society.

Fig. 2.84. "Cherokee Medicines and Rejuvenating Elixir," 19th century, trade card. Bella C. Landauer Collection of Business and Advertising Art, The New-York Historical Society.

Fig. 2.85. "Brown's Iron Bitters," 19th century, trade card, National Library of Medicine, Bethesda.

Popular belief held that Indian herbal remedies and healing practices were particularly effective against diseases peculiar to Americans. The "noble savage" motif also suggested that patent medicines promoted vigorous life, a quality sapped from white city dwellers by civilization.

Fig. 2.86. "Ebenezer Haskell Escaping . . ." in Ebenezer Haskell, *The Trial of Ebenezer Haskell* (Philadelphia, 1869). The Oskar Diethelm Library, History of Psychiatry Section, Department of Psychiatry, Cornell University Medical College and The New York Hospital, New York.

VIEWS OF MADNESS AT MID-CENTURY

In early nineteenth-century America, asylum reform had been undertaken with confidence in the power of reason and optimism about the future, sentiments which by mid-century were called into question. Throughout Europe and Anglo-America in the late nineteenth century, physicians treating mental illness began to rely on the theory of evolution, already well established in the life sciences, to develop principles of insanity which were pervaded with pessimism. Early American physicians had conceived of the human mind within the lucidity and clarity of the Newtonian paradigm, which was now replaced by a dynamic, organic universe governed by animal instincts for preservation and survival, and subject to an unsettling element of chance. Within decades, the cultural and medical scaffolding of nineteenth-century America was further dismantled by new ideas arriving from Europe—ideas about the hidden and irrational forces of the unconscious mind.

American Nervousness
1870 to 1914

SCIENTIFIC PSYCHIATRY

General medicine and surgery entered a new era of prestige in the second half of the nineteenth century. Researchers solved the mysteries of many diseases by systematically piecing together evidence from clinical observation, postmortem examinations, and laboratory investigations. In the 1880s and 1890s, the germ theory of disease, the most dramatic of these new developments, showed that different species of microorganisms entered the human body through the nose, mouth, and skin, and produced toxins that caused the characteristic symptoms of contagious diseases such as cholera and tuberculosis.

In the same spirit, researchers investigating mental illness compiled careful clinical observations about the insane, conducted detailed autopsies, and analyzed brain tissue and nerve cells under the microscope. Embracing the scientific method and the authority of the laboratory, they called themselves scientific psychiatrists to distinguish their approach from old asylum medicine. In Germany, the term "psychiatrist" had come into use in the mid-1800s; by the late nineteenth century, it had gained international acceptance, gradually replacing "asylum doctor" in America and "alienist" in England. But unlike other areas of medicine, the scientific psychiatry of the late nineteenth century, revealing neither the causes of insanity nor its cure, ushered in a period of deep pessimism about this ancient and elusive affliction.

The accumulation of vast amounts of data did, however, allow researchers to draw certain modest conclusions in the areas of diagnosis and neuroanatomy. In the mid-nineteenth century, German psychiatrists had begun a systematic effort to observe large numbers of patients over a long period of time, and had developed more detailed and sophisticated nosologies (diagnostic groupings) of mental disease. In 1883 Emil Kraepelin (1856–1926) systematized their results in a great work of descriptive psychology, *The Compendium of Psychiatry,* which would go through many editions. The 1896 revision laid out diagnostic categories that psychiatrists still use today. By following cases over time, Kraepelin and his compatriots recognized a syndrome, in which patients alternated between periods of mania and melancholia, which he called manic-depressive insanity. Kraepelin also included in his diagnostic scheme a disorder of young adults called dementia praecox (literally, premature dementia), characterized by hallucinations, bizarre behavior, and increasing withdrawal from society. In 1911 Swiss psychiatrist Eugene Bleuler renamed the illness schizophrenia (split mind).

Late nineteenth-century researchers also contributed to knowledge of the basic structure and functions of the brain and nervous system. Following the tradition of Austrian phrenologists Franz Joseph Gall and Johann Casper Spurzheim, investigators experimented with the electrical stimulation of animal brains to study the localization of functions such as speech and movement. Inspired by Paul Broca's 1861 discovery of the speech center in the brain, researchers such as Karl Wernicke (1848–1905) studied aphasia, the loss of the power to use or comprehend language, and hypothesized that other mental disturbances might

Fig. 3.1. Laboratory at McLean Hospital, Sommerville, Massachusetts, ca. 1905. Archives of McLean Hospital, Belmont, Massachusetts.

An experimental psychological laboratory was established in 1889 at McLean Hospital near Boston. The laboratory equipment included: a) a perimeter, which presented colored papers to a subject for identification, thus testing both vision and verbal skills; b) a Hipp's chronoscope, for measuring very small fractions of time; c) a model head; d) a metronome; e) a kymograph, for recording pressure variations, especially of blood; f) an ergograph, for recording the force of arm muscles; and g) a rheostat.

The white model head (detail) is not phrenological. Its face and neck bear a dot pattern that might indicate application points for electrodes used in electrical stimulation or brain recording.

someday be located in specific regions of the brain. It was in this scientific atmosphere that Sigmund Freud (1856–1939), as a young physician in Vienna, performed his early experiments in neurology, including research on aphasia. In 1895 Freud conceived a vast theoretical overview of the somatic basis of mental illness, a psychology for neurologists, in which he planned "to investigate what form the theory of mental functioning assumes if one introduces the quantitative point of view, a sort of economics of nerve forces" (letters from Freud to Wilhelm Fleiss, April 27 and May 25, 1895). In Russia, physiologist Ivan Pavlov (1849–1936) began his famous experiments on the creation and inhibition of reflexes.

This psychiatric research was conducted almost exclusively in Europe. Although a few older American asylum doctors, most notably John Gray at the New York State Lunatic Asylum at Utica, pursued anatomical researches, American psychiatry made virtually no original contributions to research in scientific psychiatry until the early 1890s, after hospitals began to establish sophisticated psychological laboratories (fig. 3.1). Still, American psychiatrists kept informed of developments in Europe and Britain in what had become a thoroughly international medical community.

Despite the new scientific tenor of psychiatry, the fundamental question of what causes insanity remained unanswered. For all the countless laboratory studies employing the latest scientific methods, psychiatric researchers remained unable to link the vast majority of mental illnesses to specific pathological changes in the brain or nervous system. This grim reality soon led the inquisitive young Freud to set aside his goal of giving a neurophysiological account of mental illness and to begin crafting a psychological account outside the laboratory.

In the absence of definitive answers, late nineteenth-century psychiatrists continued to conceptualize insanity as a functional brain disorder—albeit a perplexing one—as had the previous generation of asylum doctors. But they were far less optimistic about their ability to cure mental illness, and under the influence of new evolutionary theories originating in biology and the social sciences, they placed increasing emphasis on hereditary causes of insanity.

THE DECLINE OF ASYLUM MEDICINE

Interest in both scientific psychiatry and heredity as a factor in mental illness was prompted in part by growing disenchantment with asylum medicine. By the end of the Civil War, state mental hospitals were filled with patients left uncured by moral treatment. Many of the leading superintendents of early asylums found themselves, in their old age, defending moral treatment before hospital boards and state legislatures whose members, with increasing frequency, refused to spend the vast funds required for the upkeep of monumental asylum buildings and grounds, or for the construction of new hospitals. As state governments found themselves paying more and more to support the mentally ill, they convened regulatory boards, called lunacy commissions, composed of politicians, lay reformers, and businessmen. State lunacy commissioners challenged the medical authority and institutional autonomy of asylum superintendents, and questioned their continued allegiance to the principles of asylum design and management developed by the founding generation of the Association of Medical Superintendents of American Institutions for the Insane (AMSAII). Reformers pressured hospital administrators to consider less expensive alternatives for housing the insane. Some argued for large, stripped-down hospitals for chronic cases, such as Willard Asylum for the Insane in upstate New York (fig. 3.2), while others preferred the idea of cottage or village communities such as the innovative Gheel Colony in Belgium, where lunatics lived among the sane residents of the town.

Citing persistent patient complaints and press coverage of mistreatment and poor conditions, state lunacy boards implemented systematic plans of inspection and regulation. State hospital superintendents were required to keep more detailed case records and better tallies of the use of physical restraint. The boards increasingly restricted the superintendents' control over asylum admissions, particularly their right to refuse chronic cases. With few exceptions, the AMSAII membership bitterly fought these changes on the grounds that they would reduce public mental hospitals to custodial warehouses. Their resistance, however, was undermined not only by their own institutional problems but by the pessimistic trend of psychiatric theory in general.

Fig. 3.2. Willard Asylum for the Insane, Willard, New York, late 19th century, lithograph. Archives of Willard Asylum for the Insane, courtesy Willard Psychiatric Center, Hatch Library.

Willard Asylum for the Insane, one of the largest mental hospitals in nineteenth-century America, was opened in 1869 to provide custodial care for the chronically insane.

Asylum critics joined together in 1880 to found an organization dedicated to reforming mental health care, the National Association for the Protection of the Insane and the Prevention of Insanity. But NAPIPI disintegrated within a few years due to tensions between lay and medical members; not until the founding of the National Committee for Mental Hygiene in 1909 did a long-lasting partnership develop between lay reformers and doctors. As the superintendents of Thomas Kirkbride's generation retired or died, younger doctors accepted the reformers' critiques and began to rethink both the architecture and regime of the mental hospital. To provide smaller, more intimate treatment settings, state institutions began to add new "cottage hospitals" on the same grounds as their old linear-style buildings.

By the late nineteenth century, the care of the insane in American mental hospitals had divided into a tiered system. Private institutions, such as the McLean, Butler, Bloomingdale, and Pennsylvania asylums, continued to offer moral treatment for an affluent clientele, while state mental hospitals increasingly provided only custodial care for a poor, chronically ill population. Conditions in public asylums run by counties and cities were even worse (figs. 3.3, 3.4). The reduced status of hospital medicine as a specialty was evident when AMSAII changed its name in 1892 to the American Medico-Psychological Association, deleting any reference to institutional psychiatry.

Fig. 3.3. Nellie Bly, 19th century, photograph. The Oskar Diethelm Library, History of Psychiatry Section, Department of Psychiatry, Cornell University Medical College and The New York Hospital, New York.

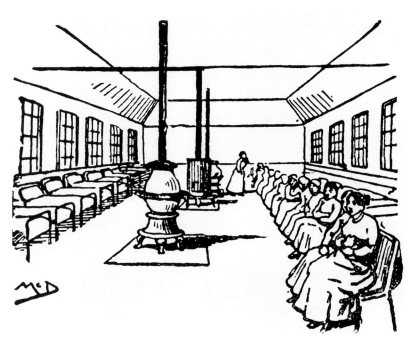

Fig. 3.4. A hall at the asylum at Blackwell's Island, cartoon by Walt McDougall in the *World,* Oct. 16, 1887.

In 1887 the *World,* a New York newspaper owned and published by Joseph Pulitzer, commissioned journalist Nellie Bly to feign madness in order to report on conditions from inside an asylum. When the reporter appeared in police court, Judge Patrick G. Duffy was convinced that this healthy young woman, who claimed to have lost her memory, must have family and friends looking for her. He asked reporters to publicize her case, and he sent Bly to Bellevue Hospital for psychiatric examination. She was declared insane and committed to the New York City Lunatic Asylum on Blackwell's Island. The *New York Times* published a description of "the mysterious waif" (Sept. 26, 1887), the *Sun* ran an article with the headline "Who Is the Insane Girl?" (Sept. 25, 1887), and the *New York Herald* published the diagnosis of the Bellevue physician: "Her delusions, her apathetic condition, the muscular twitching of her hands and arms, and her loss of memory, all indicate hysteria" (Sept. 25, 1887). After Bly was confined for ten days, the attorney for the *World,* Peter A. Hendricks, went to Blackwell's Island, accompanied by cartoonist Walt McDougall, to arrange for her release. The following Sunday, the editors of the *World* featured Bly's exposé, along with gleeful reprints of the articles written by their hoodwinked colleagues on newspaper row. Bly wrote:

> What, excepting torture, would produce insanity quicker that this treatment? Here is a class of women sent to be cured. I would like the expert physicians who are condemning me for my action, which has proven their ability, to take a perfectly sane and healthy woman, shut her up and make her sit from 6 A.M. to 8 P.M. on straight-back benches, not allow her to talk or move during these hours, give her no reading and let her know nothing of the world or its doings, give her bad food and harsh treatment, and see how long it will take to make her insane. ("Beyond Asylum Bars," *World,* Oct. 9, 1887)

EVOLUTIONARY THEORIES OF INSANITY

In the late nineteenth century, evolutionary theories that emphasized the importance of heredity in mental disease became influential in medicine and popular culture. Charles Darwin's publication of *The Origin of Species by Means of Natural Selection* (1859) profoundly influenced medical thinking about disease in general. But while Darwin certainly influenced psychiatric thinking, other strands of evolutionary theory were even more directly relevant to the subject of insanity: the degeneration theory of hereditary insanity and social Darwinism, which attempted to link the evolution of the human brain with progress in human societies.

Degeneration Theory and Hereditary Insanity

Assuming that each form of mental illness was caused by a distinctive pattern of brain deterioration, nineteenth-century psychiatrists became intrigued with the question of whether the physical degeneration and corresponding mental derangement were hereditary. In an attempt to explain the source of mental retardation, Austrian psychiatrist Benedict Augustine Morel (1809–1873) focused on the patient's parents. He proposed that psychological features such as a melancholic disposition or chemical agents such as alcohol could lead to physical changes in the brain which would be inherited by offspring. Morel believed that the degenerative trait was accentuated in each successive generation and progressed toward extinction: for example, the first generation might be slightly nervous, the second melancholic, the third severely depressed, and the fourth so demented that the family line would die out. Frenchman Valentin Magnan (1835–1916), who worked with alcoholics, adopted and extended Morel's views, hypothesizing that all forms of mental illness could be passed on. The Morel-Magnan theory of hereditary insanity was especially influential in Germany, where Richard von Krafft-Ebing (1840–1902) applied concepts of degeneration and regression to his study of sexual pathology in *Psychopathia Sexualis* (1886).

English-speaking audiences turned to the writings of British psychiatrist Henry Maudsley (1835–1918), who portrayed degeneration and heredity in psychiatric theory in his *Physiology and Pathology of the Mind* (1867). Not surprisingly, Maudsley was drawn to the story of an American family that died out due to hereditary melancholy, in Edgar Allan Poe's "The Fall of the House of Usher" (1839). In an article on Poe, an early example of pathography (a biography that traces the origins of the subject's supposed mental illness), Maudsley asserted the essence of degeneration theory: "We may rest assured of this, that infirmities of mind are transmitted from parent to child by a law as sure and constant as is any physical infirmity. . . . Before the child is born, it is certain that its after-constitution may be seriously affected by its mother's state of mind" ("Edgar Allan Poe," *AJI*, 1860–61, vol. 71, p. 167). As was common in nineteenth-century pathographies of artists and writers, Maudsley assumed that Poe's fiction was veiled autobiography. Turning his attention to Poe's actress-mother and her "ungovernable passions," Maudsley gave his diagnosis: "Edgar Poe was thus born under a canopy of remorse, and imbibed as his first lesson the melancholy dirge of 'Nevermore! Nevermore!'" (p. 170).

The American public encountered a case of hereditary insanity in the character of Helen Carrol in Louisa May Alcott's *Work: A Story of Experience* (1873). When Helen's father reveals on his deathbed that insanity runs in his family, Helen and her siblings respond with a fatalism that reflects then-popular attitudes toward the inevitability, and tragic inescapability, of the evolutionary process. One brother joins the priesthood, taking a vow of celibacy to protect the species, and other family members confront the Carrol family curse with like stoicism (fig. 3.5).

Although hereditary insanity could be construed to present its sufferers as innocent victims, the theory was also employed in more punitive ways. As with moral insanity, the volatile mixture of morality and medicine invited the narrow-minded to conflate societal customs with inviolable laws of nature. The theory that parental misdeeds weakened offspring worked particularly well to condemn those who transgressed Victorian gender conventions. The ravages of venereal disease, which inflicted suffering not only on the middle-class businessman who consorted with prostitutes but also destroyed the health of his wife and children, seemed an excellent example of nature's moral laws.

In only slightly less dramatic terms, some late nineteenth-century physicians warned about the dangers of women working outside the home. In the post–Civil War period, many new opportunities for white middle-class women opened up in higher education and the professions. As more women attended college and found work outside the home as teachers, nurses, and even

Fig. 3.5. "Helen Carrol," in Louisa May Alcott, *Work: A Story of Experience* (Boston, 1873).

Beautiful young Helen, incapacitated by severe depression, languishes in bed, staring at her lover's portrait; her suffering began after she mysteriously refused to marry him. Helen finally admits why she and her siblings cannot marry; there is a curse upon them all: "The curse of insanity I mean. We are all mad, or shall be; we come of a mad race, and for years we have gone recklessly on bequeathing this awful inheritance to our descendants. It should end with us, we are the last; none of us should marry." Although the reader is not told how the degenerative process began, Helen hints darkly that the evil lies in "the sad history of my father's family." So the Carrol children each resolve not to procreate: Augustine joins the priesthood, Harry is dissipated with drink, and Helen dies of a self-inflicted wound in the arms of her mother, whom Helen has, at long last, forgiven for bearing her. With her last breath, Helen reveals the curse to her younger sister, who cancels her own engagement on the spot. Harry then turns his life around, becoming a doctor dedicated to treating the insane, but Augustine, alas, goes "melancholy mad."

Fig. 3.6. Composite photograph of eight melancholic men, ca. 1890. Archives of the American Psychiatric Association, Washington, D.C.

Composite photographs, used as diagnostic aids, assimilated facial types of different mental disorders. William Noyes (1857–1915), a physician on the staff at Bloomingdale Asylum, White Plains, New York, gave this portrait to philosopher William James, then on the faculty at Harvard University, who wrote about and made drawings related to his own melancholy (see p. 161).

physicians, their new-found independence increasingly threatened conservative segments of American society. The reinvigoration of the women's suffrage movement in the 1880s and 1890s only heightened anxieties about the so-called new woman. With growing frequency, medical arguments linked women's allegedly unnatural activities outside the home with both diminished mental stability and reproductive capacity. In 1873 physician Edward Clarke published an influential book entitled *Sex and Education* in which he blamed the overeducation of adolescent girls for women's physical and nervous debility, including insanity. Clarke cautioned that the mental weaknesses of educated women would be compounded in what few children their puny reproductive systems could produce. Physician Mary Putnam Jacobi challenged his views, but the idea that overtaxing the female brain resulted in both insanity and degeneration of the human species remained very common in medical circles at the turn of the century. In 1900 a Baltimore physician warned:

> The female possessed of masculine ideas of independence; the viragint [a masculine woman] who would sit in the public highways and lift up her pseudo-virile voice, proclaiming her sole right to decide questions of war and religion . . . the female who prefers the laboratory to the nursery . . . is a sad form of degeneracy. . . . The progeny of such human misfits are perverts, moral or physical. (William Lee Howard, "Effeminate Men and Masculine Women," *New York Medical Journal,* 1900, vol. 71, p. 687)

Exponents of degeneration theory believed that degenerates could be recognized by physical and mental stigmata—characteristic signs and gestures indicative of regressive breeding. Building on a strong interest in the physiognomy of the insane which dated back to the early nineteenth century, late nineteenth-century investigators searched patients' faces and bodies for hereditary signs of disease. European and American psychiatric hospitals used photography to record patients and to link appearance with particular mental afflictions (fig. 3.6). Darwin himself studied photographs and clinical descriptions of the insane supplied to him by the eminent alienist James Crichton Browne, the medical superintendent of the West Riding Lunatic Asylum in England.

The concept of degeneracy was naturally of interest to psychiatrists who studied criminal behavior, notably the Italian Cesare Lombroso (1835–1909), a prolific writer who held professorships in psychiatry and medical jurisprudence at the University of Turin for more than twenty years. In *L'Uomo di Genio* (*Man of Genius,* 1864), Lombroso restated the ancient association of creativity and madness in new hereditary terms, and asserted that all creative individuals suffered from a type of degenerative, epileptic-like psychosis. Lombroso established one of the earliest collections of art by mental patients which survives today as part of the Museum of Criminal Anthropology, Turin.

After the English translation of Lombroso's work in 1891 (figs. 3.7, 3.8), American psychiatrists responded with several publications on degenerative theories of creativity. Articles often included analyses of patient art and writing. James G. Kiernan of Chicago offered a modification of Lombroso's view in "Art of the Insane" (*Alienist and Neurologist,* 1892, vol. 13, pp. 244–75), and Ales Hrdlicka from New York discussed examples of his patients' artwork and writing, again following Lombroso, in "Art and Literature in the Mentally Abnormal" (*AJI,* 1899, vol. 55, pp. 385–404). Hrdlicka established a collection of creative work by patients (fig. 3.9), and by 1900 it was common for physicians to save and study patient artwork (fig. 3.10).

Lombroso's enormously popular *Man of Genius* was also translated into French and German, and went through six editions between the 1860s and 1890s which were widely read by the general public. The degeneracy view of creativity played a formative role in the public's perception of art of the era. The subtle anti-intellectualism in Lombroso's writing was explicit in his foremost German disciple, Max Nordau (1849–1923), who directed an attack against symbolism, an international artistic and literary movement at the end of the century. In the introduction to the 1892 *Entartung* (translated as *Degeneration,* 1895), which he dedicated to Lombroso, Nordau wrote:

> Degenerates are not always criminals, prostitutes, anarchists, and pronounced lunatics; they are often authors and artists. . . . I have undertaken the work of investigating the tendencies of the fashions in art and literature; of proving they have their sources in the degeneracy of their authors, and that the enthusiasm of their admirers is for manifestations of more or less pronounced moral insanity, imbecility, and dementia. Thus, this book is an attempt at a really scientific criticism. (pp. vii–viii)

It was Nordau who provided the psychiatric basis for the Nazi concept of degeneracy, which was epitomized in the infamous exhibition of modern German art, *Entartete Kunst* (Degenerate Art), which opened in Munich in 1937.

THE WITCH.

ARABESQUES BY PARANOIAC ARTIST.

Fig. 3.7. Skull of Immanuel Kant, in Cesare Lombroso, *Man of Genius* (London, 1891). The Oskar Diethelm Library, History of Psychiatry Section, Department of Psychiatry, Cornell University Medical College and The New York Hospital, New York.

To support his case that geniuses suffer from degenerative psychoses, Lombroso illustrated the skulls of geniuses and described their supposed deformities with the scientific language of the laboratory. Lombroso wrote of German philosopher Immanuel Kant:

> Lesions of the head and brain are very frequent among men of genius. . . . [For example] the transverse occipital suture of Kant, his ultra-brachycephaly (88.5), platycephaly (index of height 71.1), the disproportion between the superior portion of his occipital bone, more developed by half, and the inferior of cerebral portion. It is the same with the frontal arch as compared to the parietal. . . . The capacity of the skull in men of genius, as is natural, is above the average, by which it approaches what is found in insanity. . . . [Many Italian geniuses] all presented great cranial capacity. The same character is found to a still greater degree in Kant (1.740 c.cm). (pp. 8–10)

Fig. 3.8. Patient artwork, in Cesare Lombroso, *Man of Genius* (London, 1891). The Oskar Diethelm Library, History of Psychiatry Section, Department of Psychiatry, Cornell University Medical College and The New York Hospital, New York.

The English edition of Lombroso's book included this illustration of artwork by an American patient of William Noyes at the Bloomingdale Asylum, White Plains, New York. Between 1884 and 1889, Noyes kept a detailed record of the development of the patient's delusions and their representations in his many drawings.

Fig. 3.9. Patient drawings, in Ales Hrdlicka, "Art and Literature in the Mentally Abnormal," *AJI,* 1899, vol. 55.

Hrdlicka wrote: "Patient was an artistic fresco-painter and decorator. Confined in asylum 9 years. Very incoherent and very mystical. Drawings very highly symbolic, principally mathematical and metaphysical refutations."

Fig. 3.10. *Self-Portrait as Christ,* by a patient at Pennsylvania Hospital for the Insane, 1892–93, oil on canvas, 13½ × 11½ in., signed and dated lower right, "Maurer 1890." Mütter Museum, College of Physicians of Philadelphia.

Benjamin Fox, a graduate of the Pennsylvania Academy of Fine Arts, was admitted to Pennsylvania Hospital for the Insane in 1892 with "acute mania." A 1902 hospital document states that Fox informed his physician, Daniel E. Hughes, that the painting was a portrait of himself as Christ. A recent cleaning of the painting revealed the signature "Maurer 1890," suggesting that the deranged artist may have produced his self-portrait by altering the work of another artist, perhaps Charles Maurer (1844–1931), a prominent Philadelphia portraitist.

It is striking that the painting by this artist and those by Ralph Albert Blakelock (see pp. 147–49) do not resemble the art of the insane as characterized by Lombroso and his followers (i.e., minuteness of detail, uniformity, arabesques, eccentricity). The works of Fox/Maurer and Blakelock are in the style of late nineteenth-century realism in which they were trained. The naive appearance of most patient art may result from lack of training rather than mental condition.

Degeneration, Insanity, and Modern Art

In the late nineteenth and early twentieth centuries, theories of degenerative and hereditary insanity provided powerful weapons against emerging modernist art throughout Europe and the United States. In 1880 the American correspondent for the *Art Journal* reported from Paris that Edouard Manet "is less mad than the other maniacs of impressionism" (vol. 6, p. 189). In 1886 a reviewer of the first major presentation of impressionist painting in America explained that "the exhibitors have hung the saner and much more important examples" at the entrance of the American Art Association so as not to discourage the visitor. But once inside, the visitor discovered that many of "these painters portray even the most cheerful and frivolous themes in the most dyspeptic and suicidal manner that is conceivable" (*Art Interchange,* April 24, 1886, vol. 16, p. 130). One observer complained that impressionist art suffered from "purple mania" (W. H. Downes, "Impressionism in Painting," *New England Magazine,* July 1892, p. 603). Critics considered impressionist paintings only rough sketches in comparison to minutely detailed neoclassical paintings, which held no trace of intuitive, primitive impulses.

Critical attitudes shifted on the occasion of the 1893 World's Columbian Exposition in Chicago. Reviewers began to extol the use of color and form for its own sake, as well as the value of spontaneous brushstroke (John Van Dycke, *Art for Art's Sake,* 1893, pp. 16–18, 245–46). The fin-de-siècle critical acceptance of impressionism, soon followed by America's embrace of this art, signaled a final reversal in taste from Enlightenment-based styles embodying reason and order to valuation of intuition and irrationality, an attitude fundamental to early modernism.

While the impressionists' sunlit pictures won approval, more abstract art, often with dark psychological undertones, did not, and critics continued to use theories of degenerative and hereditary insanity to attack it. A special target was the 1913 *International Exhibition of Modern Art* (commonly called the Armory Show), which introduced symbolism, fauvism, cubism, and futurism to New York. A *New York Times* review of the exhibition, carrying the headline "Cubists and Futurists Are Making Insanity Pay," suggested that earlier modern artists (such as van Gogh) "were for the most part sincere enough. . . . They committed suicide or died in madhouses," but that Matisse and Picasso were feigning insanity to make money (March 16, 1913).

Another New York reviewer stated, "No imagination outside the psychopathic ward of Bellevue . . . can conceive without actually seeing it what a cubist picture is. . . . Cubism must have originated in the brain of a professor of mathematics stricken with paresis." This review parodied Marcel Duchamp's *Nude Descending the Staircase* with a cartoon titled "A Nude Figure Coming Downstairs in Padded Cell I" (*Evening World,* Feb. 22, 1913; fig. 3.11).

The influential critic for the *Nation,* Frank Jewett Mather, compared the effects of seeing postimpressionist and cubist art to "one's feeling on first visiting a lunatic asylum" (March 6, 1913). In "What Cesare Saw at the Armory Art Show" (*Sun,* Feb. 23, 1913; fig. 3.12), a cartoonist with the pen name Cesare punned that he and Cesare Lombroso, author of *Man of Genius* (see p. 127), had visited the exhibit, presumably to view the degenerates (Lombroso had actually died four years earlier). Mather conveyed the moralistic attitude taken toward degenerative insanity: "The layman may well dismiss on moral grounds an art that lives in the miasma of morbid hallucination" (*Independent,* March 6, 1913).

A critic for the New York *Review* warned that "the propaganda of the cubist, futurist, and postimpressionist painter is not only a menace to art, but a grave danger to public morals"; the Armory Show, he continued, presented "degenerates of art" whose work was "the product of minds which, according to eminent psychiatrist Professor Krafft-Ebing, would be classed as hopelessly diseased. . . . By their own confession these apostles of artistic insanity do not paint things as they are, but as they see them through the eye of their imagination. . . . When they make this statement they indict themselves as victims of dementia" (March 22, 1913).

Fig. 3.11. "An Alienist Will Charge You $5,000 to Tell You If You're Crazy; Go to the Cubist Show and You'll Be Sure of It for a Quarter," *Evening World*, Feb. 22, 1913.

Fig. 3.12. "What Cesare Saw at the Armory Art Show," *Sun*, Feb. 23, 1913.

Social Darwinism

A second strand of evolutionary thinking that strongly influenced late nineteenth-century psychiatry originated with English philosopher and pioneer sociologist Herbert Spencer (1820–1903). Spencer worked out an ambitious theory of cultural evolution known as social Darwinism. Interpreting the principle of survival of the fittest in terms of human progress, Spencer posited that human societies evolved from savagery to civilization in a process parallel to the physical evolution from ape to man.

According to Spencer, the evolution of the brain and nervous system, progressing from the more primitive instinctual functions to the higher intellectual operations, was a critical factor in the evolution of society. In his influential text, *Principles of Psychology* (1855), he wrote:

> If creatures of the most elevated kinds have reached those highly integrated, very definite and extremely heterogeneous organizations they possess, through modification upon modification accumulated during an immeasurable past, if the developed nervous system of such creatures have gained a complex structure and functions little by little; then necessarily, the involuted forms of consciousness which are the correlates of these complex structures and functions, must also have arisen by degrees.

Combining Spencer's hypothesis with the wealth of new information about the nervous system, theorists developed a hierarchical conception of brain and mind that helped to explain the nature of insanity. Probably the most influential formulation was developed by the English neurologist John Hughlings Jackson (1835–1911), who argued that the nervous system reflected the course of evolution: the "lowest" forms of neurological activity, controlled by the spinal cord and brain stem, were the first to evolve and governed the basic instincts and reflexes necessary for brute survival. The next to develop, the "middle" structures seated in the basal ganglia and parts of the cerebrum, controlled more complex motor activities. The last to evolve and the most highly developed function was the intellect, seated in the frontal lobes of the brain. These "higher" centers inhibited the more primitive functions of the lowest centers.

This conception of hierarchical function helped to illustrate the course of mental and neurological diseases. The agents of disease, whatever they might be, usually first affected the highest functions of the mind/brain, that is, reason and intellect. Once

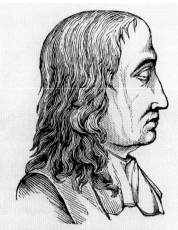

No. 5. Portrait of Milton the poet.

No. 6. Skull of a savage Hottentot. Very small in the Intellect and Sentiments.

Fig. 3.13. "Portrait of Milton the Poet," and "Skull of a Savage Hottentot," in F. Coombs, *Popular Phrenology* (1841). Library of the College of Physicians of Philadelphia.

disabled, those higher functions ceased to inhibit the lower centers of activity, accounting for the regression of behavior so common among the insane. The higher, more "civilized" regions of the mind lost their control over the lower, allowing "primitive" impulses to go unchecked.

Social Darwinist theories of the mind, with their opposition of civilization and savagery, reinforced the sense of superiority common to white, native-born, upper-class Americans. Linking individual achievement with biological superiority provided a convenient rationale for the growing inequities in American society produced by large-scale manufacturing and urbanization.

Even as late nineteenth-century industrialists sought to combine and control markets, shutting out smaller business rivals and limiting their workers' autonomy, they invoked the rhetoric of individual freedom, competition, and laissez-faire capitalism. The fact that a few men such as Andrew Carnegie and John D. Rockefeller became fabulously wealthy, while many others were reduced to penury, could be explained in biological terms as "survival of the fittest." Social Darwinism rationalized class differences as the neutral workings of natural law, not the outcome of unfair business or labor practices.

Evolutionary theories also helped Anglo-Saxon Americans preserve their cultural dominance in the increasingly diverse society of the late 1800s. This new sense of white upper-class elitism was expressed as the superiority of "highbrowed" over "lowbrowed" peoples and their cultures. Earlier nineteenth-century phrenologists had claimed superiority for the Caucasian brain primarily in terms of the size and development of the intellectual regions (fig. 3.13). In the late nineteenth century, these racist assertions took on an evolutionary twist. Facial angle became the measure of racial superiority; the supposedly greater intellectual capacities of the Caucasian brain were reflected in a high forehead, with its high facial angle, or highbrow; the lesser intellect and baser instincts of non-Caucasians were apparent in a sloping forehead, or lowbrow (fig. 3.14). In popular parlance, this evolutionary perspective was expressed in the growing tendency to divide culture according to its highbrow or lowbrow appeal.

In the early twentieth century, anthropologist Franz Boaz proved that facial angle varies within all human populations and is unrelated to race or intelligence. In 1905 the French psychologist Alfred Binet developed a test for mental ability which quickly became popular in the United States. Thereafter the often bitter debate over brain capacity and race shifted from facial angle to I.Q., a topic that continues to be highly controversial.

The application of the phrenological distinction between highbrow and lowbrow to art and culture not coincidentally developed during Reconstruction, as white and black Americans struggled to redefine their relations with one another. The Civil War brought an end to slavery, but by 1877, when northern efforts to reconstruct the former Confederate states came to an official

Fig. 3.14. Illustration in Ranson Dexter, "The Facial Angle," *Popular Science Monthly* (March 1874). Brown University Library, Providence, Rhode Island.

In "The Facial Angle," which was written for the general public, the author linked ascending facial angle with increased mental capacity: "The relative ascendency of the two factors, physical and mental . . . shows very conclusively the gradual turning from the lowest instincts of the brute to the most complex mental powers of man" (p. 592). The animals are identified, from right to left, as a fish, serpent, crocodile, bird, dog, monkey, an idiot ("with an arrest of brain development"), a savage ("chief Black Hawk, a North American Indian, same as Ethiopian"), a half-civilized man ("a Mongolian"), and the civilized Caucasian race (represented by "the illustrious statesman, Daniel Webster").

end, a virtual state of apartheid had been created in the South by the passage of restrictive social and economic laws, a system informally known as Jim Crow.

As had been the case in slavery times, apologists for Jim Crowism invoked scientific authority and brain anatomy to justify discrimination. Although after Emancipation African Americans had some access to public schooling, their opportunities for higher education remained very limited. Educated whites accepted the thinking of the day that blamed this situation on the supposedly inferior brain capacities of blacks. In 1866 the psychiatrist J. M. Buchanan observed that black children were good students only

until they reached adolescence: "In childhood Negroes are bright, intelligent and vivacious, and, as a rule learn as fast as whites of the same age, but on the approach of adult life a gradual change is manifested. The intellect seems to become clouded; they grow unambitious and indolent, and, losing interest in their books, their advancement grows slower and finally ceases altogether." Rather than consider that diminished achievement might result from maturing in a deeply racist society, Buchanan offered an anatomical explanation unsupported by any clinical data: "The growth of the brain is arrested by the premature closing of the cranial sutures and the lateral pressure of the frontal bones" ("Insanity in the Colored Race," *AJI*, 1886, vol. 2, pp. 278–80). Subsequent research has found no such racial difference in the anatomical development of the human brain.

There was also a hierarchy of moral values—from spiritual at the highest to sensual at the lowest—implicit in the highbrow/lowbrow distinction. In white culture, this was reflected in a retreat from earlier romantic views of nature and a new reverence for the fine arts. With continental exploration and expansion virtually complete by the 1890s, the American wilderness came to be seen as tamed and diminished. Its virgin forests penetrated, nature lost its connotation of untouched purity, and leading American landscapists of the late nineteenth century painted not pristine wilderness but pastoral, cultivated land. Those who felt a spiritual void now turned less to nature and increasingly to the fine arts, which were viewed as the repository of the highest moral values.

After the Civil War, as the United States entered an era of unprecedented wealth and power, the newly rich asserted their cultural superiority by forming the first major American collections of Western European art. They protected their heritage within cultural institutions—museums, theaters, opera houses—which were greatly expanded but more isolated from the general public. American theater and opera audiences, who in the early nineteenth century behaved as boisterously as sports fans, were now expected to act in a respectful, dignified manner—like highbrows. Performers of Shakespeare or Mozart no longer threw in a topical skit or minstrel sideshow, but became highly trained interpreters of the classics, which were treated like sacred texts. The New York Philharmonic was established in 1842 as the first symphony orchestra of professional musicians in America. Other orchestras founded in the last decades of the nineteenth century included the New York Symphony Society (1878), the Boston Symphony (1881), the Chicago Symphony (1891), the Cincinnati Symphony (1895), and the Philadelphia Orchestra (1900). Once storehouses of eclectic curiosities presented for the public, museums became temples of art for the initiated to reverentially view masterpieces of Western civilization. The late nineteenth century saw the founding of America's major museums, including the Museum of Fine Arts, Boston (1870), the Metropolitan Museum of Art, New York (1870), the Art Institute of Chicago (1882), and the M. H. de Young Memorial Museum in San Francisco (1895). The goal of highbrow culture was spiritual elevation and purely mental, aesthetic pleasure; lowbrow entertainment—associated with blacks, immigrants, and lower classes—was seen as satisfying baser instincts for sensual pleasure.

AMERICA: THE NERVOUS SOCIETY

The scientific study of the nervous system, which in the 1860s and 1870s emerged as a new medical specialty called neurology, played an important role not only within professional psychiatry but in popular attitudes toward mental illness. Neurology promoted awareness of many milder forms of mental distress, which came to be called neuroses, as opposed to the more serious psychoses, and led to the development of new forms of treatment for countless Americans who would never have considered entering a mental hospital.

The pioneers of American neurology, William Hammond (1828–1900) and S. Weir Mitchell (1829–1914), began their studies of the nervous system during the Civil War. Treating large numbers of soldiers, they observed not only extensive nerve injuries caused by new, more destructive bullets, but also the psychological trauma and nervous exhaustion produced by combat experience. By 1875, when the American Neurological Association was founded, neurology had expanded to include a wide range of nervous conditions that fell short of insanity.

Neurologists recognized that many Americans suffered from debilitating nervous conditions such as headaches, indigestion, insomnia, depression, anxiety, disturbances of sleep, and pains in different parts of the body. In 1869 the neurologist George Beard invented the term "neurasthenia" for this plague of ailments,

combining "neuro," for nerve, with "asthenia," for weakness. Although European physicians saw similar symptoms in their patients, Beard and other American doctors insisted that the disease was particularly common in the United States.

In his classic work, *American Nervousness* (1881), Beard argued that America created a far more intense social milieu for its citizens, particularly those with the finest mental sensibilities, because it lacked the traditional forms of authority that stabilized European society, such as a state church and titled aristocracy. Because the American social order supposedly allowed men to rise or fall according to their own merits, it fostered a stressful sense of personal accountability for one's condition in life. The hard-working, upwardly mobile businessman, of the type William Dean Howells portrayed in the popular novel *The Rise of Silas Lapham* (1885), faced intense mental and emotional pressures. Beard portrayed neurasthenia as a particular hazard for "brain workers," that is, professionals and businessmen whose minds were highly engaged in their work. In Beard's view, the fact that many people from higher walks of life experienced nervous illness was a sign of their superior degree of civilization.

To explain the physical basis of neurasthenia, neurologists invoked research being done in European physiological laboratories on the structure of nerve cells and the electrical discharges they produce. In comparison to the older asylum superintendents, whose theories grew out of clinical work with patients, American neurologists were far better versed in the technical language being developed in medical laboratories. Still, neurological theory was based on a relatively simple model of nervous energy, which doctors often described in terms borrowed from the business world: individuals inherited a certain nervous constitution, or diathesis, which determined how sensitive they were to nervous stimuli. If they overspent their allotments of nervous energy, their nervous systems became bankrupt, and a range of mental and physical symptoms would develop.

Neurologists' interpretations of their clinical data incorporated what they believed to be the facts about human variance: that men were intellectually superior to women, the middle classes superior to the working classes, and northern Europeans superior to southern and eastern Europeans and African Americans. When neurologists began to treat more and more patients in the 1870s and 1880s, they discovered that women and men seemed to suffer equally from the disease, and that it was not restricted to "brain workers" but could be found among common laborers and domestic servants. So they differentiated various forms of neurasthenia, employing the hierarchical model of brain function. Neurologists now postulated that professional men were more likely to suffer from a higher, "cerebral" neurasthenia caused by overwork of the brain, while working-class men suffered from a lower, "spinal" neurasthenia, due to sexual overindulgence. In women, the dominant influence of the reproductive organs also supposedly caused the disease to manifest itself in the spinal form.

Neurologists sought to alert the American middle classes to these nervous maladies by writing the nineteenth-century equivalent to the modern self-help book. Beard's *American Nervousness* was a popular success, and S. Weir Mitchell wrote several widely read tracts, including *Wear and Tear, or Hints for the Overworked* (1871) and *Fat and Blood* (1878), an essay on the treatment of neurasthenia and hysteria. These books fed the middle-class sense of cultural superiority by assuring readers that nervous ailments were a mark of distinction, while offering practical advice about diet and exercise as ways to reduce the mounting stress of modern life.

Neurological Treatments

Recognizing that insanity was a stigmatizing disease, and that many people associated mental hospitals with incurable madness, American neurologists sought to create more attractive alternatives. Neurasthenia was a far more hopeful-sounding diagnosis than insanity and could be attributed to factors such as overwork or physical illness that left the sufferer relatively blameless for its onset. Neurological treatments could be administered at home, in the doctor's office, or at a discreet rest home. Realizing the growing demand for alternatives to the mental hospital, especially among wealthier families, many physicians opened small rest homes, sometimes called nervine asylums, to treat mild nervous disorders.

Despite their emphasis on the somatic basis of nervous disease, American neurologists retained a fundamental faith in the ability of the individual, particularly those from privileged backgrounds, to overcome a deficient nervous endowment. Even as they incorporated aspects of biological determinism and social

Fig. 3.15. Thomas Eakins, *Badlands, Panoramic View,* 1887, photograph. The Pennsylvania Academy of Fine Arts, Philadelphia, Charles Bregler's Thomas Eakins Collection, purchased with partial support of the Pew Memorial Trust.

In February 1886 the board of directors of the Pennsylvania Academy of Fine Arts in Philadelphia dismissed Eakins from their faculty after an intense disagreement with the artist over his use of nude models. One month later, his morality questioned and his views on nudity denounced, Eakins was ousted from the Philadelphia Sketch Club. Deeply depressed for more than a year, Eakins finally accepted the advice of his doctors to take a camp cure. He spent the summer of 1887 in the Dakota Territory, hiking and sleeping under the stars. Eakins's letters to his wife indicate that his depression lifted somewhat on the trip (letters from Eakins to Susan Macdowell Eakins, Aug. 28 and Sept. 7, 1887).

Darwinism into their explanations for disease, neurologists insisted that the downward mental spiral of civilized life could be reversed by prudent action. The key to maintaining America's mental health, they insisted, was a program of physical and mental rejuvenation.

The Rest Cure and Electrotherapy

S. Weir Mitchell developed what he called a "rest cure" for neurasthenia, which combined complete bed rest, isolation from family and friends, massage and electrotherapy, and a protein-rich diet. As Mitchell admitted, the cure depended on the force of the physician's personality; by inducing patients to return to a childlike state of dependence on him, the physician could better reeducate their bodies and minds in healthful habits such as getting adequate rest, avoiding overwork, and choosing relaxing pastimes. Although offered to patients of both sexes, the rest cure for women could take on particularly regressive overtones. Among the female patients Mitchell treated for nervous conditions were reformer Jane Addams, novelist Edith Wharton, and author Charlotte Perkins Gilman (see p. 137).

The complete rest cure was a treatment that only the affluent could afford; even among that class many men had neither the time nor patience to submit to its regimen. So physicians often modified the cure for male patients, allowing them to live at home but restricting their work schedule. Another alternative popular with men was a so-called camp cure, in which patients traveled to a remote setting to engage in light exercise and to relax in nature. S. Weir Mitchell and neurologist Horatio C. Wood recommended such a cure for Philadelphia artist Thomas Eakins (1844–1916) in 1887 (fig. 3.15).

Charlotte Perkins Gilman's "Rest Cure"

A descendant of the famous Beecher clan (writers Harriet Beecher Stowe and Catharine Beecher were her great aunts), the sensitive, artistic Charlotte Perkins (1860–1935) had an intensely unhappy childhood. Her father deserted the family when she was very young, and, according to Gilman, her mother tried to spare her children the risks of emotional dependence by showing them little affection. Soon after her marriage to the artist Charles Walter Stetson in 1884, Charlotte began to suffer from depression, which deepened after the birth of her daughter in 1885.

In 1887 Stetson asked neurologist S. Weir Mitchell to treat his wife. After a month's rest cure, the doctor sent Gilman home, telling her to give up her writing and sketching. "I went home," Gilman recalled years later, "and obeyed these directions for some three months, and came so near the borderline of utter mental ruin that I could see over [it]. Then, using remnants of intelligence that remained, and helped by a wise friend, I cast the noted specialist's advice to the winds and went to work again—work, the normal life of every human being . . . ultimately recovering some measure of power" ("Why I Wrote 'The Yellow Wallpaper,'" *Forerunner,* Oct. 1913).

To regain her spirits, Gilman went on a trip to California, during which her depression lifted, only to return as soon as she headed home. Realizing that marriage and motherhood were at the time beyond her emotional capacities, she divorced her husband, giving him custody of their daughter, and began a career as an author and artist. Gilman became one of the most influential feminist critics of her generation; her book *Women and Economics* (1898) remains one of the great works of American social criticism produced in the Progressive period. By age forty, her career was well established, and she was happily married to George Houghton Gilman. But throughout her life, Gilman continued to suffer from debilitating attacks of nervous exhaustion and depression.

In 1892 Gilman wrote *The Yellow Wallpaper,* a fictionalized account of her experience of S. Weir Mitchell's rest cure (fig. 3.16). Told as a first-person narrative, the story chronicles a woman's slow descent into madness as all her forms of self-expression are taken from her by her paternalistic husband, a doctor who is familiar with Mitchell's rest cure. Significantly, in her fictional telling, Gilman fused the identities of Mitchell and her first husband. The title of the story refers to the wallpaper of the room in her home—the nursery—where she undergoes her infantilizing rest cure. Made worse by the inactivity and confinement, she begs to be allowed to leave the room, but her doctor-husband insists he knows best. Slowly her sanity disintegrates, and she begins to see the figure of a woman trapped behind the wallpaper's sinister curves. Eventually the woman goes completely mad and strips off the wallpaper to help her trapped double escape. "I've got out at last," the narrator concludes, ". . . and I've pulled off most of the paper, so you can't put me back!"

Gilman sent a copy of her story to Mitchell, the physician "who so nearly drove me mad. He never acknowledged it," Gilman reported, "[but] many years later I was told that the great specialist had admitted to friends of his that he had altered his treatment of neurasthenia since reading 'The Yellow Wallpaper'" (*Forerunner,* Oct. 1913).

Fig. 3.16. Cover of Charlotte Perkins Stetson Gilman, *The Yellow Wallpaper* (Boston, 1899).

Fig. 3.17. Davis and Kidder electric machine, 1859. Archives of the American Psychiatric Association, Washington, D.C.

Designed to stimulate the nerves with a weak faradic current, this machine, which is the type shown in Beard and Rockwell's *Practical Treatise* (see below), was a light-weight, portable model. Directions inside the lid begin:

> Connect two metallic cords or wires with the sockets in the ends of the box, and apply the handles connected with the other ends of the metallic cords or wires to any part of the person through which it is desirable to pass current of electricity.

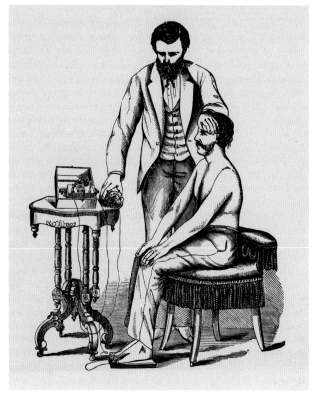

Fig. 3.18. "General Faradization," in George M. Beard and Alphonso D. Rockwell, *A Practical Treatise on the Medical and Surgical Uses of Electricity* (New York, 1871). The Oskar Diethelm Library, History of Psychiatry Section, Department of Psychiatry, Cornell University Medical College and The New York Hospital, New York.

Electrotherapy added another novel element to neurologists' treatment of nervous diseases. George Beard and his partner Alphonso D. Rockwell pioneered its medical use; their text, *A Practical Treatise on the Medical and Surgical Uses of Electricity* (1871), helped promote its wide application. In electrotherapy, different low-voltage forms of electrical current—galvanic, faradic, and static—were passed through the patient's body by means of poles, paddles, and rods. As a general treatment for the nervous system, electrical currents supposedly stimulated brain cells and nerve fibers, recharging an enervated system. Rest cure patients could get passive exercise without fatigue by having their muscles stimulated electrically (figs. 3.17, 3.18).

The Diffusion of Neurological Principles

Although members of the American Neurological Association were by far the most influential exponents of neurology, its concepts and practices spread rapidly throughout the entire late nineteenth-century medical profession. Private asylum doctors adopted aspects of the neurologist's rest cure, particularly the emphasis on a protein diet, massage, and some form of electrotherapy and hydrotherapy. General practitioners, who saw many cases of nervous distress among their patients, also easily incorporated neurology's emphasis on diet, exercise, and even electrotherapy into their treatments.

Case histories published by both specialists and general practitioners suggest that while most neurasthenics suffered relatively mild and easily managed symptoms, some were very disturbed patients, or in the "borderland" of insanity, as their doctors often put it. Asylum admission records reveal that many wealthier patients were committed only after having been unsuccessfully treated by a family physician or neurologist.

Responding to popular concerns about nervousness, patent medicine makers also developed products to alleviate nervous symptoms, including Carter's Little Nerve Pills (fig. 3.19). After the Coca-Cola Company was incorporated in 1892, its first advertisements stressed the medicinal benefits of its product as the "ideal brain tonic and sovereign remedy for headache and nervousness."

Fig. 3.19. "Carter's Little Nerve Pills," 19th century, trade card. Bella C. Landauer Collection of Business and Advertising Art, The New-York Historical Society.

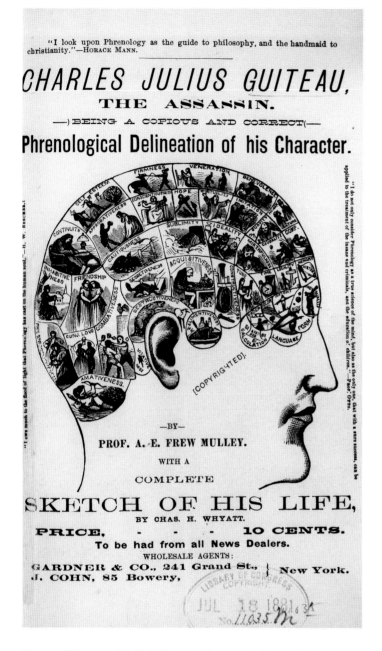

Fig. 3.20. Title page of A. E. Mulley and Charles H. Whyatt, *Charles Julius Guiteau, The Assassin: Phrenological Delineation of His Character* (New York, 1881). Library of Congress, Washington, D.C.

Basing their diagnosis on photographs of Guiteau's head, phrenologists Mulley and Whyatt wrote: "Charles Julius Guiteau is a man of coarse and depraved quality, who seldom experiences ennobling feelings. . . . His selfish and animal propensities so predominate, that they are likely to swamp the higher faculties" (p. 9).

Asylum Doctors Versus Neurologists

Although individual neurologists and asylum superintendents often established peaceful patterns of referral, the tension between the two specialties grew, especially as some neurologists lent their scientific authority to growing criticisms of mental hospitals and the AMSAII leadership. Portraying asylum doctors as old-fashioned and unscientific, neurologists argued that moral treatment did not address the somatic causes of insanity. In their view, the Kirkbride-style asylum was too inflexible and restrictive to meet the different needs of chronically and acutely ill patients. They argued that patients should be given greater freedom and more meaningful, varied work.

The deep divisions between the two specialties surfaced in the trial of Charles Guiteau, the man who killed President James Garfield in 1881. Guiteau's lawyers invoked the insanity defense, bringing in a number of neurologists, including Edward Spitzka (1852–1914), to testify that the assassin suffered from moral insanity. Invoking Lombroso's theory, neurologists portrayed Guiteau as a classic example of the criminal degenerate. But their testimony was disputed by John Gray, an older-generation asylum doctor and a deeply religious man who rejected the idea of moral insanity because it implied that the immortal soul could be diseased. In popular pamphlets, phrenologists added their opinions to the debate (fig. 3.20). Contemporary accounts of Guiteau's behavior suggest that by today's standards he would probably be considered deranged. Yet his insanity plea was turned down, and he was hanged. The many cartoons published during the trial reflect the public's deep reservations about finding an admitted assassin innocent on grounds of insanity, particularly when medical experts could not agree on a diagnosis (figs. 3.21–3.23).

Fig. 3.21. *"Certificates of Insanity,"* cartoon by Bellew, ca. 1881. New York Academy of Medicine Library.

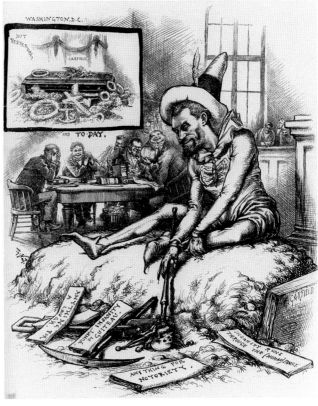

Fig. 3.22. *"From Grave to Gay,"* cartoon by Thomas Nast, Dec. 10, 1881, *Harper's Weekly.*

Nast contrasted the tragedy of the president's death with the antics of Guiteau, who wears the traditional cap and slippers of a deranged fool.

Fig. 3.23. *"Legislation and Lunacy,"* cartoon, ca. 1881, *Puck.* The Oskar Diethelm Library, History of Psychiatry Section, Department of Psychiatry, Cornell University Medical College and The New York Hospital, New York.

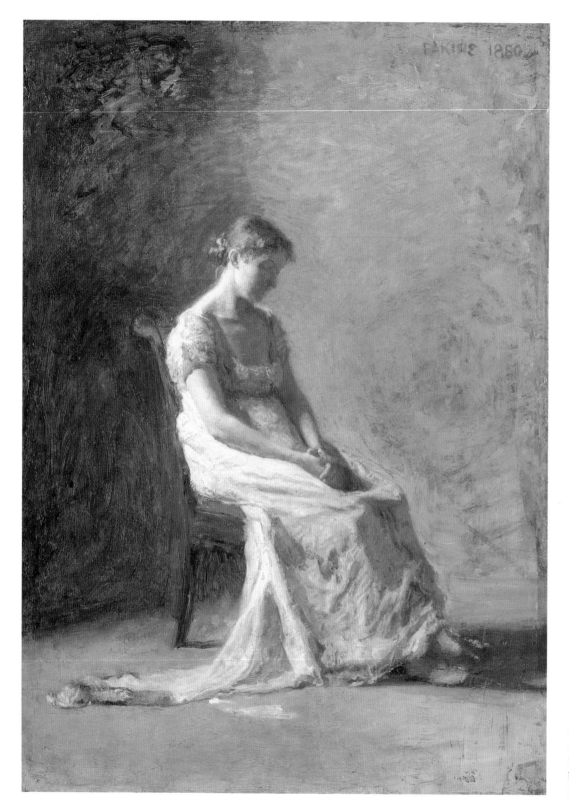

Fig. 3.24. Thomas Eakins, *Retrospection*, 1880, oil on panel, 14½ × 10⅛ in. Yale University Art Gallery, New Haven, bequest of Stephen Carlton Clark, B.A. 1903.

Fig. 3.25. Drawing of an insane patient, 1827–34, in a manuscript of John Kearsley Mitchell. Historical Collections of the Library, College of Physicians of Philadelphia.

New Views of the Psyche

Reflecting the public's new awareness of the stresses of daily life, American art of the late nineteenth century often dealt with the psychological complexity of ordinary people. The naturalistic portraits of middle-class Americans by Thomas Eakins have an intensity of character that reveals an inner vitality, which Eakins, incapable of flattery, presented with penetrating insight. His painting of an unidentified woman, entitled *Retrospection* (1880), has a melancholic mood that goes well beyond the literal naturalism of his day (fig. 3.24). The painting may be based on a sketch of a Pennsylvania Hospital patient (fig. 3.25). In the 1820s physician John Kearsley Mitchell commissioned an anonymous artist to produce a number of patient likenesses, which he assembled into a sketchbook. At the time Eakins painted *Retrospection,* he had borrowed the book from Mitchell's son, S. Weir Mitchell, who was Eakins's physician.

This interest in the psychological dimension of everyday experience was also reflected in changes in American landscape paint-

ing. In reaction to the grandiose canvases and distant, exotic wilderness favored by the late Hudson River school, especially the enormous panoramas of Albert Bierstadt, landscapists now painted more intimate scenes, often from a viewpoint deep in the woods, in which the individual's mood was reflected in nature. Perhaps the most intense psychological landscapes of the late nineteenth century were the visionary, darkly subjective paintings of Albert Pinkham Ryder (1847–1917). Having little direct relation to external reality, Ryder's landscapes, imagined or based on literary sources, have an originality of form that links him to early modernism (fig. 3.26). The aura of silent communication with nature that Ryder created in his landscapes brings to mind the mood of Poe's short story "Silence" (1840), which describes a lone, enigmatic man who stares at the moon throughout a stormy, desolate night, uttering not a word (fig. 3.27).

Ryder drew inspiration for a painting titled *Temple of the Mind* from an Edgar Allan Poe poem, "The Haunted Palace," in which a building inhabited by irrational creatures is a metaphor for the mind (fig. 3.28). Adding a classical setting to Poe's poem, Ryder presents the mind as a Greek temple occupied not by the Three Graces, the goddesses of Greek mythology who bring beauty and balance, but by a faun, a satyrlike, devilish creature. In contrast to the lucid daylight that typically illuminates scenes in the classical tradition, Ryder lights this haunted temple with eerie moonlight. As Ryder himself described it: "The theme is Poe's 'Haunted Palace.'. . . The finer attributes of the mind are pictured by the Three Graces who stand in the center of the picture, where their shadows from the moonlight fall toward the spectator. . . . On the left is a temple where a cloven footed faun dances up the steps, snapping his fingers in fiendish glee at having dethroned the erstwhile ruling graces" (letter from Ryder to John Pickard, 1907).

Closely related to Ryder was his contemporary Ralph Albert Blakelock (1847–1919), who similarly invested his landscapes with a more subjective than literal vision, especially his moonlit, melancholic views of the woods at night (fig. 3.29). Completely impractical in worldly affairs, Blakelock suffered a mental breakdown incited by his poverty. The artist spent the last decades of his life in an asylum in upstate New York, where he painted small green landscapes to resemble million-dollar bills (see pp. 147–49).

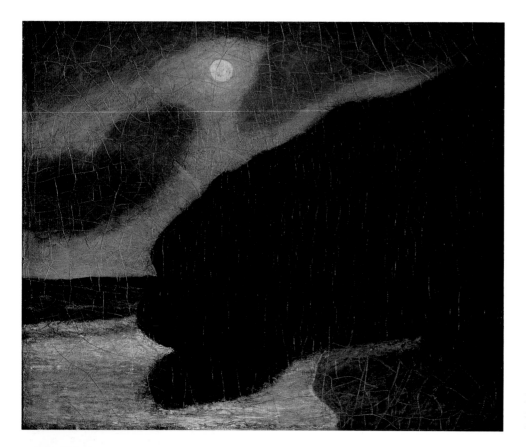

Fig. 3.26. Albert Pinkham Ryder, *Moonlit Cove,*
1880–90, oil on canvas, 14⅛ × 17⅛ in. The Phillips
Collection, Washington, D.C.

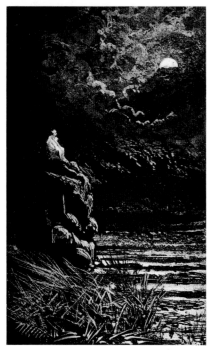

Fig. 3.27. Illustration in Edgar Allan Poe, "Silence" (1840), *Nouvelles Histoires
Extraordinaires* (Paris, 1884).

Fig. 3.28. Albert Pinkham Ryder, *The Temple of the Mind,* ca. 1885, oil on wood, 17¾ × 16 in. Albright-Knox Art Gallery, Buffalo, gift of R. B. Angus, 1918.

Ryder based this painting on Edgar Allan Poe's poem "The Haunted Palace" (1839). Through the windows of a palace set in a green valley, one sees "spirits moving musically / To a lute's well-tuned law." From the palace door emerges "a troop of Echoes whose sweet duty was but to sing, / In voices of surpassing beauty, the wit and wisdom of their king." But the balanced reason of the building's occupants is short-lived:

> And travellers now within that valley,
> Through the red-litten windows see
> Vast forms that move fantastically
> To a discordant melody;
> While, like a rapid ghastly river,
> Through the pale door;
> A hideous throng rush out forever,
> And laugh—but smile no more.

Fig. 3.29. Ralph Albert Blakelock, *Moonlight Sonata,* ca. 1892, oil on canvas, 30 × 22 in. Museum of Fine Arts, Boston, The Hayden Collection.

Ralph Albert Blakelock's Landscape Money

Blakelock's mental breakdown was precipitated by his attempt to raise money before the birth of one of his children in September 1899. He offered one of his best pictures to a collector, but when the erstwhile patron offered him half the price, Blakelock angrily refused. The collector warned that the next time he would offer even less. After trying in vain to sell the painting elsewhere, Blakelock returned in despair and accepted the lesser amount. Shortly thereafter he was found wandering the streets of New York in a deranged state, tearing up the money.

One month later Blakelock was committed to Long Island Hospital in Kings Park, and then in 1901 transferred to the State Homeopathic Asylum for the Insane in Middletown, where he remained until his death in 1919. Diagnosed with dementia praecox, he suffered from delusions, especially the recurring conviction that he was immensely wealthy.

During his years of confinement Blakelock painted intermittently, and his reputation grew. He was elected an academician of the prestigious National Academy of Design, and in 1913 one of his early landscapes sold at auction for $13,900, the highest price ever paid for a work by a living American artist. Ironically, the increased value of Blakelock's work never significantly benefited the institutionalized artist or his wife and children, who remained destitute.

According to both the asylum staff and visitors, the artist behaved normally except in matters related to money. Blakelock attempted to carry out financial transactions with a large bankroll that he carried in his pocket. In 1916 William T. Cresmer, a collector from Chicago, visited Blakelock at Middletown and recorded: "Reaching in his pocket, he removed a roll of bills closely simulating currency and presented me with one which bore across the end in yellow numerals the startling figure of $1,000,000. 'Take this back to Chicago with you. Don't spend it, but live off the interest the rest of your life. It will keep you comfortable and make me happy'" (manuscript in the William T. Cresmer estate). The bills were actually landscapes that Blakelock had painted on cloth—in the size, shape, and color of currency (fig. 3.31).

Certain works that Blakelock painted during his confinement, such as *Rider in the Park* (fig. 3.32) do not differ significantly in style from his earlier paintings. Many others, however, such as *View of the Park (Middletown)* (fig. 3.33), are in the scale and format of currency, suggesting that the symbolic conflation of art and money was often literalized in the deranged mind of the artist.

Fig. 3.30. Ralph Albert Blakelock, photograph signed and dated on verso. Courtesy William Taylor Cresmer estate by his grandchildren, William Cresmer Worthington, Michael Cresmer Seiler, Steven Lawrence Seiler, Susan Seiler Lane, and Sandra Seiler Harrington.

William Cresmer recorded that Blakelock gave him this photograph on the day of his visit to the Middletown asylum, June 20, 1916.

To Mr. Cresmer
Photo of
R. A. Blakelock
June 20th 1916

Fig. 3.31. Ralph Albert Blakelock, *Landscape Money*, 1916, watercolor on cloth, 8 × 3¼, 7¾ × 3½, and 8 × 3½ in. Courtesy William Taylor Cresmer estate by his grandchildren, William Cresmer Worthington, Michael Cresmer Seiler, Steven Lawrence Seiler, Susan Seiler Lane, and Sandra Seiler Harrington.

Fig. 3.32. Ralph Albert Blakelock, *Rider in the Park,* n.d., oil on canvas, 15 × 23 in. Courtesy Susielies Blakelock and Adamson-Duvannes Galleries, Los Angeles.

The rider is Robert Woodman, who oversaw the ward where Blakelock was confined.

Fig. 3.33. Ralph Albert Blakelock, *View of the Park (Middletown),* n.d., pen and ink on paper, 4 × 10 in. Courtesy Susielies Blakelock and Adamson-Duvannes Galleries, Los Angeles.

This landscape drawing shows Blakelock's view through the barred window in his room, a viewpoint shared with *Rider in the Park* (above).

In the late 1800s, new spiritual and psychological movements began to challenge the narrowly medical views of the mind and mental illness held by both the asylum doctor and the neurologist. From mesmerism to Christian Science, a lively experimentation with mental healing flourished in the United States. Although physicians often spoke contemptuously of them, "mind cures" appealed to Americans unsatisfied with medical explanations for their mental unrest.

Mesmerism and Hypnosis

These healing movements had their origins in mesmerism, a treatment that had been fashionable in late eighteenth-century Paris and remained popular throughout the nineteenth century. Franz Anton Mesmer (1734–1815), a Viennese physician, settled in Paris in 1778 and introduced a therapy that supposedly mobilized a mysterious force known as animal magnetism. Patients sat around a tub of magnetized water into which they dipped iron rods that conveyed a healing charge to their bodies. Mesmer's disciples later dispensed with the tub and rods, and focused instead on inducing a somnambulistic or hypnotic trance, called magnetic sleep, in which a patient was receptive to therapeutic suggestions. Many of those drawn to such treatments suffered from mental and nervous disorders that had not responded to more conventional religious and medical measures.

By the mid-nineteenth century, mesmerism had given rise in the United States to popular healing cults, which continued to attract a wide audience throughout the century. As itinerant mesmeric operators traveled the country, holding public lectures and private healings, they left behind new disciples to treat others (figs. 3.34–3.37).

Although neurologists portrayed mesmerists as charlatans, both groups shared the belief that electrical or magnetized charges flowed from healer to sufferer. Many physicians recognized hypnosis and suggestion as legitimate ways to influence patient behavior. From this interest in unusual mental states grew an increasing appreciation among late nineteenth-century American researchers of the power of unconscious mental operations. Philosopher William James (1842–1910), for example, included a chapter on hypnosis in his *Principles of Psychology* (1890), and physician Morton Prince (1854–1929) treated cases of multiple personality using hypnosis (*The Dissociation of a Personality,* 1905). Meanwhile, in France, neurologist Jean-Martin Charcot (1825–1893) and his follower Pierre Janet (1859–1947) had begun using hypnosis to treat hysteria.

Christian Science

One of mesmerism's American converts was Mary Baker Eddy (1821–1910), who in her twenties became a nervous invalid after being widowed and left to raise an infant. She tried patent medicines and hydropathy with no success. Then, in 1862, Eddy met the mesmerist and hypnotist Phineas Parkhurst Quimby. After his ministrations brought her immediate relief, she began to study his ideas, to which she gradually added her own. After a bad fall in 1866, Eddy claimed to have cured herself by reading Matthew 9:2, in which Jesus healed a paralyzed man simply by telling him, "Your sins are forgiven." In *Science and Health with a Key to the Scriptures* (1875), Eddy outlined her method of healing by prayer and scripture reading. Reacting to the increasing secularism of the late nineteenth-century laboratory, Eddy stressed that Christian Science provided a spiritual alternative to secular science, and claimed for it equal explanatory power and therapeutic results. The Church of Christ, Scientist was formally incorporated in 1879.

Christian Science methods were used to treat nervousness and even insanity. A chapter in *Science and Health* entitled "Fruitage," which reproduced the letters of grateful Christian Science converts, included testimony from people relieved of mental distress. One proclaimed himself "freed from neurasthenic and other troubles"; another claimed to have been "saved from insanity and suicide" (1913 edition, pp. 617, 637).

Fig. 3.34. John Adam Whipple, *Hypnotism,* ca. 1845, daguerreotype. Gilman
Paper Company Collection, New York.

The place of this photograph is not identified, but the stagelike setting
suggests a public hypnotism, which clearly had religious overtones for the
subjects, whose hands are clasped in prayer. Although physicians dis-
claimed nonmedical uses of hypnotism, its power to work by suggestion
had similarities to medically approved faradization. The photographer,
John Adam Whipple, was a Boston scientist who is best known for his
photographs of the moon, taken between 1849 and 1851 at the Harvard
College Observatory.

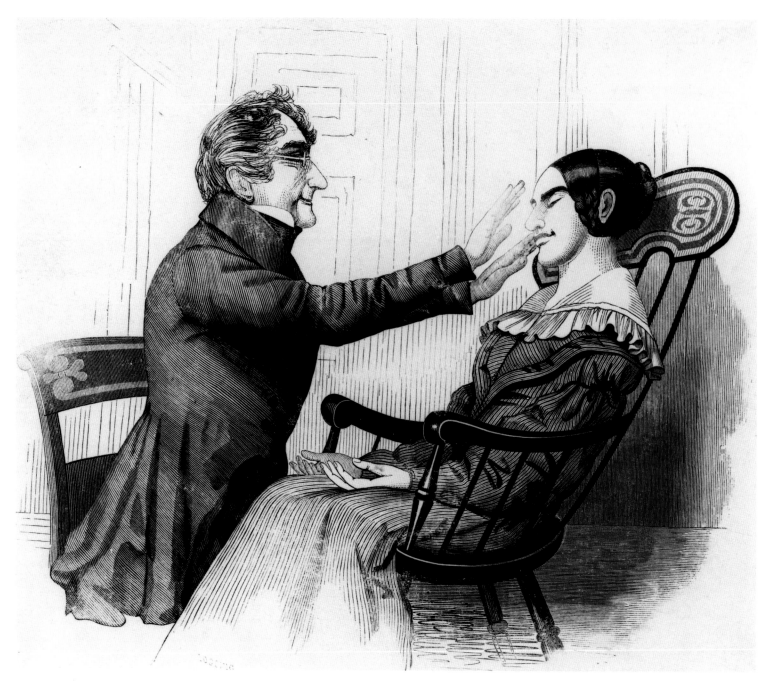

Fig. 3.35. *The Mesmerist,* 19th century, engraving. The Oskar Diethelm Library, History of Psychiatry Section, Department of Psychiatry, Cornell University Medical College and The New York Hospital, New York.

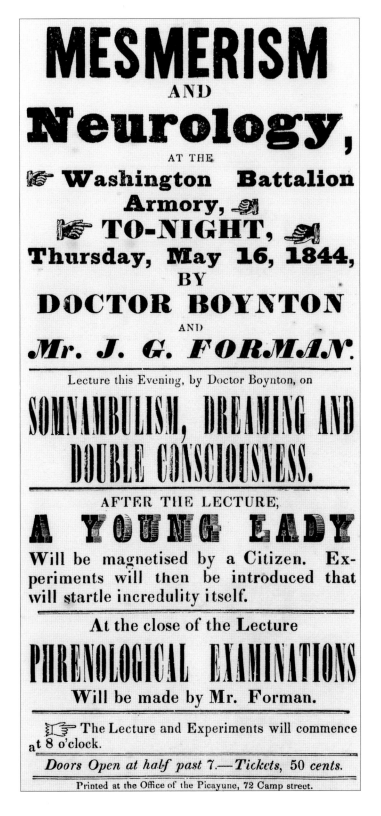

MESMERISM
AND
Neurology,
AT THE
☞ **Washington Battalion Armory,** ☜
☞ **TO-NIGHT,** ☜
Thursday, May 16, 1844,
BY
DOCTOR BOYNTON
AND
Mr. J. G. FORMAN.

Lecture this Evening, by Doctor Boynton, on

SOMNAMBULISM, DREAMING AND DOUBLE CONSCIOUSNESS.

AFTER THE LECTURE,

A YOUNG LADY

Will be magnetised by a Citizen. Experiments will then be introduced that will startle incredulity itself.

At the close of the Lecture

PHRENOLOGICAL EXAMINATIONS

Will be made by Mr. Forman.

☞ The Lecture and Experiments will commence at 8 o'clock.

Doors Open at half past 7.—Tickets, 50 cents.

Printed at the Office of the Picayune, 72 Camp street.

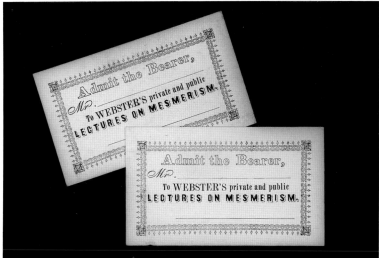

Fig. 3.37. Tickets to a lecture on mesmerism, mid-19th century. The Oskar Diethelm Library, History of Psychiatry Section, Department of Psychiatry, Cornell University Medical College and The New York Hospital, New York.

Fig. 3.36. "Mesmerism and Neurology," 1844, broadside. The Oskar Diethelm Library, History of Psychiatry Section, Department of Psychiatry, Cornell University Medical College and The New York Hospital, New York.

The term "hysteria" (derived from the Greek word for uterus) has been used since antiquity to name variously a disease, syndrome, or set of symptoms (pains, paralyses, crises, spasms). In the late nineteenth century, hysteria came under the purview of neurology as a functional disturbance of the nervous system, particularly common in women. Today, cases gathered under the nineteenth-century category of hysteria might be diagnosed as depression, hypochondria, or even schizophrenia. While paresis would become the paradigm for somatic and scientifically oriented psychiatry, hysteria now became the paradigm for psychological approaches, especially early psychoanalysis.

Jean-Martin Charcot was the leading neurologist of his day. In 1862 he was appointed physician-at-large at the Parisian asylum for women, the Salpêtrière, where he became interested in cases of hysteria, and he was made professor of pathological neurology at the University of Paris in the early 1870s. Given his strict clinical orientation, it is remarkable that Charcot attempted to unlock the minds of hysterical patients with hypnotism, which had remained in disrepute in French circles ever since 1781, when the French Royal Academy of Sciences, the Royal Society of Medicine, and the Faculty of Medicine of the University of Paris had all refused to endorse Franz Mesmer's animal magnetism.

Although Charcot erred in interpreting the data about hysteria which he derived from hypnosis, his work is historically important in legitimizing the method within the psychiatric community. While a medical student in the 1890s, Pierre Janet employed hypnotism in a study of Salpêtrière patients who exhibited what he termed "subconscious," or automatic, speaking and writing. When Freud studied with Charcot in 1885–86, he had already used hypnosis in his work with Josef Breuer (1842–1925) for the purpose of eliciting from a hysterical patient, Anna O., an account of the origin of symptoms which, when fully conscious, she was unable to recall. Freud and Breuer published their findings in *Studies on Hysteria* (1895). They emphasized tracing hysterical symptoms back to causal events in the patient's life and then dispelling them by a re-creation under hypnosis of the original traumatic situation. Extolling the relief and the emotional catharsis she felt after retelling her past, Anna O. named her therapy the "talking cure." In the late 1890s, Freud dispensed

Fig. 3.38. Dr. Scott's electric hairbrush, ca. 1885, ebonite and bristle. The Bakken Library and Museum, Minneapolis.

with hypnosis after persuading his patients to recall the same information by free association.

Earlier in the nineteenth century, certain physicians had speculated about an unconscious region of the mind; for example, Frenchman J. Moreau de Tours (1804–1884) recognized the links between dreams and delirium, and analyzed the effects of hashish intoxication on psychological functioning (*Du Haschish et de l'Alienation Mentale*, 1845). But such researchers failed to introduce a psychological approach to psychiatry because their ideas were formulated in general philosophical terms that were vague by the scientific standards of the day. Freud ultimately succeeded because he gave a precise meaning to psychological cause and effect. He approached dreams and the unconscious with the same careful observation and rigorous reasoning he had learned in the laboratory, and he introduced a suitable technique of inquiry with which he could reconstruct a patient's history and explain his or her symptoms. Freud outlined his methods in his early publications on hysteria in the 1890s, followed by *The Interpretation of Dreams* (1900).

In the scientific spirit of the late nineteenth century, many physicians sought a somatic cause for hysteria, such as "aberrant nervous action, the result of nervous exhaustion from disease

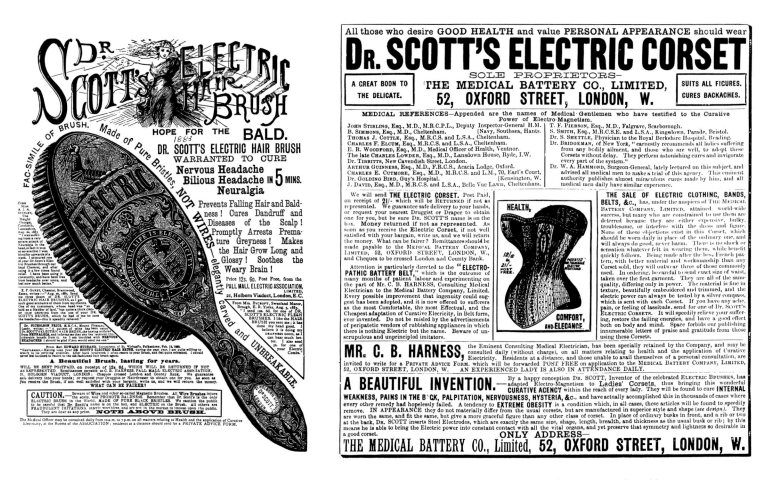

Fig. 3.39. "Dr. Scott's Electric Hairbrush," 1883, advertisement. The Bakken Library and Museum, Minneapolis.

Fig. 3.40. "Dr. Scott's Electric Corset," ca. 1885, advertisement. The Bakken Library and Museum, Minneapolis.

In addition to curing baldness, this electric hairbrush was said to cure nervous headaches and to soothe the weary brain. To demonstrate the brush's electric charge, the manufacturer provided a testing meter, which was actually a small compass activated by a bar magnet cast into the brush's ebonite body.

Dr. Scott claimed that his electric corsets could cure nervousness and hysteria. The corsets were fitted with steel electrodes, instead of whalebones, and lined with tiny single-cell, but inoperative, batteries.

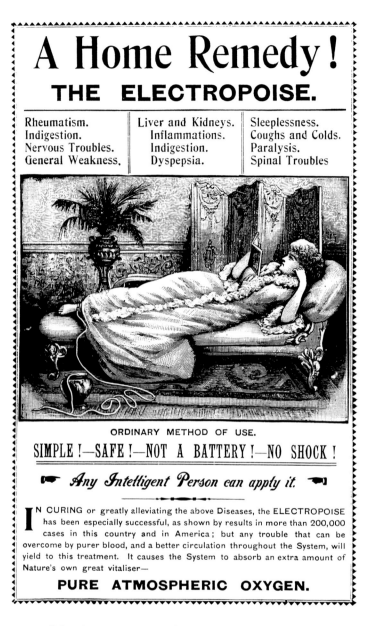

Fig. 3.41. "The Electropoise," 1895, advertisement. The Bakken Library and Museum, Minneapolis.

Promoted as a cure-all device, the electropoise was a sealed chrome cylinder connected by insulated wire to a small metal plate. The user submerged the cylinder in ice water and placed the plate on the ankle or wrist. Because the wire carried no electrical current, the only sensation delivered was the shock of cold metal on first contact with the skin. Relaxing and reading while attached to this harmless placebo gadget may have had therapeutic benefit.

and malnutrition" (Robert Barnes, *A Clinical History of the Medical and Surgical Diseases of Women*, London, 1873, p. 101). Others located the cause in the uterus and described "the reflex effects of utero-ovarian irritation" (Thomas More Madden, *Clinical Gynaecology*, Philadelphia, 1893, p. 474). Some entrepreneurs promoted electrical gadgetry as curative aids (figs. 3.38–3.41), and patent medicine makers responded with chemical cures (fig. 3.42).

It was generally agreed, however, that an organic etiology for hysteria was lacking. The acknowledged American expert on hysteria, S. Weir Mitchell, focused on behavioral causes such as improper upbringing, especially the pampering of upper-class girls, as the cause of the emotional indulgence, moral weakness, and lack of willpower that characterized the adult hysteric. Mitchell described chronic hysterics as "the pests of many households, who constitute the despair of physicians, and who furnish those annoying examples of despotic selfishness, which wreck the constitution of nurses and devoted relatives, and in unconscious or half-conscious self-indulgence destroy the comfort of everyone around them" (*Lecture on Diseases of the Nervous System, Especially in Women*, Philadelphia, 1885, p. 218). Mitchell's rest cure for neurasthenia was used especially for treating hysterical female patients; he removed the supposedly spoiled child-woman from her indulgent family, regressed her to a receptive, infantile state, and then reeducated her in mature, self-disciplined behavior. Descriptions of medical treatments for hysteria are pervaded with the parental, authoritative tone of punishing a "bad girl" (fig. 3.43). Doctors regularly complained of the hysteric's moral weakness (such as Robert Thornton, *The Hysterical Woman: Trials, Tears, Tricks, and Tantrums*, Chicago, 1893), and one physician advised, "Ridicule to a woman of sensitive mind is a powerful weapon, and will achieve something; but there is no equal to fear. . . . A few quarts of cold water suddenly thrown on the person of the chief delinquent instantly brought the ward to a state of reason and subordination" (F. C. Skey, *Hysteria*, New York, 1867, p. 60). Mitchell actively sought to root out domestic malingerers—women who threw a fit in order to avoid their household duties—just as in his early work with Civil War casualties he suspected some soldiers might feign war neurosis to avoid the battlefield.

Fig. 3.42. "Dr. R. C. Flower's Nerve Pills, the Great Brain and Nerve Food,"
19th century, trade card. National Library of Medicine, Bethesda.

TREATMENT OF HYSTERIA

Fig. 3.43. "Treatment of Hysteria," in Russell T. Trall, *Hydropathic Encyclopedia*
(New York, 1868). The New York Academy of Medicine Library.

The directions accompanying this illustration read:

> Place the head over a basin, and pour water from a jug over the head
> and chest till the patient becomes chilly and revives. Never use anything
> but cold water for the hysterical fit, unless the party turns very cold,
> when you should discontinue it, and apply warmth to the feet. I once
> saw the cold applied for three hours, but the patient was quite well the
> next day.

Russell Trall (1812–1877), a physician active in the water cure and spa
movement, recommended this treatment, insisting that drugs were ineffec-
tual against hysteria. Trall directed the Hygeio-Therapeutic College in
New York, which was accredited to give M.D. degrees.

Although Freud has been criticized for his blind spots in treat-
ing hysteria (such as overlooking women's social role as a con-
tributing factor), he was aware of the subtleties and power of
the doctor/patient relationship, in which repressed impulses,
often of sexual origin, were expressed in analysis. Freud wrote,
"A person who has become normal and free from the operation
of repressed instinctual impulses in his relation to the doctor
will remain so in his own life after the doctor has once more
withdrawn from it. The transference possesses this extraordi-
nary, and for the treatment, positively central, importance in
hysteria" ("Introductory Lectures on Psychoanalysis," *Standard
Edition of the Complete Psychological Works of Sigmund Freud*, trans.
James Strachey, London, 1974, vol. 16, p. 445).

Mitchell likewise understood the doctor/patient relationship
as central to his rest cure, but he conceived of it on a dominance/
submission model and was unreflective about his own erotic feel-
ings toward patients. He ended a discussion of the treatment of
female patients with: "Physicians make good husbands, and this
is in part due to the fact that their knowledge of the difficulties of
feminine life causes them to be more thoughtfully tender" (*Doc-
tors and Patients: A Series of Essays of Advice to Women*, Philadelphia,
1888, p. 99).

Fig. 3.44. Frontispiece of *Mollie Fancher: The Brooklyn Enigma*, by Abraham Dailey (Brooklyn, 1894).

Mollie Fancher, the most famous fasting girl in the late nineteenth century, had herself photographed in this pose, which is disturbingly like a corpse in a coffin.

Fig. 3.45. Announcements of the public fast of Helen Coppage, *New York Times*, Dec. 7, 1897, and Jan. 2, 1898.

ANOREXIA NERVOSA

The phenomenon of anorexia mirabilis, the seemingly miraculous ability of female saints and mystics to survive without eating, dates back to the Middle Ages. In the nineteenth century, some young women continued to express their piety through fasting, for which they were venerated by relatives and neighbors. Their abstinence from food occasionally became a public spectacle, with the women written up in the newspapers as wondrous "fasting girls."

Neurologists campaigned against public fasting and argued that anyone claiming to be above nature's immutable laws was either deluded by religious fanaticism or an outright trickster. Neurologist William Hammond wrote *Fasting Girls: Their Physiology and Their Pathology* (1879) in order to expose their pretensions as a form of hysteria, and George Beard accused a young woman of fraud for claiming to have fasted for seven weeks ("The Scientific Lessons of the Mollie Fancher Case," excerpts in the *Sun*, Dec. 23, 1878; fig. 3.44). Despite widespread medical warnings against self-starvation in the late nineteenth-century American press, the public continued to be fascinated by the spectacle of a starving woman. Helen Coppage, for example, fasted for sixty days during December 1897 and January 1898 on the stage of Huber's Museum in New York, for which she was paid three thousand dollars (fig. 3.45). American society's fascination with fasting girls also reflected, in a broader sense, morbid associations of femininity with spirituality, self-sacrifice, madness, and death (figs. 3.46, 3.47).

In the late nineteenth century, physicians began to recognize a different kind of fasting behavior among upper-middle-class young women. They abstained from food not to demonstrate piety but to achieve a more diffuse spirituality, a release from the material body. With few outlets for autonomy within the bourgeois family, these girls may have used food refusal to resist parental control. In 1873 two physicians, William Gull in England and E. C. Lasègue in France, first described this troubling and sometimes deadly syndrome, anorexia nervosa (fig. 3.48).

Fig. 3.46. Toby Edward Rosenthal, *Elaine*, 1874, oil on canvas, 38⁹⁄₁₆ × 62½ in. The Art Institute of Chicago, gift of Mrs. Maurice Rosenfeld, 1917.3.

Clearly aware of the powerful fascination that a beautiful, dead woman had for audiences of his day, Toby Rosenthal illustrated an episode from Tennyson's *Idylls of the King* (1859). The maiden Elaine, having fallen in love with the knight Lancelot, desires "to be sweet and serviceable" and, realizing that Lancelot loves another, confesses to him: "I have gone mad. I love you: let me die." Elaine's bedecked corpse floats on a barge; in her hand she holds a lily and a letter, which reads "I loved you, and my love had no return,/and therefore my true love has been my death."

Rosenthal's painting had a successful United States tour and was awarded a bronze medal at the Philadelphia Centennial in 1876. It was so popular in the late 1870s that "Elaine" women's clubs formed in cities where the painting toured, music stores sold hundreds of copies of "The Elaine Waltz," and a play entitled *Elaine* was presented in New York's Madison Square Garden, complete with a huge reproduction of the painting as part of the set.

Fig. 3.47. Marcella Sembrich, shown as Lucia in Act 3 of Donizetti's *Lucia di Lammermoor*, in its New York Metropolitan Opera premiere performance, Oct. 24, 1883. The Music Division, The New York Public Library for the Performing Arts, Astor, Lenox, and Tilden Foundations.

Fig. 3.48. Illustration of a patient "before" and "after" treatment, in "Anorexia Nervosa" by William Gull, *Lancet*, March 17, 1888. National Library of Medicine, Bethesda.

This opera, based on the Sir Walter Scott novel *The Bride of Lammermoor* (1819), tells of a woman who goes mad with passion for a man who has betrayed her. At the beginning of the opera Lucia is a rational woman, her hair tidily arranged; by Act 3, lovesick Lucia has lost her mind, and her hair streams wildly about her face. According to one reviewer, Sembrich performed the famous mad scene with a brilliant "frenzy of vocal *floriture*" (*New York Times*, Oct. 25, 1883).

William James

William James's life-long interest in psychology and psychiatry was related to personal experience. Wanting to become an artist, but convinced by his father that science was a higher calling, in the late 1860s James (1842–1910) entered Harvard Medical School, where he became depressed and suicidal. Following a frequently prescribed antidote to depression, James left Harvard to travel in Europe. He "took the cure" at several resorts and intermittently tried to study medicine and psychology. He was able to return to Harvard and finish his M.D. degree, but suffered another serious breakdown in 1872.

 James's writings and sketchbooks provide a vivid account of his thoughts about mental illness: "In civilized life, in particular, it has at last become possible for large numbers of people to pass from cradle to grave without ever having had a pang of genuine fear. Many of us need an attack of mental disease to teach us the meaning of the word" (*The Principles of Psychology*, New York, 1890). A particular image stuck with him as the ultimate fate he dreaded: "There arose in my mind the image of an epileptic patient whom I had seen in the asylum, a black-haired youth with greenish skin, entirely idiotic, who used to sit all day on one of the benches, or rather shelves against the wall, with his knees drawn up against his chin, and the coarse gray undershirt, which was his only garment, drawn over them enclosing his entire figure" (*The Varieties of Religious Experience*, New York, 1902).

Fig. 3.49. William James, pencil drawing, ca. 1890. Houghton Library, Harvard University, Cambridge.

Fig. 3.50. William James, pencil drawing, ca. 1890. Houghton Library, Harvard University, Cambridge.

By misspelling a word in this sketch, James, who so resisted becoming a physician, included "MD" in his picture of sorrow.

From colonial days through the mid-nineteenth century, the church condemned individuals who had same-sex relations as sinners, and the state punished them as criminals. In the late nineteenth century, doctors sought to bring a more scientific, secular perspective to the understanding of human sexuality. In defining deviant behavior, they focused on broad issues of sexual roles. During the Victorian era doctors considered male aggression and female passivity to be biologically determined. They diagnosed individuals who did not conform to these patterns as sexually inverted, or reversed: a masculine man became an effeminate one. Inverts were thought not to be true men or women, but hermaphrodite-like individuals who combined elements of the male and female.

Following this reasoning, doctors assumed the naturalness and immutability of male and female traits when explaining behaviors that did not fit within Victorian sexual roles. The aggressive demands of women for voting rights were put down to excessive masculinity. According to physician Herbert J. Claiborne: "Now while I do not mean to state that all suffragettes are inverts . . . I believe that exaggerated masculine traits in their structural and psychic being is the original cause" ("Hypertrichosis in Women," *New York Medical Journal,* 1914, vol. 99, p. 1183). According to British physician John Russell Reynolds, men with symptoms of hysteria, the disease of the passive sex, must be "either mentally or morally of feminine constitution" ("Hysteria," *A System of Medicine,* ed. J. Russell Reynolds, London, 1866–79, vol. 2, p. 207).

Several American physicians writing in the late 1880s developed an evolutionary, biological account of inversion. James G. Kiernan (1852–1923), superintendent of the Chicago County Asylum for the Insane, noted that since embryos are originally bisexual and that sexual differentiation occurs during development, then inversion must be arrested development at a bisexual stage ("Sexual Perversion and the Whitechapel Murders," *The Medical Standard,* vol. 4, Nov. 1888, pp. 129–30). Similarly, G. F. Lydston defined inversion as "arrested development" which can occur as early as the womb "prior to the commencement of sexual differentiation" ("Sexual Perversion, Satyriasis and Nymphomania," *Medical and Surgical Reporter,* 1889, p. 255). Richard von Krafft-Ebing praised the explanatory power of the Kiernan/Lydston

biogenetic explanation of inversion and inserted it in the 1892 edition of his *Psychopathia Sexualis.*

American physicians differed over whether or not inversion was a mental illness. Lydston believed that inverts must be mentally defective because of arrested development: "The unfortunate class of individuals who are characterized by perverted sexuality have been viewed in the light of their moral responsibility rather than as the victims of physical and incidentally of a mental defect" (*Medical and Surgical Reporter,* 1889, p. 253). In a well-publicized 1880 case, inverted behavior was given as evidence of mental illness to obtain a certificate of insanity against Lucy Ann Lobdell, a woman who supported herself as a hunter from the 1850s to 1870s in upstate New York. The "medical" reasons cited for committing Lobdell included that she wore men's clothing and called herself a hunter (see pp. 164–65). Responding perhaps to the growing visibility of homosexual male subcultures in the late nineteenth-century city, George Beard viewed inversion as a form of sexual neurasthenia and attributed its epidemic rise to the nervous exhaustion caused by urban life (*Sexual Neurasthenia,* ed. A. D. Rockwell, New York, 1884, pp. 102–107).

Some physicians, however, argued that inversion was not a mental illness but that the invert's brain had simply developed in a body of the opposite sex. According to William Lee Howard, anatomy was secondary in determining whether an individual was male or female. "The real sexual center, the brain, which is the primary factor in determining the sex" meant that an invert (with male genitals) was really a woman, and her desire for a man was "really a normal sexual feeling" of a woman towards a man ("Sexual Perversion in America," *American Journal of Dermatology and Genito-Urinary Diseases,* 1904, vol. 8, p. 10).

Just as social Darwinism was used at this time to justify racial segregation as the inevitable result of social evolution, so these medical explanations of "natural" and "deviant" sexual behavior reinforced the inevitability of Victorian sexual roles. A heterosexual ethos was seen as a mark of advanced civilization, whereas only primitive societies tolerated deviations from this norm. Several turn-of-the-century medical publications cited the long tradition of inversion in American Indian tribal culture as proof of its primitive stage of development (for example, C. G. Seligmann,

Walt Whitman

The poet Walt Whitman (1819–1892) defied Victorian conventions with his literary celebrations of sexuality. His evocation of love between men, especially in the "Calamus" series of poems brought together in the third edition of *Leaves of Grass* (1860), gained him a devoted following of men such as Edward Carpenter and Oscar Wilde who openly identified themselves as homosexuals. Whitman himself remained deeply ambivalent about the homoerotic themes in his poetry. Raised in an era when both men and women had a greater degree of freedom to express their love for members of the same sex, he nonetheless felt troubled by what he termed his "passionate fondness" for other men and wrote in his journal: "Repress the adhesive nature. ["Adhesiveness" was a phrenological term for the love between members of the same sex.] It is in excess—making life a torment . . . diseased feverish disproportionate adhesiveness." In 1890, when asked directly by John Addington Symonds about the homosexual overtones of the "Calamus" poems, Whitman responded by rejecting such "morbid inferences" about his work and alluding to his illegitimate children (who may or may not have existed) as a way of reasserting his heterosexuality.

In a short story entitled "Bervance," published in 1841, the young Whitman portrayed a father who considers confining his son to a lunatic asylum to end a threatening intimacy between the boy and a male teacher. Yet one of Whitman's closest friends later in life was the Canadian asylum superintendent Richard M. Bucke, whom he met in 1872. Whitman seems to have had no fear that Bucke would regard him as mentally "diseased," and the

Canadian doctor became his physician, confidante, and biographer. Bucke regarded Whitman as the incarnation of a higher spiritual existence, a view that he popularized in his 1883 biography of the poet—Whitman's favorite account of his life—as well as his best-known book, *Cosmic Consciousness* (1901).

Fig. 3.51. Walt Whitman, engraving by Samuel Hollyer, frontispiece to *Leaves of Grass* (1855). The Pierpont Morgan Library, New York, MA 6069.

Lucy Ann Lobdell

The life of Lucy Ann Lobdell Slater (1829–1912), the legendary hunter of Delaware County in upstate New York, illustrates the efforts of doctors to define unconventional gender behavior as a sign of mental illness. Her story is known from contemporary accounts by Lobdell herself, several journalists, a prominent neurologist, and her asylum doctors. According to a reporter for the *New York Times*:

> Mrs. Slater was 17 years old, and was known far and wide for her wonderful skill in shooting the rifle, not only at the target, but at deer and other game, for which the Delaware Valley was then famous. After a year of married life, Slater deserted his wife and a babe a few weeks old, and has never been heard of since. Mrs. Slater's parents were very poor, and objected to her making her home with them. She occasionally put her child in their charge, and laying aside the habiliments of her sex, donned male apparel and adopted the life of a hunter." ("A Modern Romance," *New York Times*, April 8, 1877)

Lobdell asks the reader of her autobiography to "allow me to state the reasons for my adoption of man's apparel":

> I have no home of my own; but it is true that I have a father's house, and could be permitted to stay there, and, at the same time, I should be obliged to toil from morning till night, and then could demand but a dollar per week; and how much, I ask, would this do to support a child and myself.

> . . . I feel that I can not submit to all the bondage with which woman is oppressed, and listen to the voice of fashion. . . . Help, one and all, to aid woman, the weaker vessel. If she is willing to toil, give her wages equal with that of man." (*Lucy Ann Lobdell: The Female Hunter*, New York, 1855, pp. 42–45)

Lobdell supported herself as a hunter for many years. In 1868 she befriended a young woman from Boston, Marie Louise Perry, who had also been deserted as a young wife. The two began living together, with Lobdell assuming the role of husband. According to a reporter, "For two years they roamed about that region, living in caves and in the woods, and subsisting on berries and roots." After being jailed as paupers, the couple could not prevent "the discovery that Mr. Lobdell was a woman" who was "insane, foul and unsexed" (*New York Times*, April 8, 1877). In the next two years, as rumors of Lobdell's mental instability circulated, her relatives became increasingly uneasy at the prospect of a lunatic in the family, and they literally wrote her obituary ("Death of a Modern Diana," *New York Times*, Oct. 7, 1879; interview with Susan Shields, Lobdell's great-great-great-granddaughter, Deposit, New York, April 16, 1994).

In 1880 Lobdell, then fifty-one years old, was committed to Willard Asylum in upstate New York, an institution built for the chronically insane. Three reasons were given for declaring her insane: "She insists on wearing male attire. She calls herself a huntress. She threatens violence to herself and others." But the physical examination performed at the time of her admission records no self-inflicted wounds, and there is no note of violent behavior in her asylum records, which span several decades (Certificate of insanity of Lucy Ann [Lobdell] Slater, Oct. 9, 1880, Archives of Willard Asylum).

Physician James G. Kiernan, following his view of inversion as a form of arrested development resulting in hermaphroditism, discussed Lobdell's case with special attention to her masculine characteristics, both social and physical, such as her childhood "liking for boyish games and attire" and, as a patient at Willard, her "enlarged clitoris" ("Psychological Aspects of the Sexual Appetite," *Alienist and Neurologist*, April 1891, pp. 202–203.) Lobdell's physician at Willard, P. M. Wise, regarding inversion as a mental illness, diagnosed Lobdell with dementia and erotomania, and wrote:

> It would be more charitable and just if society would protect them from the ridicule and aspersion they must always suffer . . . by recognizing them as the victims of a distressing monodelusional form of insanity. It is reasonable to consider true sexual perversion as always a pathological condition and a peculiar manifestation of insanity. ("A Case of Sexual Perversion," *Alienist and Neurologist*, Jan. 1883, p. 91)

Lobdell was transferred in 1892 to Binghamton State Hospital (Kiernan incorrectly reported in his article that Lobdell died at Willard in the 1890s), where she died in 1912 at age eighty-three.

Fig. 3.52. Lucy Ann Lobdell, ca. early 1870s. Courtesy Lucy Ann Lobdell family, Long Eddy and Deposit, New York.

Fig. 3.53. Lucy Ann Lobdell, ca. late 1870s. Courtesy Lucy Ann Lobdell family, Long Eddy and Deposit, New York.

Lucy Ann Lobdell is shown in buckskins and braids, her hunting attire (left), and after getting a man's haircut (above).

Fig. 3.54. Letter from Sigmund Freud to an American mother, April 9, 1935. The Kinsey Institute for Research in Sex, Gender, and Reproduction, Bloomington, Indiana, copyright A. W. Freud, et al., by arrangement with Mark Paterson and Associates.

Freud wrote the following letter to an American woman worried about her son's sexual orientation:

> I gather from your letter that your son is a homosexual. I am most impressed by the fact that you do not mention this term yourself in your information about him. May I question you why you avoid it? Homosexuality is assuredly no advantage, but it is nothing to be ashamed of, no vice, no degradation; it cannot be classified as an illness; we consider it to be a variation of the sexual function, produced by a certain arrest of sexual development. Many highly respectable individuals of ancient and modern times have been homosexuals, several of the greatest men among them. (Plato, Michelangelo, Leonardo da Vinci, etc.) It is a great injustice to persecute homosexuality as a crime—and a cruelty, too. If you do not believe me, read the books of Havelock Ellis.
>
> By asking me if I can help, you mean, I suppose, if I can abolish homosexuality and make normal heterosexuality take its place. The answer is, in a general way we cannot promise to achieve it. In a certain number of cases we succeed in developing the blighted germs of heterosexual tendencies, which are present in every homosexual; in the majority of cases it is no more possible. It is a question of the quality and age of the individual. The result of treatment cannot be predicted.
>
> What analysis can do for your son runs in a different line. If he is unhappy, neurotic, torn by conflicts, inhibited in his social life, analysis may bring him harmony, peace of mind, full efficiency, whether he remains homosexual or gets changed. . . .

"Sexual Inversion among Primitive Races," *Alienist and Neurologist,* vol. 23, Jan. 1902, pp. 11–15). Living in a society that prided itself on its European heritage, physicians avoided the awkward topic of male homosexual relations in ancient Greece, the birthplace of Western civilization, although the noted English scholar John Addington Symonds discussed the topic in *A Problem in Greek Ethics* (1883).

By 1900 researchers were beginning to distinguish passive / aggressive sexual behavior from the much narrower issue of choice of sexual object, and to define deviance in terms of object choice. This trend is reflected in a terminology change, from "inversion," which refers to the reversal of a whole cluster of male or female attributes, to "homosexuality," which refers only to the choice of a same-sex love object. Two key figures in this shift were British sexologist Havelock Ellis (1859–1939), who argued that passive or aggressive sexual behavior was independent of the sex of the love object (*Sexual Inversion*, 1897), and Sigmund Freud, who distinguished the concepts of sexual object and aim in his seminal *Three Essays on Sexuality* (1905). According to Freud, sexual aim referred to a person's preferred mode of sexual pleasure, including passive or active behavior, whereas

sexual object referred to the object of sexual desire; he defined homosexuality in terms of object choice only. Like Krafft-Ebing, Freud also found plausible the view that homosexuality resulted from arrested biogenetic development, although Freud stressed it was a nonpathological, normal variation of the sexual function.

In 1932 the American Medical Association published the first American classification of disease, *Standard Classified Nomenclature of Disease,* including a list of mental disorders compiled by the American Psychiatric Association that classified homosexuality as a psychopathic personality disorder. Three years later an American woman wrote to Freud and asked for "his help" with her son. In his famous reply, Freud stated that he and Ellis did not consider homosexuality an illness, but rather a variation of healthy sexual development (fig. 3.54). In 1952 the American Psychiatric Association published its own classification system, which included homosexuality as a sociopathic personality disorder (*Diagnostic and Statistical Manual of Psychiatric Disorders,* 1952). Homosexuality was not removed from the American Psychiatric Association's official diagnostic list until 1973, under pressure from the burgeoning gay-rights movement.

The Talking Cure and Modern Culture

First using hypnosis and then free association, in the 1890s Freud developed the "talking cure," the cornerstone of classic psychoanalysis. In "Recommendations to Physicians Practicing Psychoanalysis," he stated one fundamental rule: "The patient should relate everything that his self-observation can detect, and keep back all the logical and affective objections that seek to induce him to make a selection from among them" (*Standard Edition of the Complete Psychological Works of Sigmund Freud,* trans. James Strachey, London, 1974, vol. 12, p. 115). That patients should say whatever came into their minds placed an overwhelming value on verbal articulation for Freudian psychoanalysis and its many hybrid offshoots.

The emergence of the talking cure, however, occurred during an era when fundamental doubts emerged about the ability of words, along with images and other communicative codes, to impart anything meaningful about either natural or divine reality. This mistrust was manifested in a core of early modern art produced throughout Europe and the United States between the 1890s and World War I. The art was more radically abstracted from nature and more severely withdrawn from shared experience than any previously known.

This secretive, obscure art emerged onto the cultural scene in America before World War I and pervaded the rest of the century. Charles Ives (1874–1964), for example, composed "The Unanswered Question" in 1906 with notes to the performers that the strings, playing with no change in tempo, should represent "the silences of the Druids—who know, see, and hear nothing" (fig. 3.55). Trumpets are to intone "the perennial question of existence," other wind instruments are to search

Fig. 3.55. Charles Ives, "The Unanswered Question," first page of the 1906 score. Yale University Music Library, Ives Collection, New Haven.

for an answer, and when none is found, "the silences" are to fade to "undisturbed solitude" (revised score, 1930–35, Yale University Music Library, Ives Collection).

In 1910 in Munich, Wassily Kandinsky painted the first completely nonobjective painting. Poet Ezra Pound responded to the new art ("L'Art," 1910):

> Green arsenic smeared on an egg-white
> cloth,
> Crushed strawberries! Come, let
> us feast our eyes.

After American artist Marsden Hartley visited Kandinsky in 1913, he executed *Painting Number One* (fig. 3.56). The absence of imagery in modern abstract painting such as this—the blankness and enigmatic quality that so disturbed visitors to the 1913 Armory Show—represents a fundamental tendency of the art, music, and literature of this century, one at odds with the self-exposure at the heart of the psychoanalytic method.

There are, of course, many complex causes of this phenomenon. One that relates directly to the history of psychiatry is the psychological impact on Western culture of secular science and the corresponding decline in religion, already evident by the 1890s. In the early nineteenth century, medical research was seen

Fig. 3.56. Marsden Hartley, *Painting Number One,*
1913, oil on canvas, 39¾ × 31⅞ in. Sheldon Memorial
Art Gallery, University of Nebraska, Lincoln, UNL-
F. M. Hall Collection, 1971.H-39.

Freud had a fundamental faith in the
power of words to communicate indirectly the
unconscious, irrational realm of the psyche:
"How are we to arrive at a knowledge of the
unconscious? It is only, of course, as some-
thing conscious that we know it, after it has
undergone transformation or translation into
something conscious. Psychoanalytic work
shows us every day that translation of this
kind is possible" ("The Unconscious," *Stan-
dard Edition,* vol. 14, p. 166). Given his confi-
dence in words and images, it is not surprising
that Freud's taste was for Egyptian and classi-
cal art from ancient Greece and Rome, which
he collected, and that he was unsympathetic
to the silent, obscure art of his day, from fin-
de-siècle symbolism to post–World War I sur-
realism. When Freud was eighty-one years
old, he met Salvador Dali: "Until then I was
inclined to look upon surrealists, who have
apparently chosen me for their patron saint,
as absolute . . . cranks" (letter from Freud to
Stefan Zweig, July 20, 1938).

As the syntax of verbal and visual commu-
nication was further shattered by two world
wars, psychoanalysts increasingly realized that
the modern mistrust of language raised fun-
damental doubts about psychotherapy and
the analytic situation. Thus the theoretical
developments of psychoanalysis in this cen-
tury have been reformulations of classical
Freudian theory on broader linguistic and
symbolic foundations, including structural
linguistics and nonverbal semiotic systems.
In recent research, American historians, phi-
losophers, and literary critics have adopted
either classical Freudianism, which typically
aspires to scientific lucidity, or neo-Freudian
theories, whose irrational subject matter
seems to demand an intentionally obscure
style. Such interdisciplinary mergers between
psychoanalysis and the humanities increas-
ingly have characterized the intellectual land-
scape of the later twentieth century.

as consistent with Christianity and the New-
tonian universe as designed by God. By the
mid-nineteenth century, however, Darwin had
presented human beings as a product of the
natural world, driven by passions associated
with reproduction and survival, without
appeal to transcendent purposes. By the end
of the nineteenth century, psychiatrists and
neurologists had ceased questioning the pro-
priety of purely secular explanations for men-
tal phenomena.

In this scientific atmosphere the demands
for clarity and verifiability that undermined
religious doctrine also threatened the artistic
realm. Certain modern artists defensively
withdrew from this scientific, technological
society and, shunning representational sub-
ject matter, stationed themselves in a psycho-
logically primitive, irrational zone. From
this defensive position they created art with
shrouded content and scrambled codes that
defies interpretation. This withdrawal at
times has superficial similarities to ancient or
Eastern mysticism, often encouraged by the
artists themselves, such as Ives's reference to
the Druids, but it is essentially secular, leading
not in a transcendental direction but narcissis-
tically inward.

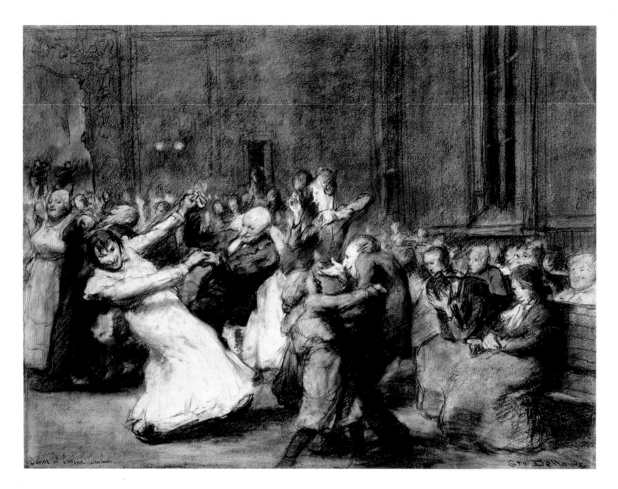

Fig. 3.57. George Bellows, *Dance in a Madhouse,* 1907, charcoal with crayon, pen, and black ink, heightened with brown and white chalks, on paper. The Art Institute of Chicago, Charles H. and Mary F. S. Worcester Collection.

After the decline of moral treatment, one of the last depictions of a lunatic ball was done by American realist George Bellows, who grew up in Columbus, Ohio. He was friendly with the superintendent of the Ohio Lunatic Asylum and knew many patients. According to Bellows:

> Each of the characters . . . represents a definite individual. Happy Jack boasted of being able to crack hickory nuts with his gums. Joe Peachmyer was a constant borrower of a nickel or a chew. The gentleman in the center had succeeded with a number of perpetual motion machines. The lady in the middle center assured the artist by looking at his palm that he was a direct descendant of Christ. This is the happier side of a vast world which a more considerate and wiser society could reduce to a not inconsiderable degree (*Exhibition of Original Lithographs by George Bellows,* Albert Roullier Art Galleries, Chicago, 1919).

SCIENCE AND PSYCHIATRY IN THE NEW CENTURY

In 1921 American psychiatrists chose a new name for their professional organization that would reflect their solid commitment to clinical and laboratory research. But even as the organization abandoned its hyphenated identity as the American Medico-Psychological Association to become the American Psychiatric Association, its members were becoming increasingly disparate in both orientation and place of practice. From the turn of the century to World War I, mental health practitioners became more and more divided in their allegiance between somatic approaches in line with Emil Kraepelin's systematizing work and psychological treatments derived from neurology and early psychoanalysis. Although ecumenical voices were heard from both sides, the profession gradually split into hospital psychiatry for the somatic treatment of psychotic patients and private psychotherapy for the mildly neurotic.

Psychosis, Somatic Treatment, and Hospital Psychiatry

After 1900 prospects remained bleak for the cure of psychotic disorders characterized by a deterioration of normal intellectual and social functioning and a withdrawal from reality. As psychiatrists witnessed dramatic chemical and surgical cures develop in other areas of medicine, they sought their own somatic solutions to manic depression and schizophrenia. In 1910 they were greatly inspired when German bacteriologist Paul Ehrlich (1854–1915) discovered an arsenical compound that killed the spirochete responsible for syphilis. Although the drug, which Ehrlich named salversan, was dangerously toxic and had terrible side effects, Ehrlich's work proved that chemotherapy could cure a mental illness. Effective drug treatment eventually eliminated paresis, the tertiary stage of syphilitic infection, whose victims had populated the back wards of nineteenth- and early twentieth-century mental hospitals.

During these years, as more opportunities opened up for psychiatrists outside asylum walls, fewer physicians chose careers in hospital psychiatry. Although many private hospitals such as the Institute of Pennsylvania Hospital and the Hartford Retreat continued to provide excellent, individualized care in the tradition of moral treatment, by World War I most public mental hospitals offered only custodial care. Ward life was characterized by monotony and anonymity, and complaints of patient abuse were common.

A movement to improve hospital conditions in this era was begun by Clifford Beers (1876–1943). Himself a manic depressive, Beers wrote *The Mind That Found Itself* (1908), an autobiographical account of his experiences as a patient in several mental hospitals. Beers's vivid descriptions of the institutional monotony and cruelty that made it difficult for even a motivated patient to recover drew the attention of many reformers, including William James and Jane Addams. They joined with Beers in 1909 to found the National Committee for Mental Hygiene. The committee soon focused its attention almost exclusively on the prevention of mental illness; as Beers wrote, "Protecting *sanity* is the main object" (letter from Beers to William James, Feb. 25, 1909). Beers continued to suffer from manic depression and spent his last years in Butler Hospital, Providence, Rhode Island, where he died in 1943. The organization he helped to found survives today as the National Mental Health Association.

In the first half of the twentieth century, psychiatrists tried various surgical, electrical, and chemical remedies for mental illness. Many treatments were based on the concept of shocking the nervous system to improve its physiological functioning. In the 1930s psychiatrists injected insulin to induce shock and temporary coma as a treatment for schizophrenia. In a controversial descendant of nineteenth-century electrotherapy, American mental hospitals in the 1940s began to produce the desired shock by applying electric current to the brain. The most radical somatic solution, however, was the lobotomy, a surgical operation that severed the connections between the prefrontal lobes and other parts of the brain, on the theory that pathological thought processes originated in those lobes. One of only two Nobel Prizes in medicine given for work in psychiatry was awarded in 1935 for the invention of the prefrontal lobotomy. Between 1936, when the procedure was first performed in the United States, and the mid-1950s, an estimated twenty thousand lobotomies were performed on American mental patients.

While somatic treatments raised hopes that severely ill patients could be cured, the numbers of institutionalized patients remained very high. In the 1940s and early 1950s, 50 percent of all hospital beds in the United States were filled with mental patients. In many public institutions, chronically ill patients

received no medical treatment and lived in extremely poor conditions. This grim situation began to change in the 1950s with the discovery of chlorpromazine, better known by its trade name Thorazine, which finally provided the first effective, somatically based treatment for schizophrenia, followed in the late 1960s by lithium, which revolutionized the treatment of manic depression. Although opponents referred to Thorazine as a chemical lobotomy, for those administering mental hospitals the effects were little short of miraculous. Overnight, calm descended on wards that for more than a century had been filled with despairing cries and violent eruptions. Some chronic patients improved enough to be released, contributing in the late 1950s to the first decline in state hospital populations in more than a hundred years. The development of effective drug therapy, together with the adoption of entitlement programs, including Medicare and Medicaid, which provide a disability stipend for chronic cases, led to widespread deinstitutionalization after 1965, a trend that continues to the present.

Neurosis, Psychoanalysis, and Private Practice

After 1900 American psychiatrists continued using methods developed by nineteenth-century neurologists to treat various forms of mild, neurotic disorders such as anxieties and phobias. As psychoanalytic concepts arrived from Europe, American psychiatrists developed new forms of psychotherapy which further broadened their clientele to those who suffered from emotional problems but still functioned in the everyday world. Psychiatry's growing focus on neurotic, as opposed to psychotic, patients was reflected in a shift to private office practice, with a reduced commitment to institutional psychiatry. In place of the taxing regimen and administrative frustration typical of a hospital practice dealing with chronic, psychotic cases, private practice offered articulate, mildly afflicted patients, flexible hours, and involvement with the stimulating new concepts of a rapidly expanding psychological frontier.

American psychiatrists during this era were especially receptive to European ideas, and America imported and nurtured psychoanalysis, albeit in homegrown varieties. Pierre Janet spoke at Harvard Medical School in 1906, and in 1909 Sigmund Freud made a historic visit to America, accompanied by Carl Jung, Sandor Ferenczi, A. A. Brill, and Ernest Jones. Freud was the guest of

Fig. 3.58. Sigmund Freud at Clark University, 1909. The Oskar Diethelm Library, History of Psychiatry Section, Department of Psychiatry, Cornell University Medical College and The New York Hospital, New York.

Seated, from left: Freud, Stanley Hall, president of Clark University, Carl Jung. *Standing, from left:* A. A. Brill, Ernest Jones, and Sandor Ferenczi.

Clark University in Worcester, Massachusetts, where he delivered a lecture series on psychoanalysis which was attended by William James and Adolf Meyer (fig. 3.58). For more than a decade, Freud's revolutionary theories had been dismissed by the medical community in Vienna. This invitation to speak at an American university constituted the first significant professional recognition given to Freud, who began his first lecture, "It is with novel and bewildering feelings that I find myself in the New World, lecturing before an audience of expectant enquirers" ("Five Lectures on Psychoanalysis," *Standard Edition of the Complete Psychological Works of Sigmund Freud,* trans. James Strachey, London, 1974, vol. 11, p. 9).

Some of Freud's American followers, including Brill and James Jackson Putnam, founded the American Psychoanalytic Association in 1911, and the rival New York Psychoanalytic Society was formed the same year. As in Europe, American psychoanalytic training and certification were organized outside medical schools.

Although the training of lay analysts (those without an M.D. degree) was disputed in Europe, it was nowhere more discouraged than in the United States, where the American Psychoanalytic Association ruled in 1918 that only individuals who had completed medical school and a psychiatric residency could become candidates for psychoanalytic training. (Freud himself promoted the training of lay analysts, especially those with a background in psychology.) The American Psychoanalytic Association admitted nonmedical candidates for clinical training only beginning in 1986, under pressure from reformers within the organization and from a lawsuit brought by three psychologists with Ph.D. degrees.

The "Americanized" versions of psychoanalysis popular among psychiatrists in the United States prior to World War II gave an optimistic twist to Sigmund Freud's theories of early childhood experience and personality development. American psychiatrists seized on the idea that improving child-rearing practices and channeling sexual energies in more "wholesome" directions would produce happier, more productive citizens. Although Freud himself repudiated this interpretation of his work, American-style psychotherapy harmonized with the social engineering ethos of early twentieth-century America, whereby psychological science was put to use to "adjust" ineffective or troublesome individuals to better fill their roles in a democratic society.

The most influential American school of psychodynamic theory was founded by Adolf Meyer (1866–1950), a Swiss-born psychiatrist who headed the psychiatric department at the Johns Hopkins School of Medicine. Meyer was a founder of the American Psychoanalytic Association, yet he maintained an intellectual and professional distance from the psychoanalytic community. He did not believe in emphasizing infantile sexuality or the recovery of unconscious material. He preferred what he called a "common-sense" approach to psychiatry which focused more on improving the patient's skills in everyday living. Meyer's "psychobiology," as he called it, dominated American psychiatry for the first half of the twentieth century.

CONCLUSION

As we wrote this study of the evolution of American perceptions of mental illness, we found that present-day attitudes often resonated with those of the past. The first hospital in colonial America was established to remove from the streets a growing number of "lunatics" who "going at large are a terror to their neighbors, who are daily apprehensive of the violence they may commit"— words that could describe the feelings of many today toward the mentally ill homeless. Accusations of "moral insanity" reverberate in contemporary attacks that disparage the mental status of political foes. While today we reject unfounded racial, ethnic, or sexual stereotypes about the human mind and brain, these poisonous mind-sets continue to infect our culture and its practice of medicine. Although society is more egalitarian than a century ago, equality of treatment for all mentally ill Americans remains an ideal rather than a reality.

But there are striking improvements today in the psychiatric treatment of mental illness. Both sophisticated new drug therapies and improved psychotherapies offer mental patients more hopeful prospects than were available in the eighteenth and nineteenth centuries. Mental health professionals have a greater awareness of patient rights, and society at large is more tolerant of variety in human behavior, especially in the realm of sexuality.

Although many attitudes toward mental illness presented in this study persist in our present era, other viewpoints, firmly entrenched just a century ago, now seem remote in their obsolescence. With the benefit of hindsight, we have been able to illuminate past perceptions of mental illness. Occasionally we have despaired at how many of our intelligent, well-intentioned forebears cherished beliefs about the human mind and brain that are so blatantly inconsistent with the democratic principles on which the United States is founded. Thus reminded of how misguided one's suppositions about sanity and madness can be, we are left to wonder what future historians will bring into relief when they turn the spotlight on our own times.

References

In writing this book, we relied on a number of secondary works on the history of psychiatry and American culture. We found the following titles to be most helpful as sources of information and inspiration.

Baxter, William E., and David W. Hathcox. *America's Care of the Mentally Ill: A Photographic History*. Washington, D.C.: American Psychiatric Association, 1994.

Blassingame, John W. *The Slave Community: Plantation Life in the Antebellum South*. New York: Oxford University Press, 1979.

Brumberg, Joan Jacobs. *Fasting Girls: The Emergence of Anorexia Nervosa as a Modern Disease*. Cambridge: Harvard University Press, 1988.

Chauncey, George. "From Sexual Inversion to Homosexuality: The Changing Medical Conceptualization of Female 'Deviance.'" In *Passion and Power: Sexuality in History*, edited by Kathy Reiss and Christina Simmons with Robert A. Padgug, pp. 87–117. Philadelphia: Temple University Press, 1989.

———. *Gay New York: Gender, Urban Culture, and the Making of the Gay Male World, 1890–1940*. New York: Basic Books, 1994.

Dain, Norman. *Concepts of Insanity in the United States, 1789–1865*. New Brunswick: Rutgers University Press, 1964.

Davies, John D. *Phrenology: Fad and Science, a Nineteenth-Century American Crusade*. New Haven: Yale University Press, 1955.

Davidson, Abraham A. "Art and Insanity, One Case: Blakelock at Middletown." *Smithsonian Studies in American Art,* vol. 3, no. 3 (1989), pp. 54–71.

Deutsch, Ronald M. *The Nuts among the Berries: An Exposé of America's Food Fads*. New York: Basic Books, 1968.

Donnegan, Jane B. *"Hydropathic Highway to Health": Women and Water-Cure in Antebellum America*. Westport, Conn.: Greenwood Press, 1986.

Dwyer, Ellen. *Homes for the Mad: Life inside Two Nineteenth-Century Asylums*. New Brunswick: Rutgers University Press, 1987.

Feinstein, Howard M. *Becoming William James*. Ithaca, N.Y.: Cornell University Press, 1984.

Foucault, Michel. *Madness and Civilization: A History of Insanity in the Age of Reason*. Translated by Richard Howard. New York: Pantheon Books, 1965.

Gamwell, Lynn. "A Century of Silence: Nonrepresentation and Withdrawal in Modern Art." In *Psychoanalysis and Culture,* edited by Nancy Ginsberg. Palo Alto: Stanford University Press, 1995.

Gay, Peter. *The Bourgeois Experience: Victoria to Freud*. Vol. 1, *Education of the Senses*. New York: Oxford University Press, 1984.

Gilman, Sander L. *Disease and Representation: Images of Illness from Madness to AIDS*. Ithaca: Cornell University Press, 1988.

———. *Seeing the Insane: A Cultural History of Madness and Art in the Western World*. New York: Wiley, Brunner / Mazel, 1985.

Goodrich, Lloyd. *Albert Blakelock: A Centenary Exhibition*. New York: Whitney Museum of American Art, 1947.

Gorn, Elliot J. "Black Magic: Folk Beliefs of the Slave Community." In *Science and Medicine in the Old South,* edited by Ronald L. Numbers and Todd L. Savitt, pp. 295–326. Baton Rouge: Louisiana State University Press, 1989.

Gosling, F. G. *Before Freud: Neurasthenia and the American Medical Community, 1870–1910*. Urbana: University of Illinois Press, 1987.

Grob, Gerald N. *Mental Institutions in America: Social Policy to 1875*. New York: The Free Press, 1972.

———. *Mental Illness and American Society, 1875–1940*. Princeton, N.J.: Princeton University Press, 1983.

Gould, Stephen Jay. *The Mismeasure of Man*. New York: Norton, 1981.

Haller, John S. *Outcasts from Evolution: Scientific Attitudes of Racial Inferiority, 1859–1900.* Urbana: University of Illinois Press, 1971.

Hawkins, Kenneth. "The Therapeutic Landscape: Nature, Architecture and Mind in Nineteenth-Century America." Ph.D. diss., University of Rochester, 1991.

Hollander, Stacy C. "Asa Ames and the Art of Phrenology." *Clarion,* vol. 14 (Summer 1989), pp. 28–35.

Hungerford, Edward. "Poe and Phrenology." *American Literature,* vol. 2, no. 3 (March 1930), pp. 209–31.

Jamison, Kay R. *Touched with Fire: Manic-Depressive Illness and the Artistic Temperament.* New York: The Free Press, 1993.

Jimenez, Mary Ann. *Changing Faces of Madness: Early American Attitudes and Treatment of the Insane.* Hanover, N.H.: University Press of New England, 1987.

Katz, Jonathan. *Gay American History: Lesbians and Gay Men in the United States, a Documentary History.* New York: Meridan, 1992.

Kenney, John Andrew. *The Negro in Medicine.* Tuskegee, Alabama: Tuskegee Institute Press, 1912.

Leibold, Cheryl. "Thomas Eakins in the Badlands." *Archives of American Art Journal,* vol. 27, no. 1 (1987), pp. 2–15.

Levine, Lawrence. *Highbrow/Lowbrow: The Emergence of Cultural Hierarchy.* Cambridge: Harvard University Press, 1988.

Lifton, Norma. "Thomas Eakins and S. Weir Mitchell: Images and Cures in the Late Nineteenth Century." In *Psychoanalytic Perspectives on Art,* edited by Mary Mathews Gedo, pp. 247–74. Hillsdale, N.J.: The Analytic Press, 1987.

McCarthy, Paul. "Forms of Insanity and Insane Characters in *Moby-Dick.*" Colby Library Quarterly, vols. 23–24 (1987–88), pp. 39–51.

McGovern, Constance. *Masters of Madness: Social Origins of the American Psychiatric Profession.* Hanover, N.H.: University Press of New England, 1985.

MacGregor, John M. *The Discovery of the Art of the Insane.* Princeton: Princeton University Press, 1989.

Maultsby, Maxie C. "The Origin of Black Distrust of Psychiatrists." In *Behavior Modification in Black Populations: Psychosocial Issues and Empirical Findings,* edited by Samuel M. Turner and Russell T. Jones, pp. 39–55. New York: Plenum Press, 1982.

Novak, Barbara. *Nature and Culture: American Landscape, 1825–1865.* New York: Oxford University Press, 1980.

Porter, Roy. *Mind Forg'd Manacles: A History of Madness in England from the Restoration to the Regency.* London: The Aithone Press, 1987.

Rosenberg, Charles. *The Trial of the Assassin Guiteau: Psychiatry and Law in the Gilded Age.* Chicago: University of Chicago Press, 1968.

Rosenberg, Charles, and Carroll Smith-Rosenberg. "The Female Animal: Medical and Biological Views of Woman and Her Role in Nineteenth-Century America." *Journal of American History,* vol. 60 (1973), pp. 332–56.

Rothman, David. *The Discovery of the Asylum: Social Order and Disorder in the New Republic.* Boston: Little, Brown, 1971.

Savitt, Todd L. *Medicine and Slavery: The Diseases and Care of Blacks in Antebellum Virginia.* Urbana: University of Illinois Press, 1978.

Showalter, Elaine. *The Female Malady: Women, Madness, and English Culture, 1830–1980.* New York: Pantheon Books, 1985.

———. "Hysteria, Feminism, and Gender." In *Hysteria Beyond Freud,* edited by Sander L. Gilman et al., pp. 286–344. Berkeley: University of California Press, 1993.

Sicherman, Barbara. "The Uses of a Diagnosis: Doctors, Patients, and Neurasthenia." *Journal of the History of Medicine and Allied Sciences,* vol. 32 (1977), pp. 33–54.

Smith, Henry Nash. "The Madness of Ahab." In *Democracy and the Novel: Popular Resistance to Classic American Writers,* edited by Henry Nash Smith, pp. 35–55, 173–77. New York: Oxford University Press, 1978.

Smith-Rosenberg, Carroll. "The Hysterical Woman: Sex Roles and Role Conflict in 19th-Century America." *Social Research,* vol. 39 (1972), pp. 652–78.

Steiner, George. *In Bluebeard's Castle: Some Notes towards the Redefinition of Culture.* New Haven: Yale University Press, 1971.

———. "A Note on Psychoanalysis and Language." *International Review of Psychoanalysis,* no. 3 (1976), pp. 253–58.

Stern, Madeleine Bettina. *Heads & Headlines: The Phrenological Fowlers.* Norman: University of Oklahoma Press, 1971.

———, ed. *A Phrenological Dictionary of Nineteenth-Century Americans.* Westport, Conn.: Greenwood Press, 1982.

Taylor, Joshua C. *The Fine Arts in America.* Chicago: University of Chicago Press, 1979.

Thielman, Samuel. "Southern Madness." In *Science and Medicine in the Old South,* edited by Ronald L. Numbers and Todd L. Savitt, pp. 256–75. Baton Rouge: Louisiana State University Press, 1989.

Tomes, Nancy. *A Generous Confidence: Thomas Story Kirkbride and the Art of Asylum-Keeping, 1840–1883.* New York: Cambridge University Press, 1984.

———. "The Great Restraint Controversy: A Comparative Perspective on Anglo-American Psychiatry in the Nineteenth Century." In *Anatomy of Madness,* edited by W. R. Bynum, Roy Porter, and Michael Shepherd, vol. 3, pp. 190–225. New York: Routledge, 1988.

———. "Historical Perspectives on Women and Mental Illness." In *Women, Health and Medicine,* edited by Rima Apple, pp. 143–71. New York: Garland Press, 1990.

Vogel, Virgil. *American Indian Medicine.* Norman: University of Oklahoma Press, 1970.

Wallace, Anthony F. C. "The Institutionalization of Cathartic and Control Strategies in Iroquois Religious Psychotherapy." In *Culture and Mental Health: Cross-Cultural Studies,* edited by Marvin K. Opler, pp. 63–96. New York: Macmillan, 1959.

Walters, Charles Thomas. "Sculpture and the Expressive Mechanism." In *Pseudo-Science and Society in Nineteenth Century America,* edited by Arthur Wrobel, pp. 180–204. Lexington: University Press of Kentucky, 1987.

Whitehead, Harriet. "The Bow and the Burden Strap: A New Look at Institutionalized Homosexuality in Native North America." In *Sexual Meanings: The Construction of Gender and Sexuality,* edited by Sherry B. Ortner and Harriet Whitehead, pp. 80–115. New York: Cambridge University Press, 1981.

Willie, Charles V., Bernard M. Kramer, and Bertram S. Brown, eds. *Racism and Mental Health.* Pittsburgh: University of Pittsburgh Press, 1973.

Acknowledgments

The staff of Pennsylvania Hospital in Philadelphia encouraged this project from its beginning and opened its historic collections to us. We thank James B. Hoyme, M.D., Medical Director, for first introducing us to each other, and Howard Sudak, M.D., Psychiatrist-in-Chief, Caroline Morris, Archivist-Librarian (retired), Susan Anderson, Conservationist, and Jane Century, Assistant Director of Marketing, for their assistance throughout our research.

A generous grant from the National Endowment for the Humanities aided our research and allowed us to assemble a distinguished team of consultants, who discussed the project with us from an early stage and gave us comments on the manuscript: William E. Baxter, Director of the Library and Archives, American Psychiatric Association; George Chauncey, Department of American History, University of Chicago; Ellen Dwyer, Department of Criminal Justice, Indiana University; Peter Gay, Professor Emeritus of History, Yale University; Sander L. Gilman, Departments of German, History of Science, and Psychiatry, University of Chicago; Maxie C. Maultsby, M.D., Department of Psychiatry, Howard University; David Rothman, Center for the Study of Society and Medicine, Columbia University; Elaine Showalter, Department of English, Princeton University; Michael Vergare, M.D., Department of Psychiatry, Albert Einstein Medical Center, Philadelphia, and Chairman of the 150th Anniversary Commemoration Committee, American Psychiatric Association.

We also benefited from comments on the manuscript given by George J. Makari, M.D., Acting Director of the History Section, Cornell University Medical College, and coeditor of Cornell Studies in the History of Psychiatry, as well as Gerald N. Grob, Department of History, Rutgers University. We thank J. Worth Estes, M.D., Department of Pharmacology, Boston University School of Medicine, for advice on patent medicines and information on bloodletting; Mary Jane Phillips-Matz, author of *Verdi: A Biography* (1993), for advice on mad scenes in opera; Kenneth Hawkins, author of "The Therapeutic Landscape" (1991), for sharing his work-in-progress on Frederick Law Olmstead. We are especially grateful to Albert Wolkoff, M.D., Binghamton, New York, for always finding time in his busy schedule to give needed advice on psychiatric aspects of the project.

Many institutions and individuals aided in the assembling of images for this book, and we thank all who granted us the right to reproduce documents, artworks, and objects from their collections. The Oskar Diethelm Library of the History of Psychiatry Section, Cornell University Medical College, New York, proved to be an especially rich trove of rare and unique items related to the history of psychiatry; we extend special thanks to George J. Makari, Acting Director, and Paul Bunten, Curator. We were especially pleased that Jean Carlson allowed us to reproduce two phrenological heads from the collection of her late husband, Eric T. Carlson, M.D., who for many years was himself Director of the History of Psychiatry Section.

Elizabeth Eckert, the daughter of Ralph Albert Blakelock's physician, Robert Woodman, graciously lent a photograph from the asylum at Middletown. Mrs. Eckert knew the artist as a child and was herself a librarian at Middletown for more than thirty years. We also extend thanks to many individuals who went out of their way to help us locate items and obtain photographs: Gretchen Worden, Director of the Mütter Museum, College of Physicians of Philadelphia; Jeffery M. Flannery, Manuscript Reference Librarian, Library of Congress, Washington, D.C.; Minora

Pacheco, Assistant Loans Coordinator, Metropolitan Museum of Art, New York; Jan Lazarus, Library Technician, National Library of Medicine, Bethesda; Terry Bragg, Archivist, McLean Hospital, Belmont, Massachusetts; Albert W. Kuhfeld, Curator, The Baaken Library and Museum, Minneapolis; Jerome Adamson, Director, and Kevin Murphy, Curator, Adamson-Duvanne Gallery, Los Angeles; Mary Artino, Registrar, Newport Harbor Art Museum, Newport Beach, California; Judith A. McGrath, Senior Librarian, Middletown Psychiatric Center, New York; Diane Meschefske, Museum Curator, Winnebago Mental Health Institute, Winnebago, Wisconsin; R. Blanton McLean, Library Director, Archives of Eastern State Hospital, Williamsburg, Virginia; Margaret H. Harter, Head of Information Services, The Kinsey Institute for Research in Sex, Gender, and Reproduction, Bloomington, Indiana; Edmund Sullivan, Curator (retired), Museum of American Political Life, University of Hartford.

Locating several rare items reproduced in this book required special effort, and we would like to acknowledge those who assisted us. In 1947, the Whitney Museum of American Art published a centenary exhibition catalogue of Ralph Albert Blakelock which included a reference to landscapes painted by the deranged artist in the size and shape of currency. This "landscape money" had been rumored in the art world ever since but never found. Susielies Blakelock, whose late husband was the artist's grandson, gave us the clue that eventually led to a descendent of William T. Cresmer, a collector to whom the artist had given three painted bills in 1916. Mr. Cresmer's grandson, William Cresmer Worthington, and his wife, Jeri, graciously retrieved the painted bills and related documents from their family papers, and brought them to their local museum, where James Ballinger, Director of the Phoenix Art Museum, was kind enough to advise us on the condition and photographing of this fragile work. We thank Norman Geske, Director of the Blakelock Archives, Lincoln, Nebraska, and John Driscoll, Director of the Babcock Galleries, New York, for, respectively, authenticating and appraising these three Blakelock paintings on cloth, as well as Mary Jane Harris, for her sound advice on the matter. The three examples of Blakelock's landscape money are reproduced here for the first time, along with a related photograph, through the courtesy of William Cresmer Worthington and the other grandchildren of William T. Cresmer, Michael Cresmer Seiler, Steven Lawrence Seiler, Susan Seiler Lane, and Sandra Seiler Harrington, whose generosity is greatly appreciated.

The case of Lucy Ann Lobdell, the female hunter of Delaware County, New York, had been widely published in the nineteenth century, as well as in recent secondary sources on gender studies and histories of New York State, yet no photograph of this remarkable woman was known, and her death date varied in the literature. We thank Lobdell's descendent Susan Shields for entrusting us with her family photograph of Lobdell in male attire and for giving us the tip that led to a lost photograph of Lobdell in buckskins and braids. In the course of our investigation of Lobdell's three recorded death dates, Shields was helpful in determining the source of the obituary written by Lobdell's family in 1879 when she was rumored insane, and in locating Lobdell's 1912 grave on the old asylum grounds in Binghamton.

In connection with the research for this book, Lynn Gamwell curated a related traveling exhibition, which opened in Philadelphia in May 1994 in conjunction with a national convention commemorating the 150th anniversary of the American Psychiatric Association. She thanks the following people for advice on the exhibition: on educational programming, Marian Burleigh-Motley, Director of Academic Programs, Metropolitan Museum of Art, New York; on installation design, Dextra Frankel, Dextra Frankel Associates, Santa Monica; on video, Robin White, Owen Electric Pictures, New York. She also is grateful for the help of her colleagues at the exhibition venues. In Philadelphia at the Arthur Ross Gallery, University of Pennsylvania, Dilys Winegrad, Director, and Lucia Dorsey, Coordinator, offered able assistance, and for exhibition funding in Philadelphia, thanks go to Philip Hallen, President, Maurice Falk Medical Fund; the Arthur Ross Gallery Exhibition Fund; and the American Psychiatric Association. In New York, at the New York Academy of Sciences, warmest thanks are extended to Rodney Nichols, C.E.O.; Henry Greenberg, M.D., President; Ann Collins, Public Relations; Bill Horn, Development; Elizabeth Meryman, Art Editor of *The Sciences;* and Vernon Bramble, Director of Facilities. The encouragement of Clara Sujo at this venue is especially appreciated. At the New York Academy of Medicine, Arthur Downing, Librarian; Ann Pasquale-Haddad, Curator; Elaine Schlefer and Susan Martin, Conservationists, were of great help. The New York venue was enriched by contemporary artist Mary Klein, whose concur-

rent exhibition, *Gender Outlaws: Women Yesterday and Today Who Have Passed as Men,* was in part a response to the case of Lucy Ann Lobdell. Acknowledgment is also owed to Alice Bouknicht, Curator, and Eugene Kaplan, M.D., Department of Neuropsychiatry and Behavioral Sciences, at the McKissick Museum of the University of South Carolina, Columbia, and to Kim Rorschack, Director, Richard Born, Curator, and Stephanie D'Alessandro, Associate Curator, at the David and Alfred Smart Museum, University of Chicago.

This book and the related exhibition were developed at the State University of New York at Binghamton, and Lynn Gamwell offers thanks to her many colleagues there: President Lois B. DeFleur, who inspires the pursuit of ambitious projects; Thomas F. Kelly, Vice-President for External Affairs; Marcia R. Craner, Associate Vice-President; and the Development Team, for all of their advice and assistance in funding this project; Deanna France, Senior Associate for Sponsored Programs, for coordination of grant proposals; Margery M. Heffron, Director of University Relations, for her help with publicity; Donald J. Paukette, Vice-President for Administration and Controller, for contract assistance; Carol Baker, Director of University Publications, David Skyrca, Publications Designer, and Karin Stack, Associate Publications Designer, for their excellent exhibition-related publications; Mary S. Collins, Dean of the Decker School of Nursing, for her cosponsorship of the exhibition; Floyd Herzog, Director of the Anderson Center for the Performing Arts, for his professional advice and steadfast friendship; James J. Mellone, Head of Interlibrary Loan, for extensive research assistance; Chris Focht, Photographer, whose large contribution is indicated in the photography credits; Stan Kauffman, Graphic Artist, for computer imaging; and the museum staff. Special appreciation is given to Susan S. Strehle, Associate Vice-Provost, for her kindness in helping the author to work undistracted during the final months of manuscript preparation.

We are honored that Cornell University Press chose to launch a new series on the history of psychiatry with the publication of our book, and we especially appreciate the efforts made by John Ackerman, Director, and Susan Kuc, Associate Director, to facilitate this joint venture with the Binghamton University Art Museum. We are very thankful for the generous support of the Burroughs-Wellcome Co., and we especially appreciate the early interest expressed by Peter Lammers and the continuing assistance of Monte Rosen, President of H & R Communications.

Our deepest gratitude, however, is reserved for those who worked with us most closely and tirelessly to give the words and images in this book their final form: Suzanne Kotz, our editor; Allyson Tasato, Registrar for Photographic Rights and Reproductions at the Binghamton University Art Museum; and Ed Marquand and John Hubbard, who designed the book.

Lynn Gamwell
Nancy Tomes

Index

Photography Credits

Where not credited, photographs have been supplied by the lending institution or collector. Chris Focht: front cover, figs. 1.2, 1.7–1.11, 1.13, 1.14, 1.16, 1.17, 1.20, 1.22–1.26, 2.1, 2.4–2.6, 2.8–2.10, 2.12, 2.13, 2.15–2.20, 2.23–2.27, 2.29–2.32, 2.37, 2.38, 2.40–2.43, 2.48, 2.50–2.52, 2.54, 2.57, 2.59, 2.64–2.66, 2.71–2.74, 2.76, 2.77, 2.82–2.86, 3.1–3.12, 3.15–3.23, 3.27, 3.30–3.33, 3.35–3.45, 3.52, 3.53, 3.58; Rick Echelmeyer: 1.12, 1.23, 2.28, 3.25; Brooke Hammerle, 3.14.